FASHION
IN PICTURES

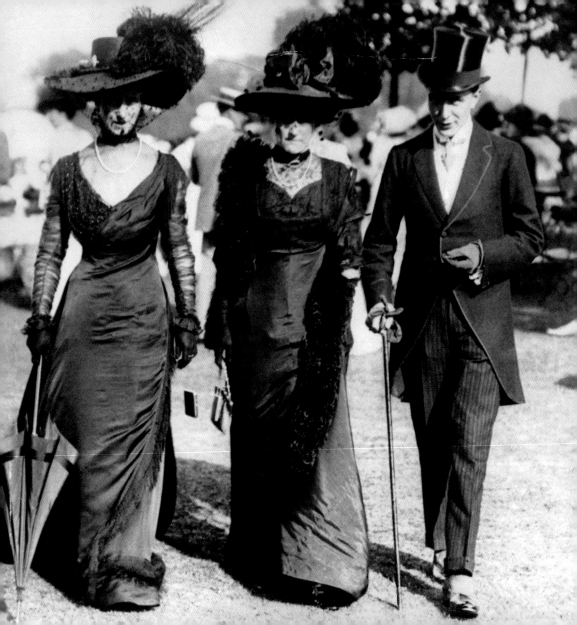

FASHION

IN PICTURES

mirrorpix

AMMONITE
PRESS

First published 2012 by
Ammonite Press
an imprint of AE Publications Ltd,
166 High Street, Lewes, East Sussex, BN7 1XU

Text © AE Publications Ltd, 2012
Images © Mirrorpix, 2012
Copyright © in the work AE Publications Ltd, 2012

ISBN 978-1-90770-832-9

British Cataloguing in Publication Data. A catalogue
record of this book is available from the British Library.

Editor: Caroline Watson
Series Editor: Richard Wiles
Picture research: Mirrorpix
Design: Gravemaker+Scott

Colour reproduction by GMC Reprographics
Printed and bound in China by C&C Offset Printing Co. Ltd

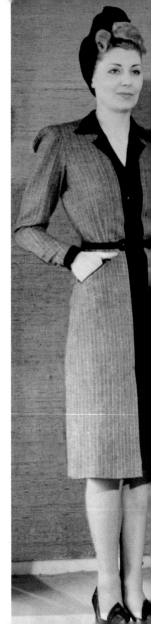

Page 2
Air of formality
Elegant hour-glass dress
styles, topped off with
elaborate, wide-brimmed hats
were paraded by fashion-
conscious Edwardian ladies at
Ranelagh Gardens, Chelsea,
while gentlemen opted for
formal morning coats
and top hats.
July, 1908

Right
Slim shapes
A selection of slim,
knee-length, button-through
dress styles, paired
with coats in contrasting
colours and accessorised
with thin belts, help to
emphasise small waists.
15th May, 1942

Page 6
Pearly Kings and Queens
Carnaby Street in London:
the fashion Mecca of the
1960s. The 'Pearly King
and Queen' fashions on
display here, however, did
not seem to catch on.
October, 1966

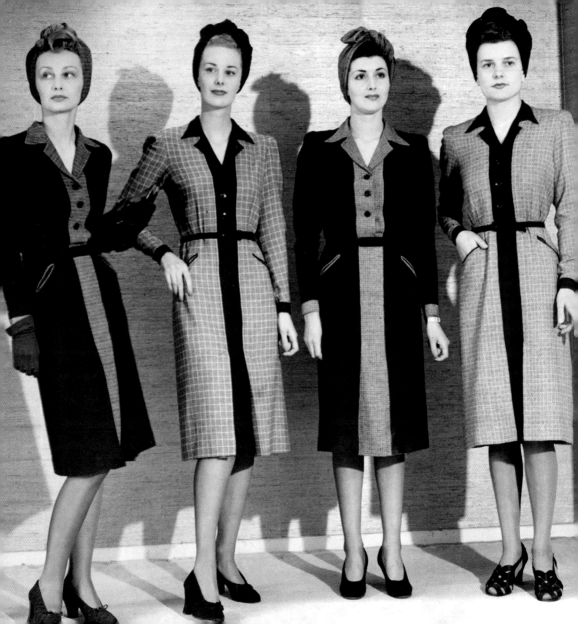

Introduction

The history of fashion throughout the 20th century is a fascinating reflection of the great social and political changes that occurred in the history of Great Britain and the rest of the world. Many of the changes, as well as the people who shaped them, were captured for posterity in photographs taken for the *Daily Mirror* newspaper, and those images provide us with a fascinating snapshot of life in a bygone era.

The beginning of the century saw fashions that were the preserve of the privileged and wealthy late-Victorian and Edwardian upper classes, and most of the photographic records of the period come from the social events of the season, principally the Ascot race meeting and the Henley Regatta, where the wealthiest and most prominent members of society gathered to see, and be seen, in all their conspicuous finery. While the First World War swept away much of the strait-laced fashion and social attitudes of the Victorian and Edwardian eras, mainly to the benefit of women, the social divide endured and high fashion continued to be the preserve of the privileged few for several decades.

Fashion itself, however, evolved swiftly, with the Roaring Twenties ushering in daring short dresses and hairstyles, far from the corsets, long skirts and bustles that had been considered the norm two decades earlier. The economic depression of the 1930s, followed by the shortages created by the Second World War, introduced a period of austerity reflected in plainer fashions; the phrase 'Make do and mend' became the watchword of the times. The opulent 'New Look' of the 1950s reflected post-war optimism and fashion became available to the masses, not just the privileged few. By the 1960s, this period of transition was complete and the Swinging Sixties became a byword for outrageous styles, available to everyone.

The 1970s was the decade that time forgot, ushering in an unfortunate mixture of clumpy, unflattering styles that many who lived through that period would rather forget. However, it also signalled the beginning of greater choice on the high street, which meant affordable fashion for all. The rise of the Yuppy culture of the 1980s saw the return of conspicuous wealth, enjoyed by a new class of entrepreneurs and reflected in more formal, business fashions. The style through the 1990s, and up to the present day, has relaxed again and now, in the 2000s, we have a wealth of affordable fashion styles, available on the high street to suit all, regardless of class, wealth, taste or age. This history in pictures illustrates the journey.

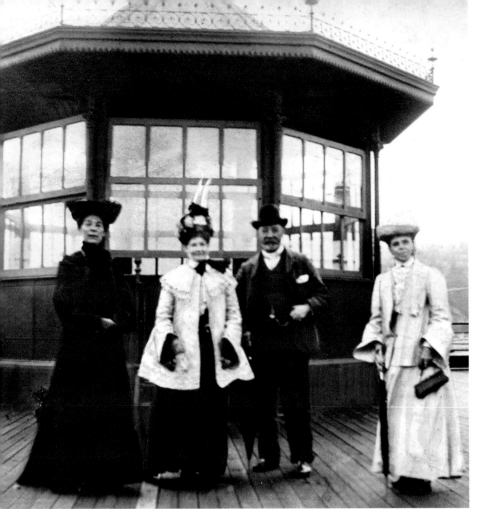

Seaside style

A day trip to the seaside at Roker Beach, Sunderland, North East England, was a chance for Edwardian ladies and gentlemen to show off their Sunday best clothes.

c.1900

1900s

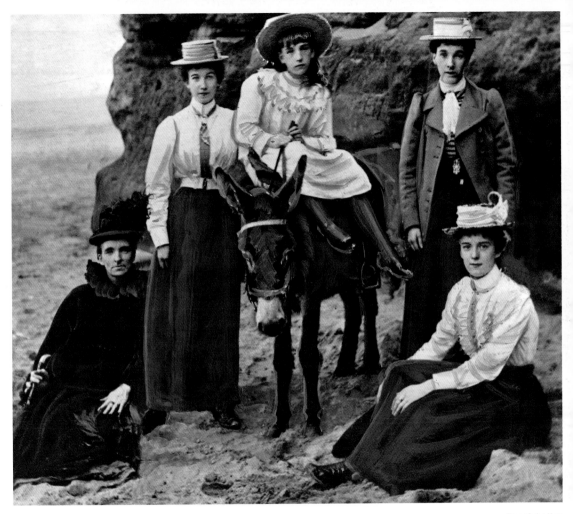

Beach belles

A family outing to the beach: cinched-in waists, long skirts and ruffled blouses, topped off with straw boaters, offered a more casual, holiday style, although not entirely suitable for frolicking in the sand.

1901

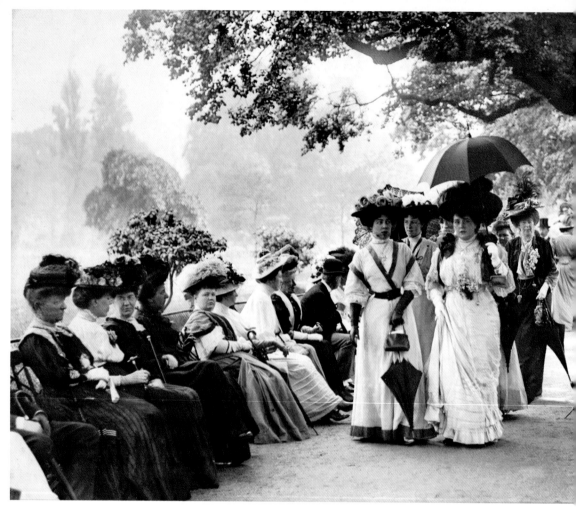

Society stroll

Edwardian society ladies promenading in Hyde Park, London, *the* place to be seen in the latest fashions.

1905

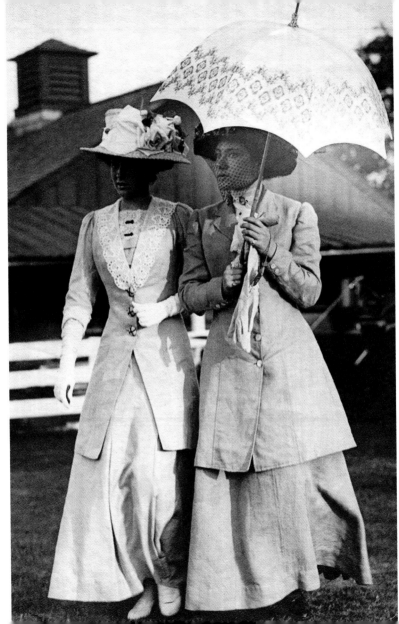

Embroidered detail

Elegant Ascot outfits enhanced by fine detailing of decorative buttons, broderie anglaise collars and delicate scarves, fastened at the neck with pretty brooches.

c.1900s

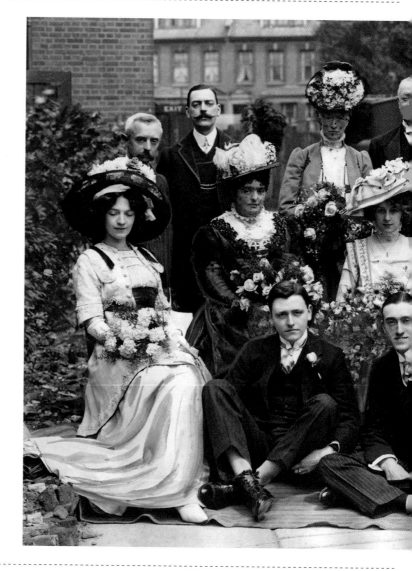

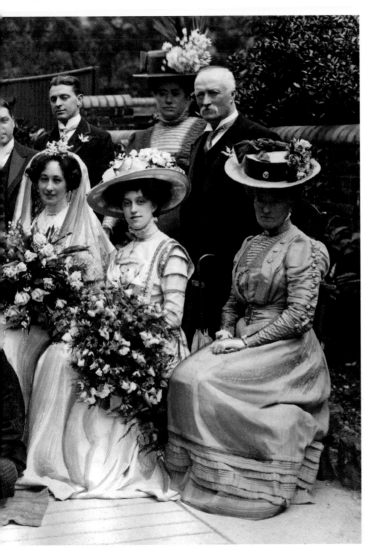

Wedding attire

An Edwardian family wedding: the menfolk all wearing traditional, formal, three-piece suits with tall, stiff collars, while the ladies have ignored the unwritten rule not to outshine the bride and are all resplendent in full-length, silk dresses and elaborately decorated, wide-brimmed hats.

c.1900s

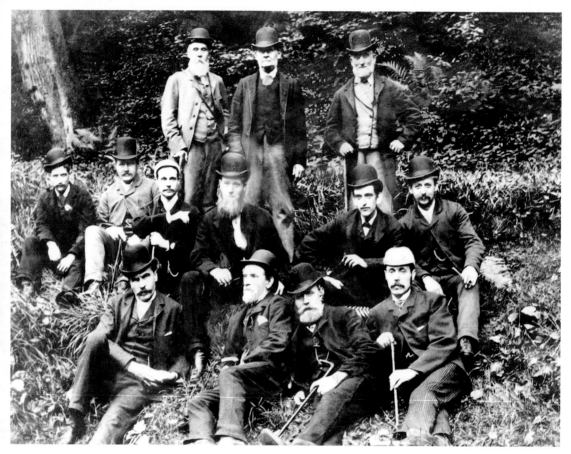

Sunday best

Foremen from the Armstrong Whitworth Newcastle works
on their annual outing at the turn of the century: Sunday suits,
waistcoats, bowler hats and an impressive display of facial hair,
sported by several generations of working men.

c.1900s

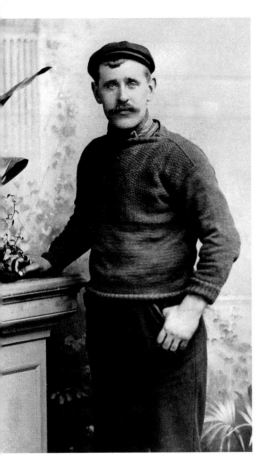

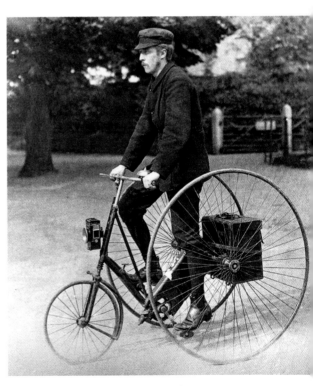

A gentleman on his tricycle wears practical breeches
and long socks that were designed for comfortable cycling.
c.1900s

Early knitwear

A more informal look for an Edwardian gentleman, at the
beginning of the 20th century, who wears a hand-knitted
gansey, or sweater, and flat cap. The seaman's style
sweater originated in Guernsey, Channel Islands.

c.1900s

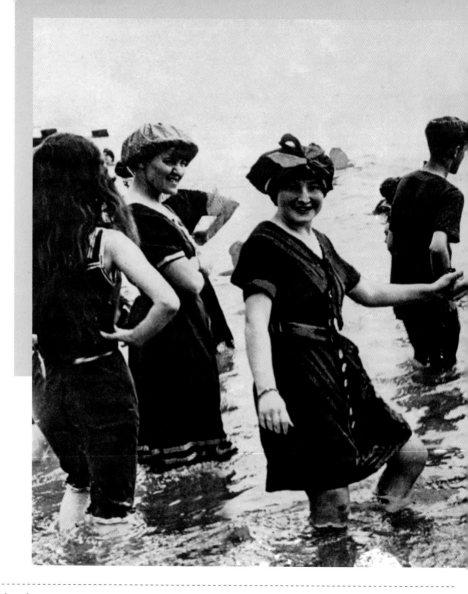

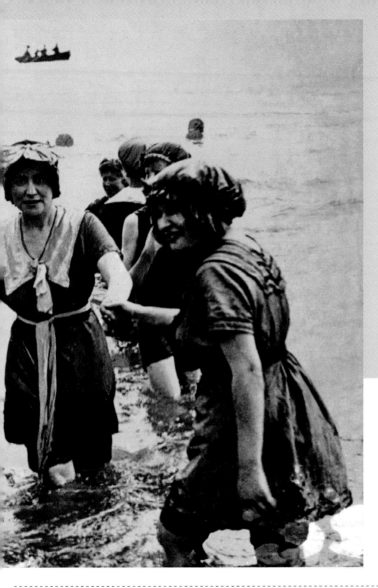

Sailor style

Edwardian ladies paddling in the sea and showing off the new style of bathing costumes: tunics with sailor suit collars and mop caps to keep hairstyles intact.

1906

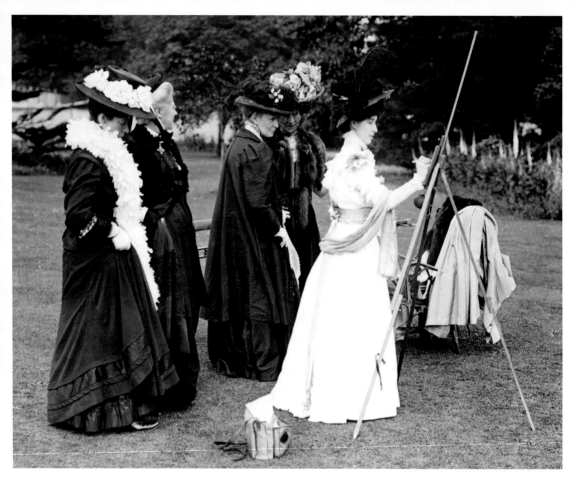

Stylish accessories

The addition of feather boas, fur wraps and elaborate hats gave these otherwise sombre Edwardian long skirts and jackets a dash of style. Miss Dorothy Cox (R) demonstrates her lightning sketches in the grounds of Eltham Palace, South East London, to a group of admiring ladies.

July, 1909

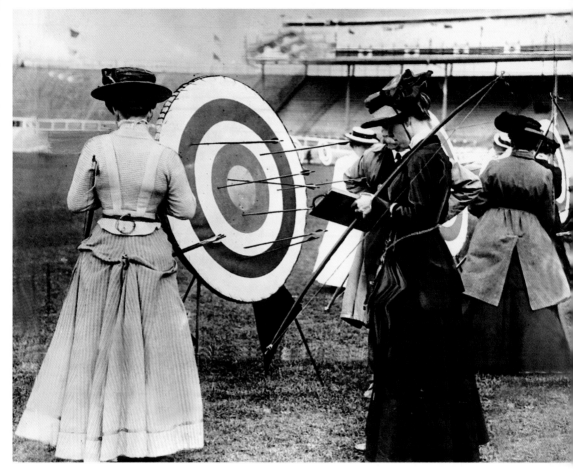

Target practice

Sportswear in the 1900s was unheard of: these ladies, competing in an archery contest at the Olympic stadium in London, simply wore the rather restrictive fashions of the day.

1908

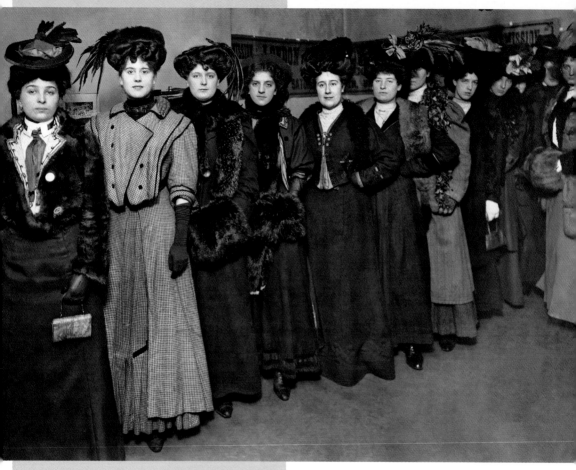

Fashion parade

A fashion show at Earls Court in London: models wait to parade the latest coats, jackets and hats. The new winter look is completed with the addition of accessories in the form of fur stoles and muffs.

May, 1908

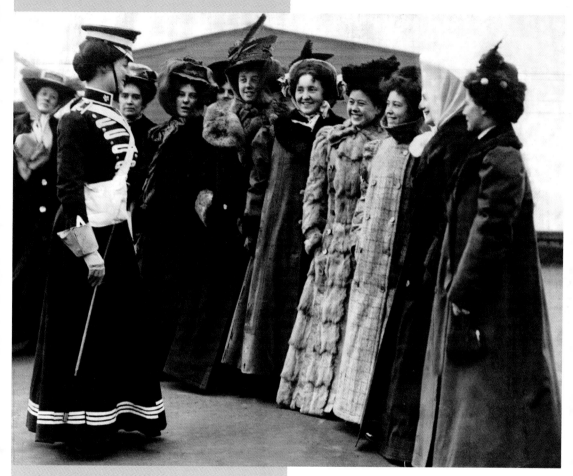

Cover up

An inspection for recruits in Whitehall: a group of ladies
all wearing hats and a wide selection of long, tweed
and fur coats, trimmed with fur collars and rows of buttons.
1909

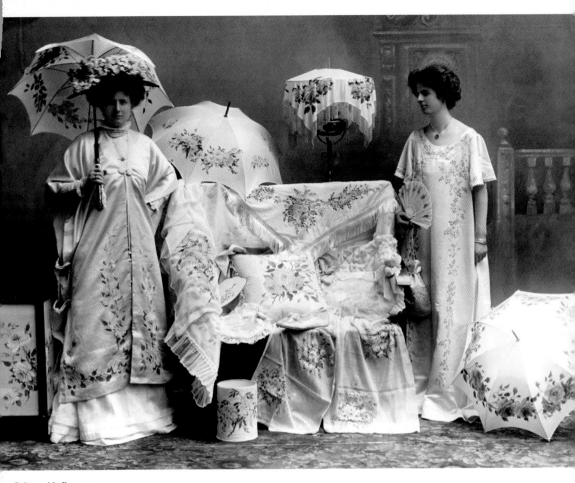

Oriental influences

The *Daily Mirror* Fair of Fashion showcased a more romantic side of Edwardian style. Models wearing hand-painted, silk gowns and holding matching parasols, demonstrated Oriental-inspired influences that were also reflected in the matching soft furnishings.

May, 1909

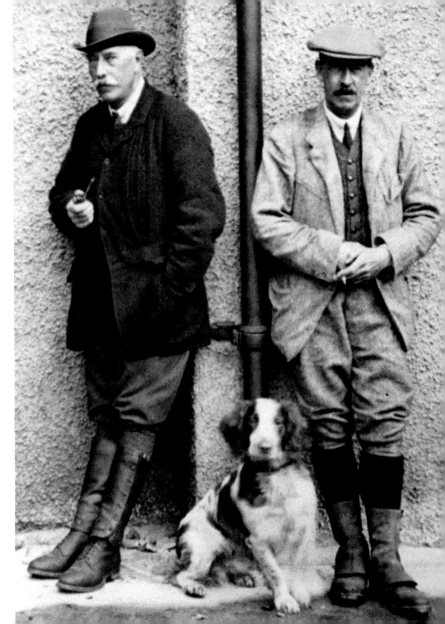

Country gents
Sir John Stewart-Clark (R) and another gentleman pictured on the Dundas Estate, Scotland, sporting country attire: tweed jackets, breeches, hats and gaiters. A year earlier, Sir John had gained notoriety after buying a 1908 Rolls-Royce motor car at auction for the astronomical sum of £500,000.
1909

The Winslow Boy

The Winslow Boy, George Archer Shee, seen here dressed formally to attend court, with (L–R) his mother and sister and Miss Turner. The 13-year-old cadet at the Isle of Wight's Osbourne Naval College was the subject of an infamous trial in July, 1910, when he was accused of stealing a five-shilling postal note from the locker of a fellow cadet in 1908. George's father Martin Archer-Shee took on the Admiralty to contest his son's innocence and, with the aid of the family barrister Edward Carson (who had previously defended Oscar Wilde during his libel suit against the Marquis of Queensberry) successfully won his case.

1910

1910s

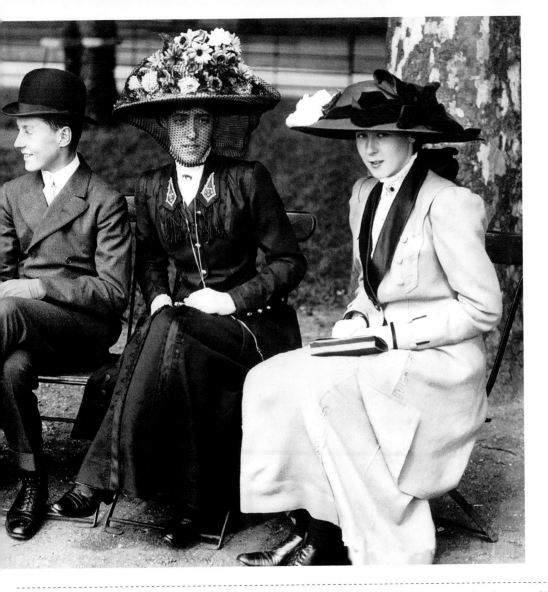

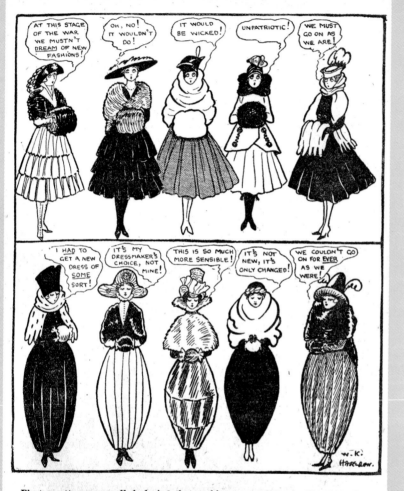

Cartoon creations

A cartoon from the *Daily Mirror Reflections Volume 11*: Young women all declaring that nothing will induce them to change their fashions and buy extravagant new peg-top skirts, followed by the inevitable buying and wearing of the said skirts on various excuses.

1917

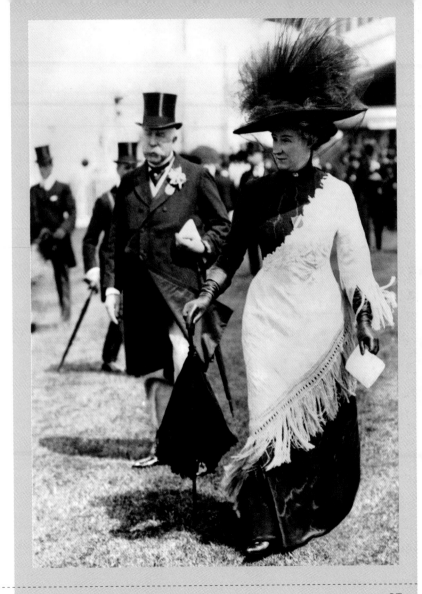

Swagged and tasselled

Two-tone, black and white dress with diagonal-cut panel and tassel detailing: a striking design that, nevertheless, gave the unfortunate impression that the wearer was draped in a tablecloth.

1910

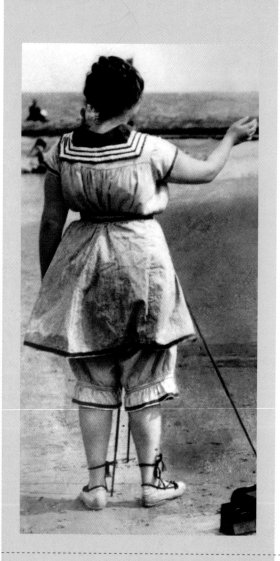

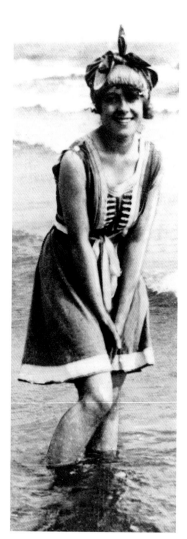

◀◀ Beach modesty
Covering up was the
order of the day on the
fashionable Edwardian
beach: voluminous
tunics worn over
pantaloons helped
to protect a girl's
modesty.
1911

◀ Bathing beauty
A young lady playing
in the sea wearing a
one-piece swimming
costume and early
swimming hat
– possibly just a
handkerchief tied
around her head.
1915

Costume cover-up ▶
Bathers at Norderney
in France, wrapped in
towels to keep warm
after a bracing dip in
the sea. The fashion
for nautical-inspired
beachwear also
extended to children's
fashions
August, 1911

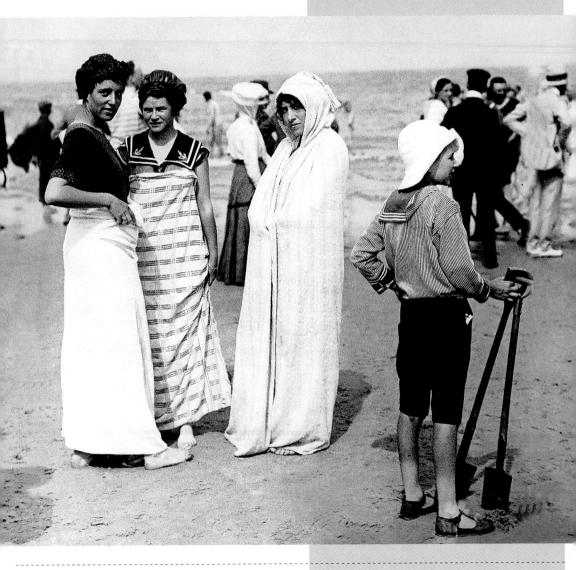

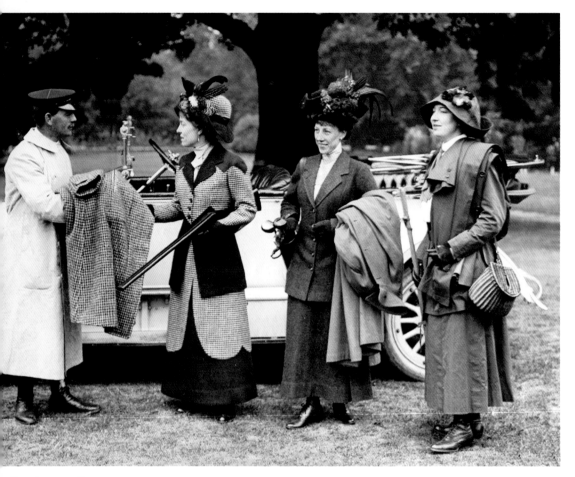

Country pursuits

Edwardian society ladies model Burberry outdoor outfits ideal for hunting, golfing and fishing, at the Fair of British Fashion, held at the Royal Botanic Gardens, Kew.

July, 1912

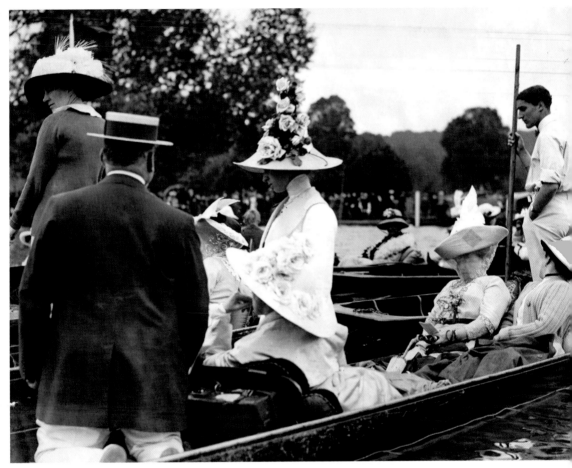

Regatta styles

Society ladies watch the rowers at the Henley Regatta from the comfort of their punt: one of *the* social events of the year
called for bold hats and fine dresses for the ladies, while the gentlemen sported blazers and straw boaters.

July, 1912

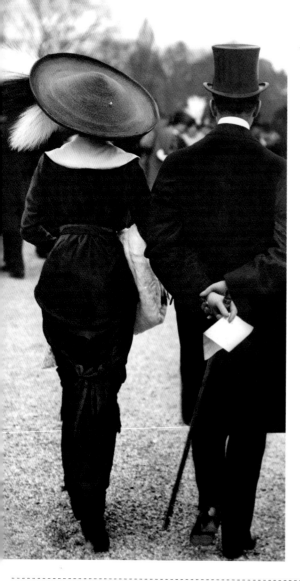

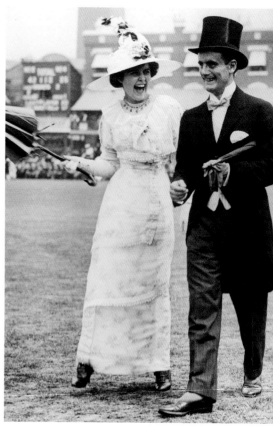

◄ Easter bonnets

A dramatic 'coolie' straw hat, with three giant
osprey feathers bursting from beneath the brim,
was the sartorial sensation of the Easter Parade
held on the Champs-Élysées in Paris, France.
1912

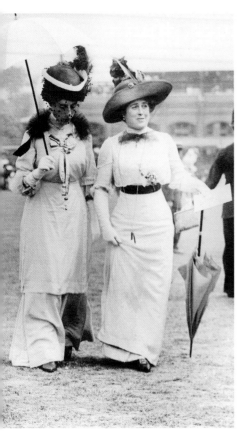

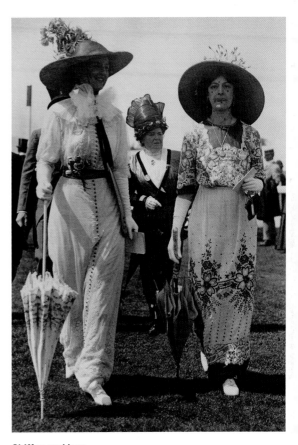

Eton elegance

Cricket match at Lords between
Eton and Harrow: among the spectators, an
elegantly dressed couple share a joke as
they celebrate Eton's victory.

July, 1912

Chiffon and lace

Feminine delicate chiffon dress with button-through detailing (L)
and bold embroidered lace dress (R), both accessorised
with wide-brimmed hats, long white gloves and parasols.

1912

A bit of leg

A striking silk outfit, complete with a daring slit skirt, anticipated the dramatic rise in hemlines over the next few years. The contrasting fitted jacket and feather-trimmed hat complete the look.

1913

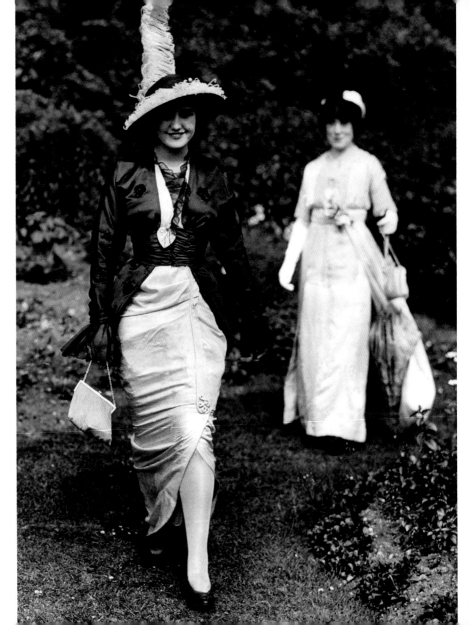

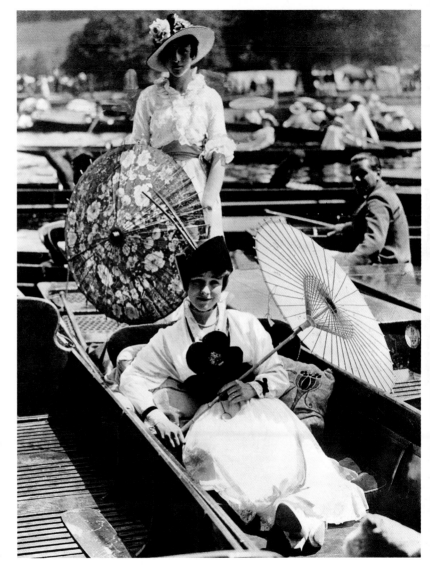

A hint of the Orient

Two ladies at the Henley
Regatta, modelling the latest
kimono-style, Oriental dress
fashions and parasols (R), as
well as the more traditional
dress styles (L).

July, 1914

Lakeside leisure

Ladies punting on Reading Water:
late Edwardian fashion made
few concessions towards those
of a sporty persuasion.

1919

Society wedding ▶

On 2nd June, 1919, the society wedding of the year took place between Lady Diana
Manners and Albert Duff Cooper. Cooper went on to become First Lord of the
Admiralty, but famously resigned from his post on 3rd October, 1938 over Prime
Minister Neville Chamberlain's appeasement of Adolf Hitler.

June, 1919

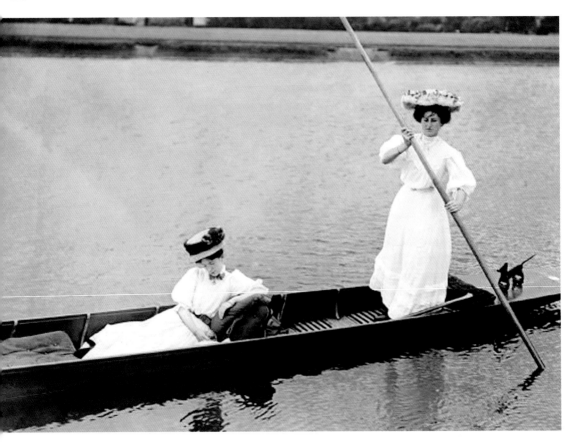

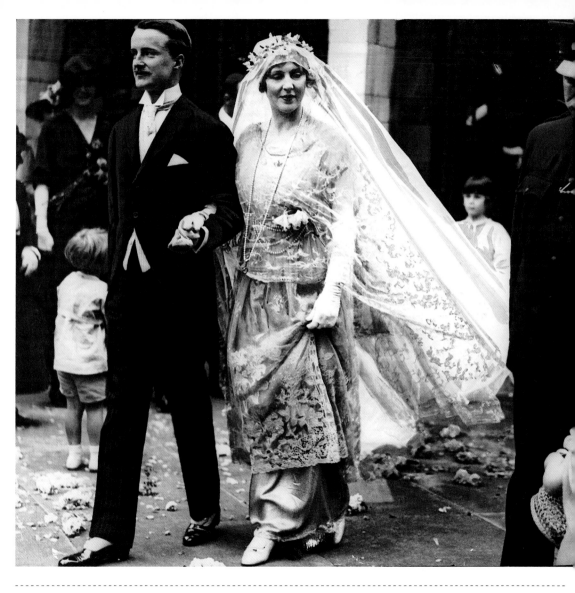

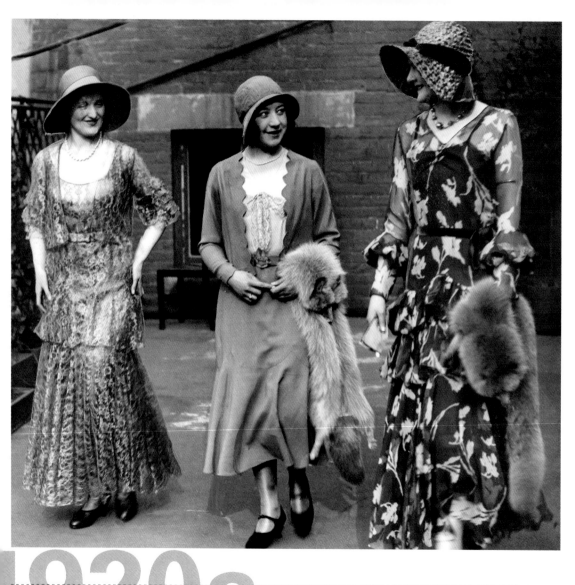

1920s

◄ Trend-setting trio
A variety of dress styles, materials and patterns, accessorised by a pair of fox stoles is displayed by trend-setting ladies of the Roaring Twenties
1920s

Foxy lady ►
It's debatable whether the addition of the all too real fox fur, slung casually around the model's neck, actually improves this mid-length coat and cloche hat outfit.
1920s

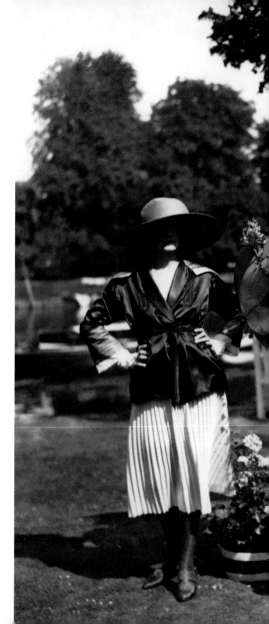

Ascot elegance

These Ascot race-goers demonstrate how far hemlines
rose in the early years of the 20th century: floaty,
knee-length dress styles and a mixture of wide-brimmed
and cloche hats made for a bold, modern look.

1921

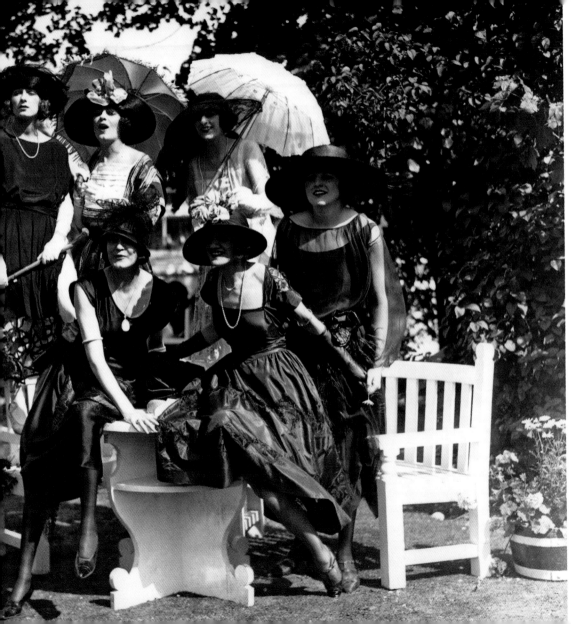

High society ladies

Society ladies May Cambridge, Alvira Anderson and Phyllis Sellick show off *the* fashions to be seen in at the racecourse: elaborate hats, long gloves, strings of pearls and ruffled parasols accessorise the latest chic dress styles.

June, 1921

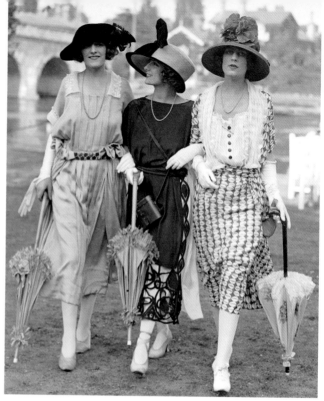

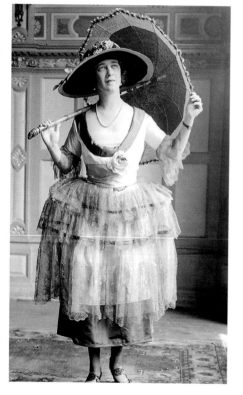

Lampshade chic

Dame Attalini wearing a rather less successful Ascot outfit: this unflattering concoction with its hooped skirt, draped in lace, looks for all the world as if the unfortunate Dame has pulled on a lampshade by mistake.

June, 1921

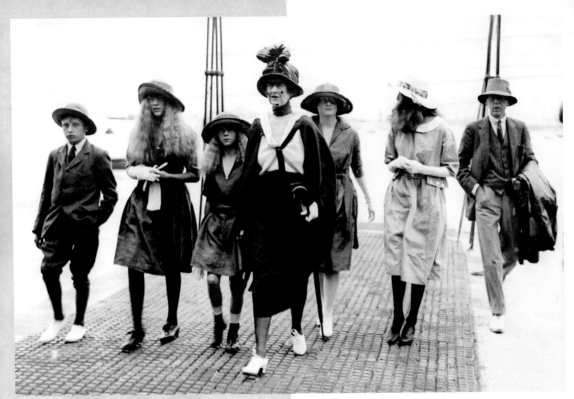

Guinness collection

Members of the Guinness family dynasty
on holiday in Cowes on the Isle of Wight,
dressed in appropriate daywear.

August, 1921

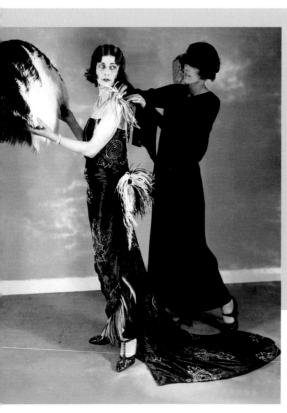

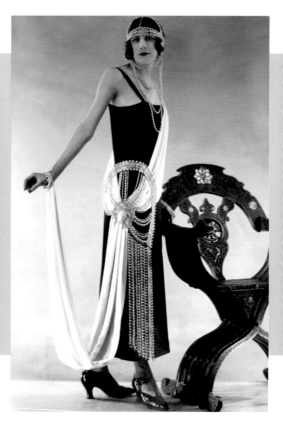

Feathered features

Ms Christabel Russell is helped to show off this long, embroidered evening gown with feather detailing, at the *Daily Mirror* Fashion Fair held at Holland Park Hall, London.

April, 1923

Bead appeal

This plain black dress is given an unusual twist with the addition of the pearl bead detail, fixed at the waist and also worn as a headdress. The outfit is completed with the addition of a white silk sash, draped across one shoulder, knotted at the hip and sweeping into a length of material linked to the model's wrist.

1924

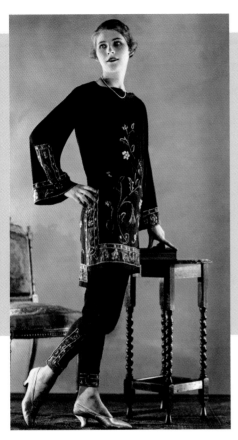

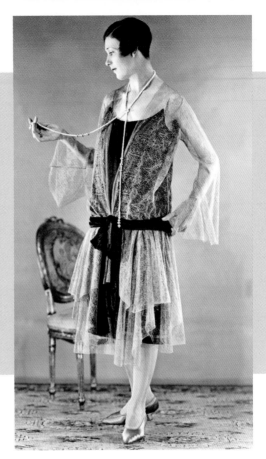

Tailored tunic

This embroidered tunic with flared sleeves
and matching trousers, tapered to the
ankle, creates a slim, tailored silhouette.

July, 1925

Boyish hairstyles

One of the biggest trends of the 1920s was short hair:
the style was young and sporty with an almost boyish
look to it. The fashion led, in turn, to an explosion in the
number of hairdressers. Flapper dresses with low waists
and long strings of pearls completed the look.

November, 1925

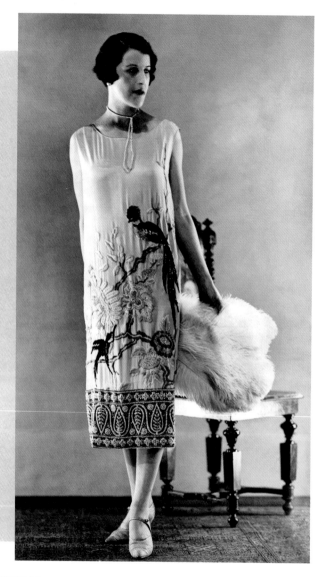

◀ Exotic embroidery

This sleeveless white dress, with an embroidered black parrot design and white sequin detailing at the hem, is another example of the Oriental-inspired designs of the period.

July, 1925

Layered styles ▶

Ascot race-goer Miss Ogden sported a rather severe, layered-style dress with sharp, diagonally-cut flounces that appeared to have been created with the aid of a pair of pinking shears.

June, 1925

Dramatic prints ▶▶

Bold prints combined with a slim silhouette, plunging neckline and shorter length, finishing just below the knee, made this another eye-catching Ascot ensemble.

August, 1926

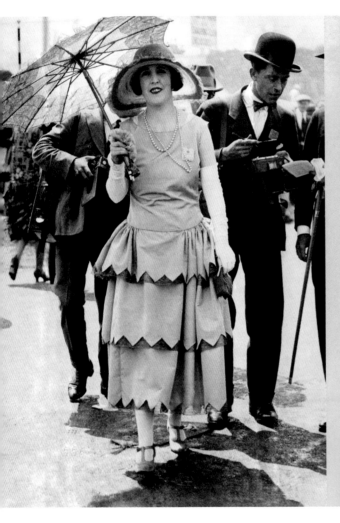

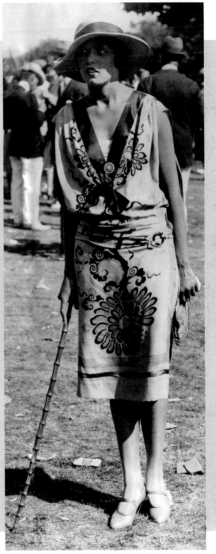

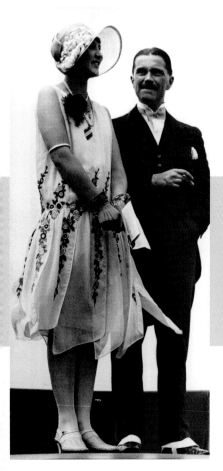

◄ Ascot flapper

An elegant couple watch from the grandstand at Ascot: the woman's embroidered flapper-style dress is accessorised with matching gloves and hat – a look that appears to meet with the approval of her more soberly-dressed partner.

June, 1926

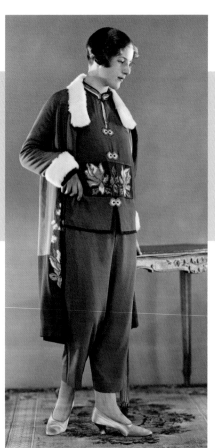

◄ Trouser suit trends

Embroidered trouser suits were much in evidence in the mid-1920s, teamed here with a matching, three-quarter-length lambswool-trimmed coat.

March, 1926

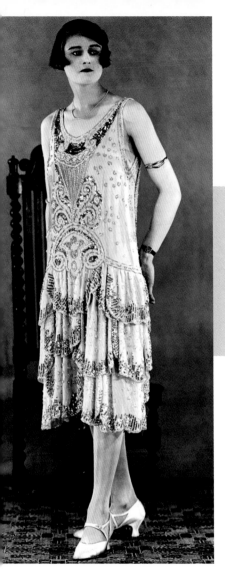

◄ Diamanté detail
An evening gown designed by Eve Valere: elaborate paillette and diamanté embroidery on chiffon, with a petalled skirt and asymmetric hemline.
July, 1926

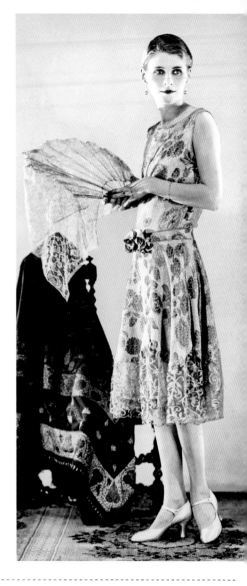

White and gold ►
An elegant, sleeveless, white and gold brocade evening gown, the skirt edged in wide gold lace: the matching lace fan and the model's short, boyish hairstyle carry off this classic 1920s look.
1926

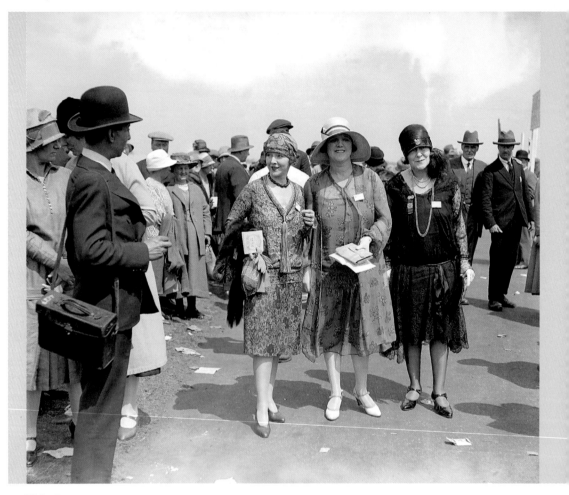

Waist lines

Ladies' Day at Royal Ascot: drop-waisted styles generally worked best on taller ladies and were not particularly flattering for the shorter, rounder figure.

June, 1927

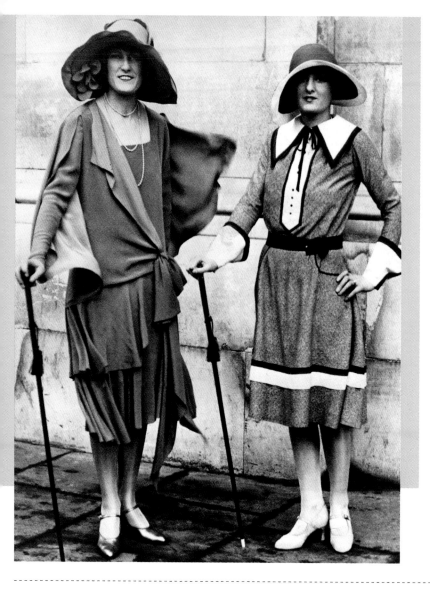

Artificial silk

Two eye-catching spring outfits demonstrate the versatility of modern, man-made dress materials at the Artificial Silk Exhibition, Olympia, London.

1927

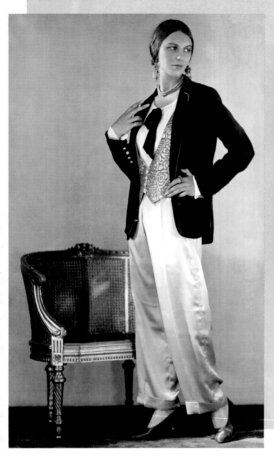

Unisex styles

The introduction of trousers into women's fashion, teamed here with a blazer and embroidered waistcoat, signalled the beginning of a more unisex look for dedicated female followers of fashion.

1928

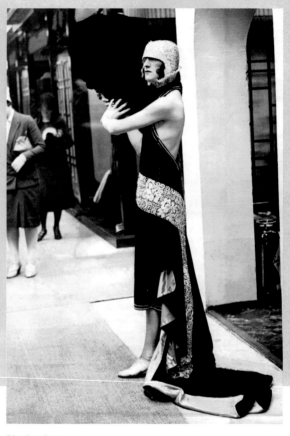

Black velvet

A dramatic, black velvet evening dress, with long train and lace sash across the waist. However, the rather severe matching lace cloche hat, resembling a lacy crash helmet, detracts from this otherwise striking outfit.

1927

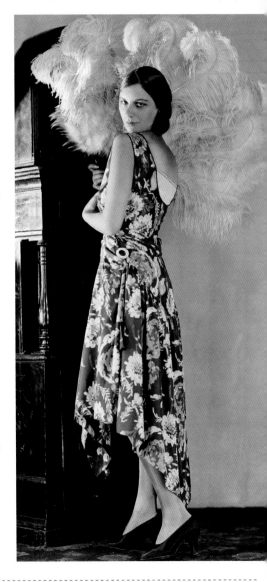

Bold taffeta

A soft taffeta evening gown in a wraparound style, printed with a bold floral design in bright colours, and finished with modern, triangular, handkerchief points at the hem.

September 1928

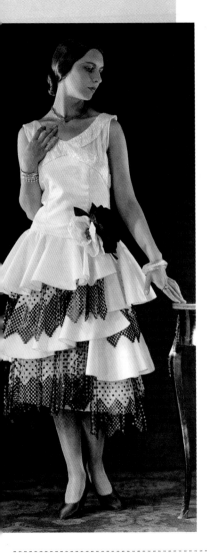

Monochrome design

A layered white evening gown with embroidered neckline and black cire lace detailing: bold black and white poppies, attached to the waistline, complete the look.

October 1928

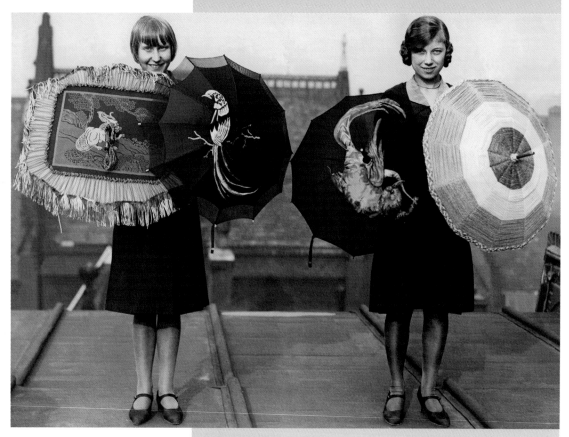

Exotic parasols

Young ladies sporting the new,
shorter, bobbed hairstyles
display the latest fashions
in Oriental-inspired parasols.

February, 1928

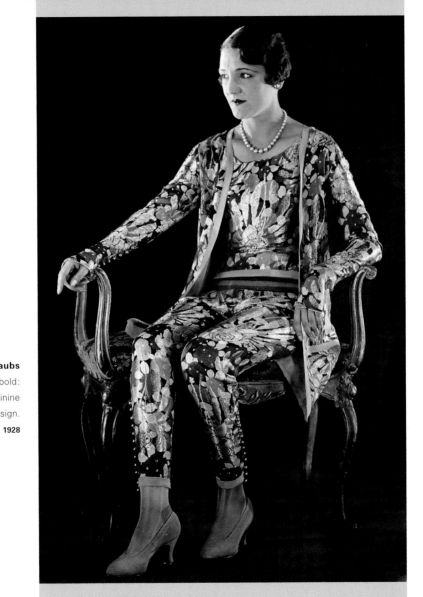

Paint daubs
Bright and bold:
a rather more feminine
trouser suit design.
1928

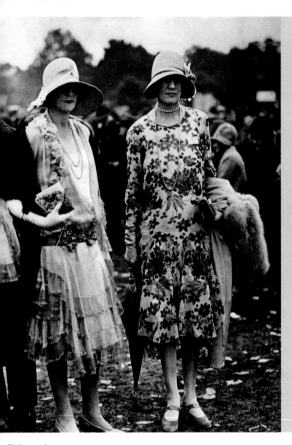

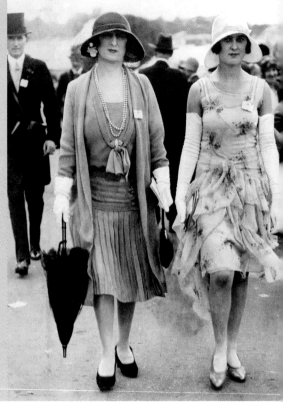

Tall stories

Dropped waistlines gave the appearance of height, creating long, elegant lines that were further accentuated by long strings of pearls worn around the neck. Cloche or wide-brimmed hats and low-heeled court shoes completed this late 1920s, Ascot look.

July, 1928

Formal versus floaty

An elegant knitted dress with dropped waistline and pleated skirt, worn with a matching long cardigan (L), alongside a feminine chiffon dress with ruffle skirt (R): both ladies wear long gloves to complete their Ascot Ladies' Day outfits.

1929

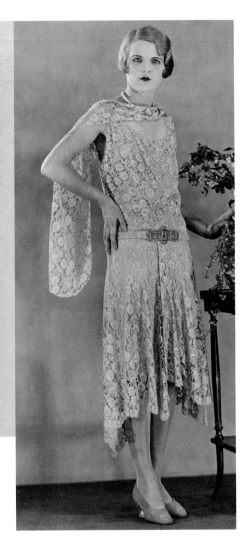

◀ Asymmetric hemline

A good example of the fashion for asymmetric hemlines during the 1920s: a long, bold-patterned dress worn with matching scarf.

1929

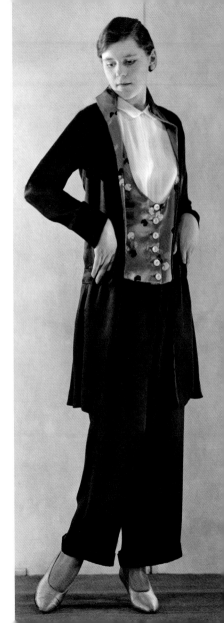

Lustrous satin ▶

An elegant ensemble of a lustrous black satin trouser suit with contrasting, embroidered lapels, teamed with an eye-catching, matching waistcoat and plain white blouse.

September, 1929

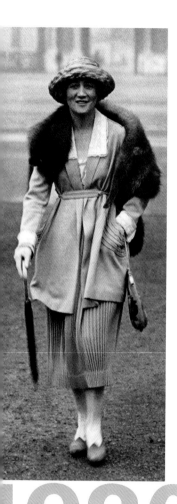

◄ Warm wool

An elegant wool jacket, cinched high at the waist, with matching pleated skirt, fur stole and stylish brimmed hat.

c.1930

Aristocratic Ascot ►

Lady Nancy Astor at the Ascot race meeting dressed in an elegant, but rather sombre pinstripe suit and toning fur coat: the only nod to colour is the large corsage attached to the lapel of her Ladyship's jacket.

c.1930

Black lace ►►

Two ladies sporting complementary, full-length evening gowns: (L) white crepe de Chine dress, patterned with large pink flowers and trimmed with black lace frills; (R) apricot pink and black lace dress, accessorised with a double, silver fox fur, and large apricot and black straw hat.

c.1930

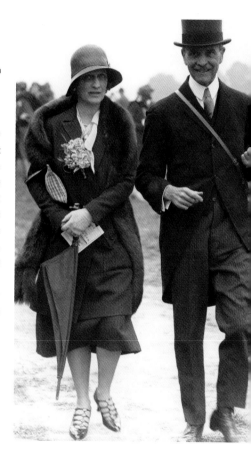

1930s

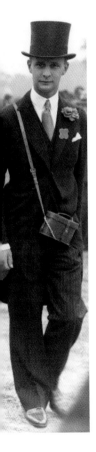

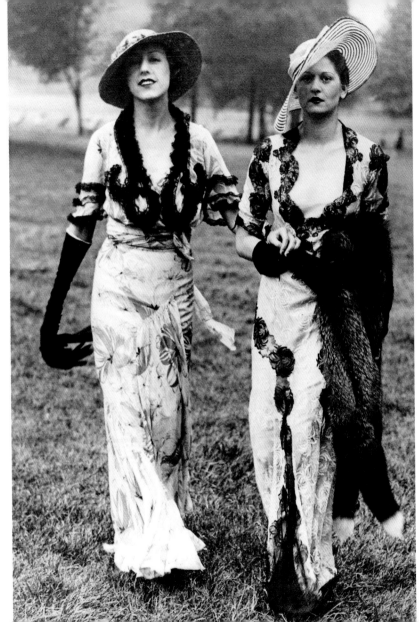

Distress flares ▶

This rather eccentric black and white evening trouser suit, featuring the pleated, flared trouser style, failed to catch on.

April, 1931

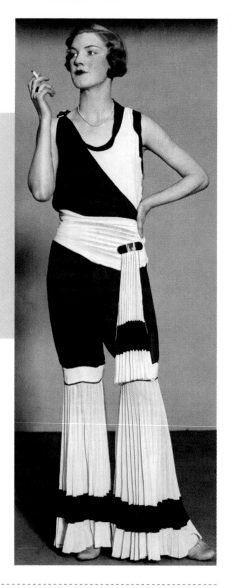

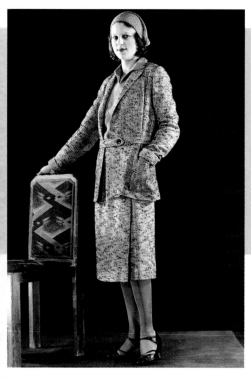

Sporting tweed

A black and yellow, flecked tweed sports suit, teamed with a jumper made of yellow stockinette and a matching chenille cap.

March, 1931

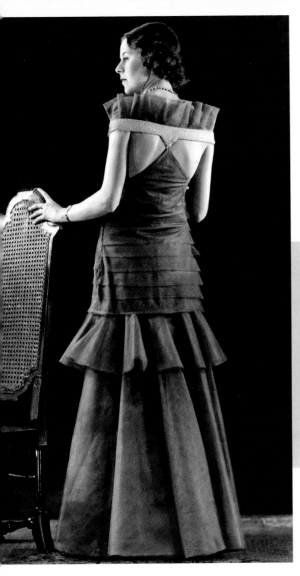

◀ **Brown sugar**
A burnt sugar, brown tulle evening gown,
finished off with massed turquoise beads,
a pierrot ruffle and an unusual back design.
March, 1931

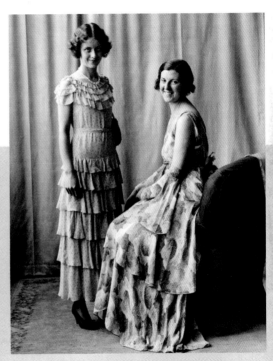

Lancashire lasses
Flounced evening gown designs, made from
the Lancashire fabric Grafton's Meronelle,
November, 1931

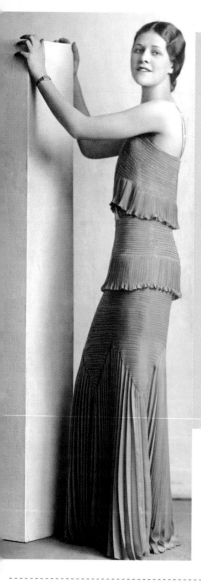

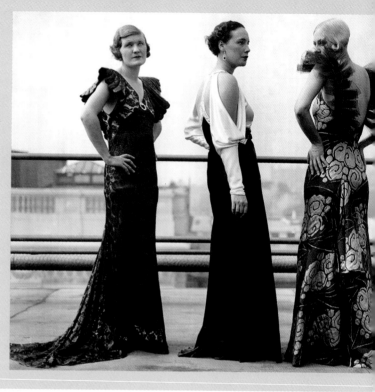

Shimmering chiffon

A figure-hugging, flattering long evening gown: the material was leaf-bud green chiffon falling into crystal-pleated frills.

July, 1932

Barely formal

A selection of long, backless evening dresses, in a variety of styles, patterns and materials.

September, 1933

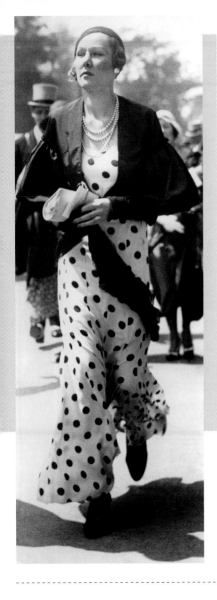

◄ Spot-on

The opening day
of Royal Ascot:
a race-goer makes
her own fashion
statement in a
full-length, black
and white spotted
dress, teamed
with a wrap-around
black jacket with
puffed sleeves
and matching hat.

June, 1932

Naval gazing

Naughty naval
underwear: a risqué
look from the early
1930s.

October, 1933

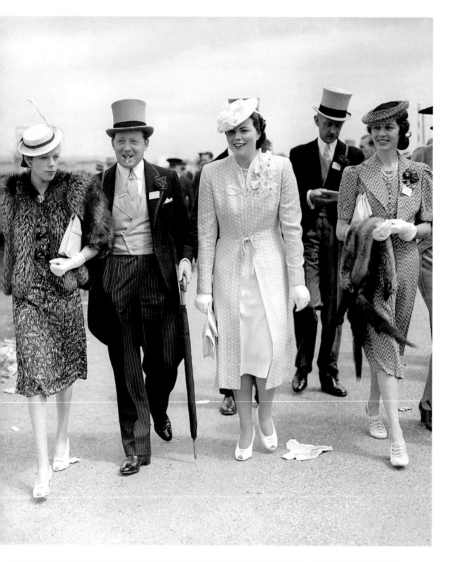

◀ **Ladies on parade**

A Royal Ascot group of ladies parade their Ladies' Day outfits while the men stick to their traditional, timeless, morning suits.

June, 1935

Going to the dogs ▶

The rather incongruous sight of glamorous Hollywood film star Bette Davis, presenting the *Daily Mirror* £200 Challenge Trophy to Miss E. Whitley, owner of Satan's Baby, the winner of the trophy, at Harringay Greyhound Stadium, North London.

August, 1935

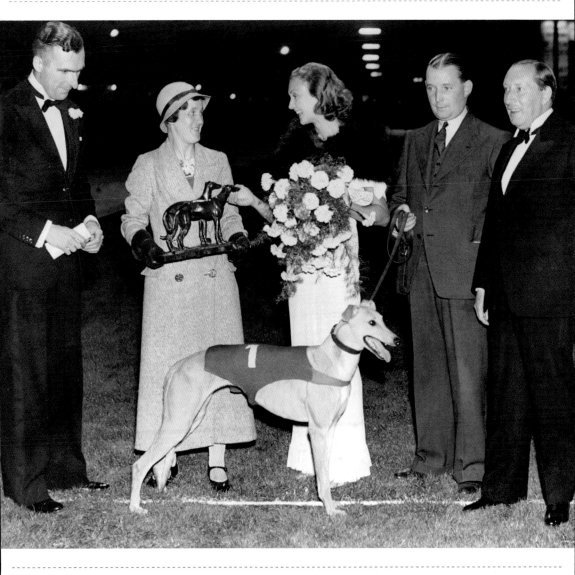

Stewards' enquiry

A lady sporting a bold patterned dress, worn with a short, puff-sleeved jacket, long gloves and wide-brimmed hat, meets with the approval of the Ascot stewards.

August, 1936

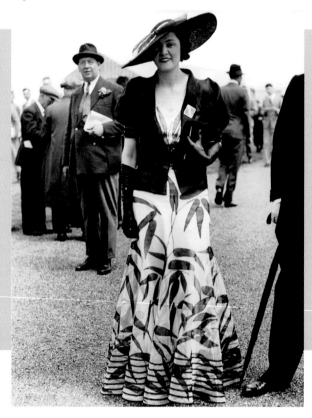

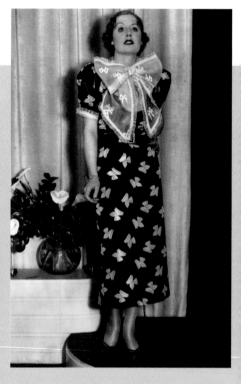

Bow belle

This navy blue, taffeta dress with lovers' knots motif, designed by Barbara Blenn, is somewhat overwhelmed by a huge, white, organdie bow at the neck.

March, 1936

Flowing styles

A long flowing summer dress worn with a spotted, three-quarter length coat, with black trimmed collar and cuffs and accessorised with a wide-brimmed hat and mushroom-like parasol.

June, 1936

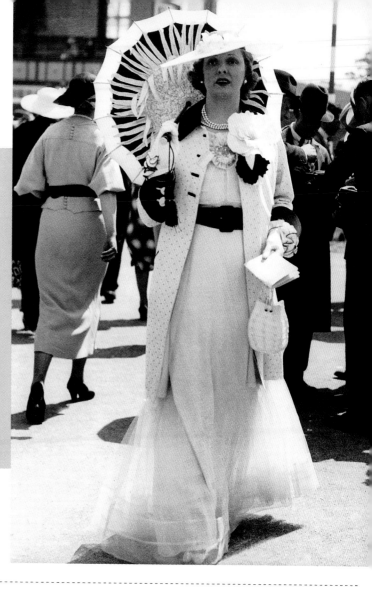

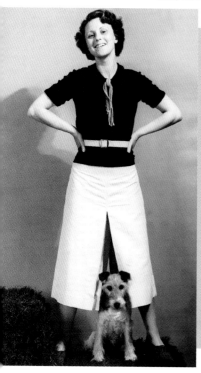

unctional culottes

ulottes, here teamed with a black jersey, gnalled a move into functional daywear in e 1930s.

ly, 1936

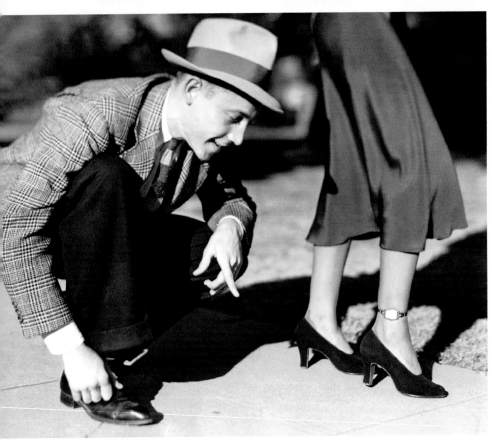

Watch this space

A man, in typical 1930s dress of tweed jacket, trousers and a trilby hat, attempts to check the time on a watch worn on the ankle of a lady. Ankle watches required the wearer to be something of a contortionist to read the time and, inexplicably, the fashion never really caught on.

December, 1937

Stocking tops

The instant feminine allure of sheer stockings, worn with suspenders, was about to be curtailed by the shortages that arose with the arrival of the Second World War, just over a year later.

April, 1938

Short and sweet

A daringly short summer dress for the period, this laced bodice with flower detailing on the halter-neck straps, skimpy skirt, is topped off with a straw hat.

December, 1937

Shimmering silver ▶

A horizontally striped, silver lamé evening gown, with braided silver straps, worn with a black beret, trimmed with velvet.

October, 1937

Full-length lace ▶▶

An eye-catching, full-length, wrap-around white lace coat, topped off with a white hat, trimmed with two seal lilies.

January, 1938

Chopsticks ▶▶▶

A Mandarin-style outfit in white and navy crepe de Chine: the look is completed with a navy hat in fine straw with chopstick decoration.

January, 1938

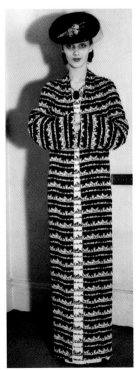

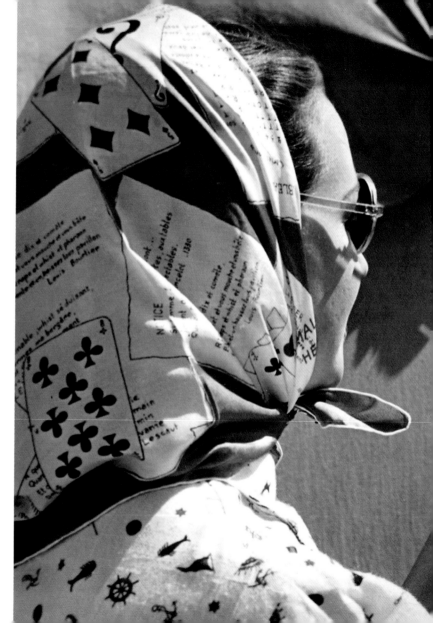

Following suit

Two ladies attending the races at Deauville in France: both sporting identical, nautical-themed dresses and wearing matching headscarves with a playing card motif.

1938

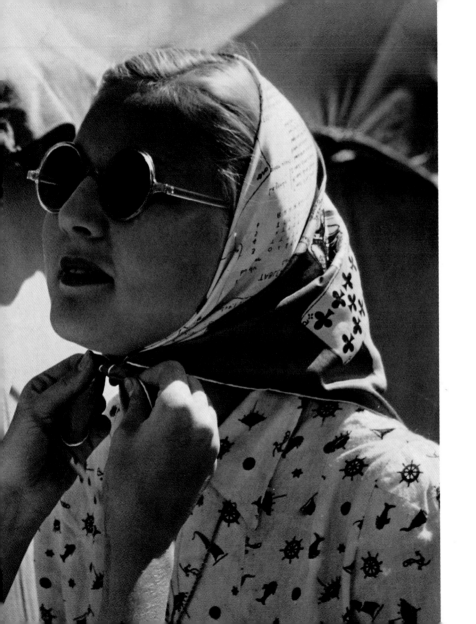

73

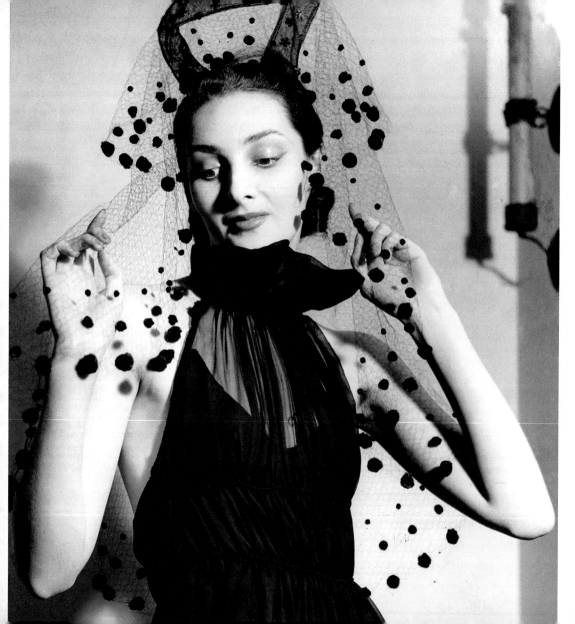

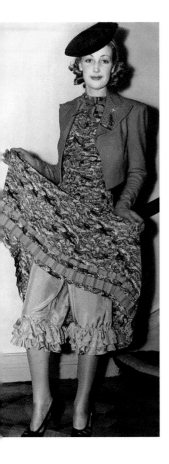

◀◀ Black widow

Funereal ensemble: a black chiffon evening gown, worn with a striking black Manhattan net and chiffon headdress.

January, 1938

◀ Knickerbocker glory

A cropped bolero jacket and ruched, patterned dress, worn, rather bizarrely, over old-fashioned, satin knickerbockers.

March, 1939

Big bird ▶

This black, full-length, ostrich feather evening coat is the perfect outfit for long-legged models.

July, 1939

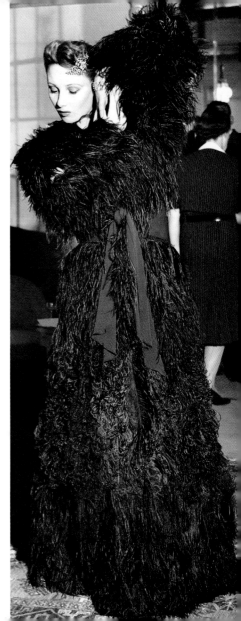

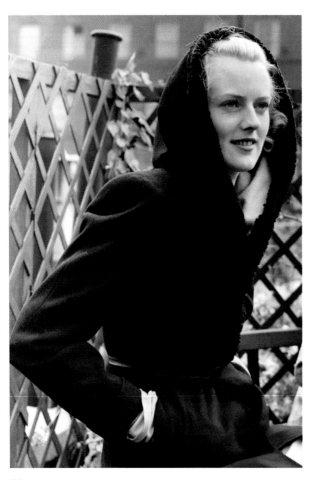

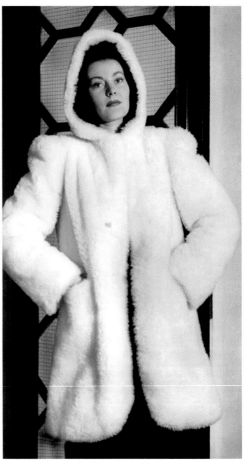

Winter warmers

A timeless, black wool coat with toning, sheepskin-lined hood:
even in the 1930s winter fashions were photographed in
the middle of the summer.

August, 1939

Swagger coat

A short, sheepskin, swagger coat, cut to flow loosely
from the shoulders and finishing at the thigh: perfect
for those chilly evenings spent in the air raid shelter.

October, 1939

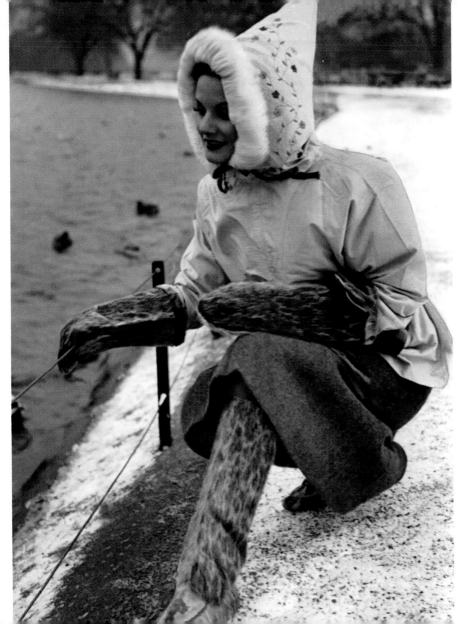

Eskimo Nell

An unusual combination of matching fur boots and gloves adds a hint of the Eskimo to this winter coat with embroidered hood.

1938

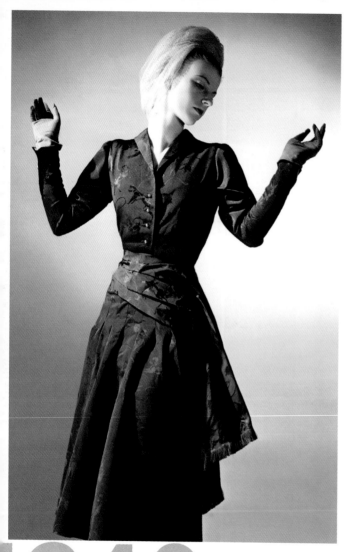

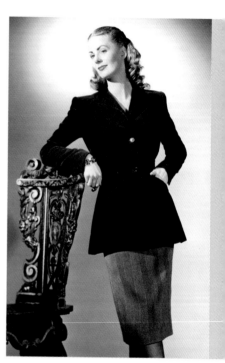

A long-sleeved, dark silk afternoon dress, designed
by Bianca Mosca: drapery is arranged around
the waist and falls in a fringe drape at one side.

c.1940s

Riding high

A suit designed by Dorville: brown corduroy
riding jacket and tweed skirt in brown and
white, featuring the new design of slant
pockets and a longer jacket length.

c.1940s

1940s

A bit of flannel ▶

A lightweight flannel coat, designed by Fischelis, in pearl grey with pleated detailing and ruffle collar, worn with platform shoes and small shoulder bag.

c.1940s

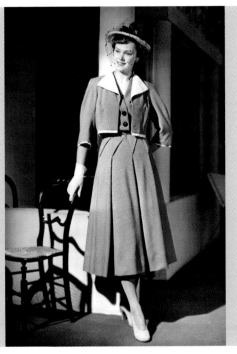

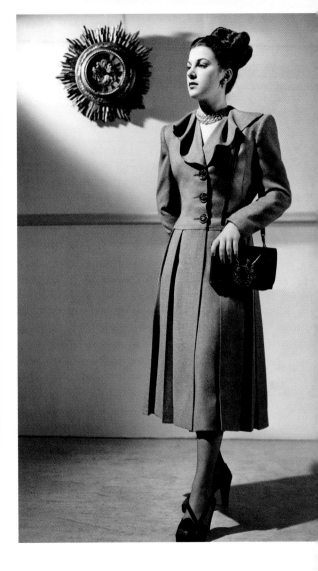

Bolero styles

A pleated, full, three-quarter-length suit with large, feature buttons, teamed with a matching bolero jacket, netted straw hat and white gloves.

c.1940s

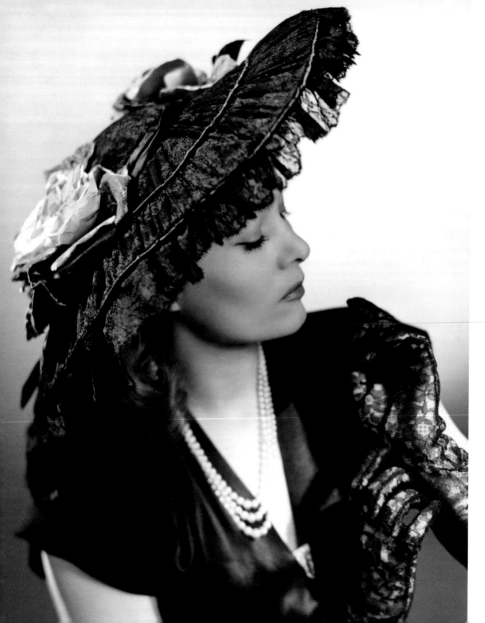

◄ All in black
A formal silk evening dress, accessorised with a dramatic, lace-trimmed hat decorated with silk roses, matching lace evening gloves, and a triple-string, pearl necklace.
c.1940s

Picture this ▶
An elegant, natural plaited straw picture hat, designed by Hugh Beresford: with black velvet ribbon threaded through the brim and falling on to the shoulder.
c.1940s

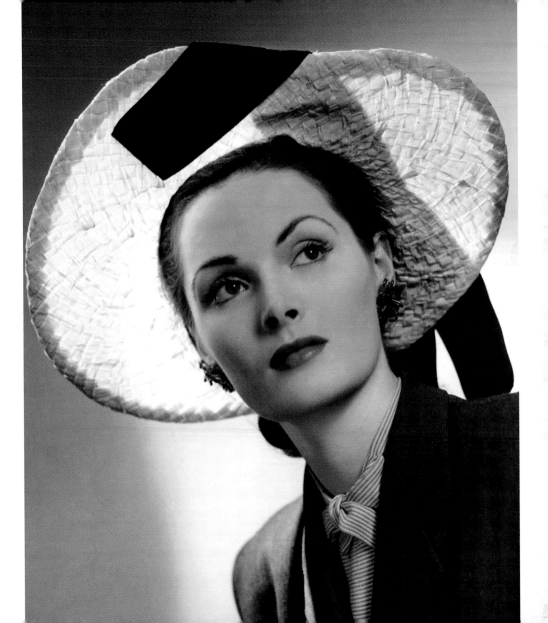

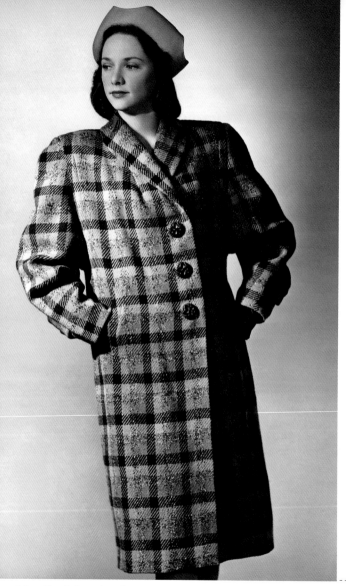

◀ Country swagger

Stylish swagger country coat, designed by
Meredith: in large red, brown and green check
with dolman sleeves and three chunky buttons.
c.1940s

Great Scotts ▶

A classic felt sports hat produced by Scotts
Ltd of Old Bond Street, London: the long-
established company had a reputation for
producing the perfect sports hat for any
occasion.
c.1940s

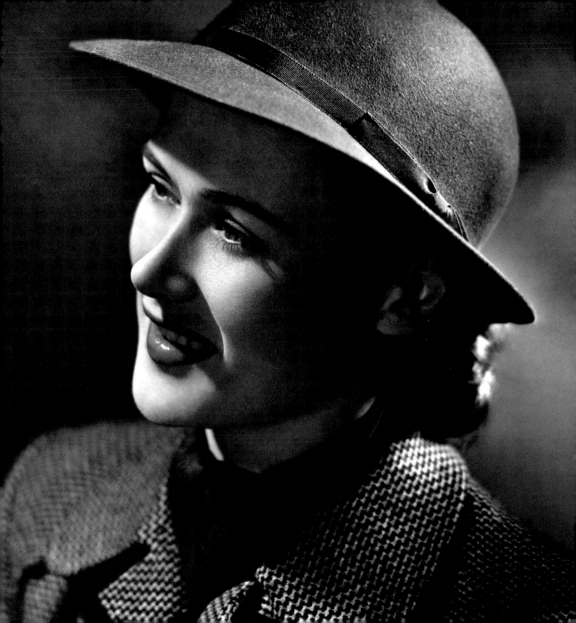

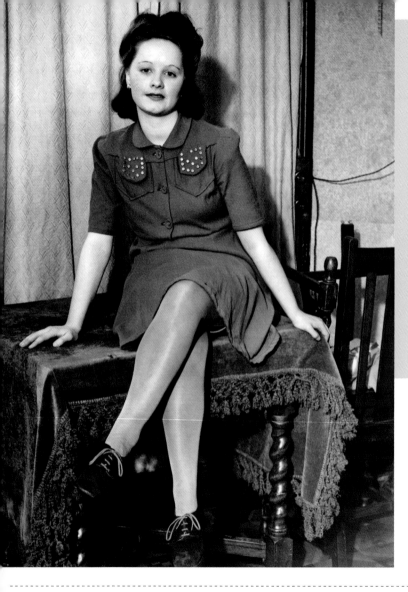

Wartime utility fashion

A simple shift dress with only modest, studded detailing is an example of wartime utility fashion.

December, 1944

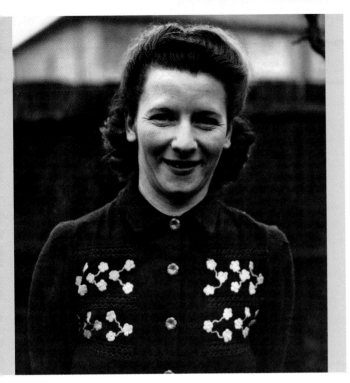

Make do and mend

Mrs Vera Killick, seen here modelling an embroidered,
battledress-inspired jacket: an example of the make-do-and-mend
fashions of the mid-1940s.

December, 1944

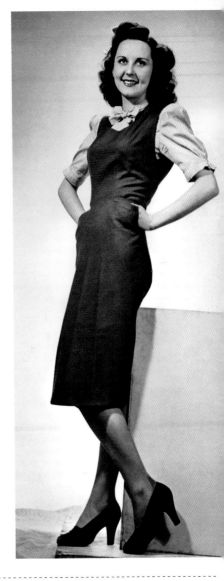

Practical pinafore

Another utility wartime outfit: a plain, long pinafore
dress worn with a puff-sleeved blouse.

March, 1943

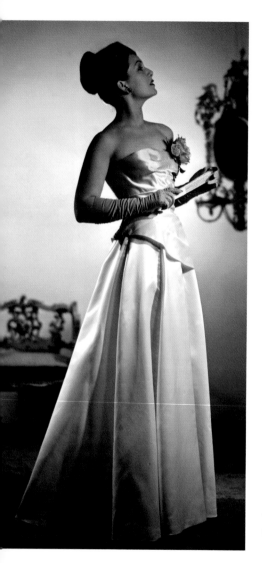

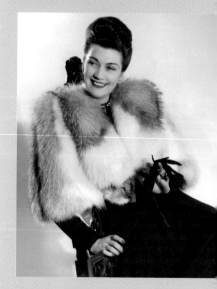

◀ **Royal Command Performance** Actress Jean Kent, star of *Bond Street*, models a glamorous evening gown, designed for her by Matilda Etchere for the Royal Command Film Performance: the strapless, peach-coloured, satin dress is worn with silver platform sandals. **1948**

◀ Edwardian flavour

A white crepe
georgette blouse, with
a black sequin motif
embroidered on the
yoke: the frilled band
inserted on the deep,
rounded yoke adds
a slightly Edwardian
influence.

c.1940s

◀ Fur trends

The appetite for fur
garments, designed to
add a touch of glamour
to any outfit, was still at
its height in the 1940s,
as demonstrated by this
fox fur coat.

c.1940s

Belt up ▶

A wide belt, with a
large decorative buckle
and leaf detailing, gives
this plain dress style a
touch of glamour.

c.1940s

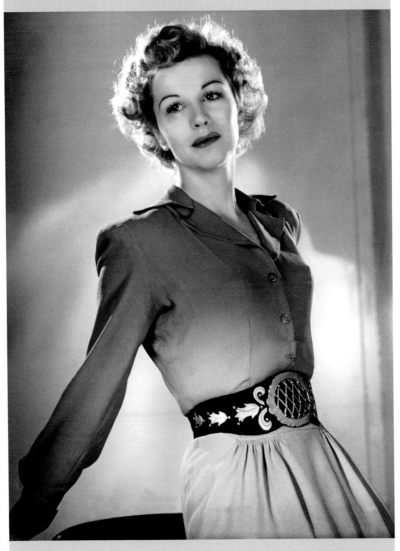

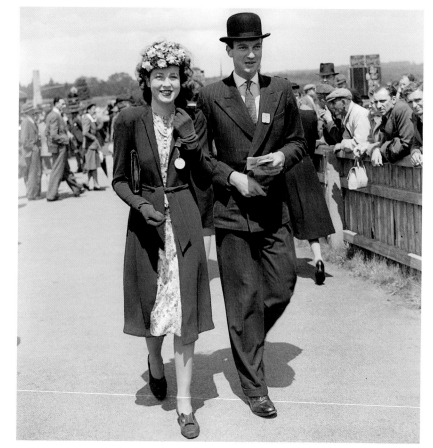

Sober Ascot styles

The austerity of the post-war years was reflected in the simpler, less flamboyant styles on display at Royal Ascot. The woman wears a simple cotton dress and plain, mid-length coat, while her partner opts for a plain pinstripe suit, rather than the more traditional morning suit.

1946

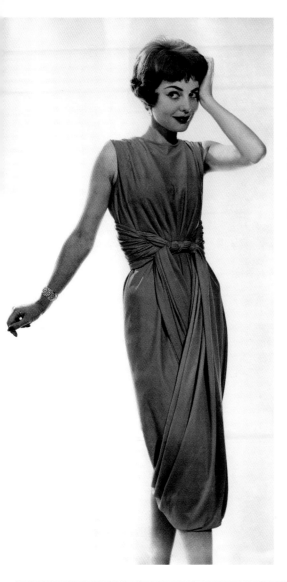

Wrap-around
◀ riddles

A rather complicated wrap-around dress, cinched at the waist and also, apparently, at the knee. The model's expression would suggest that it might prove a tricky manoeuvre to get it off again in a hurry.

September, 1946

Four-way outfit ▶

An intriguing four-way fashion idea, one of the designs on show at an exhibition held at the Mayfair Hotel: a plain black, wool dress, with hidden blue sequined belt, worn underneath a white, flared, three-quarter-length skirt, slit up the front and paired with a sleeveless, bolero top with a small peplum, decorated with black sequined designs.

June, 1946

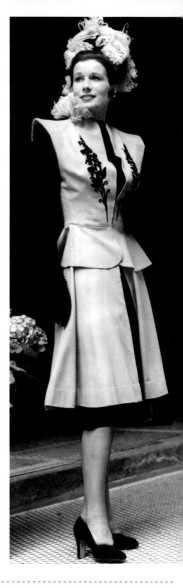

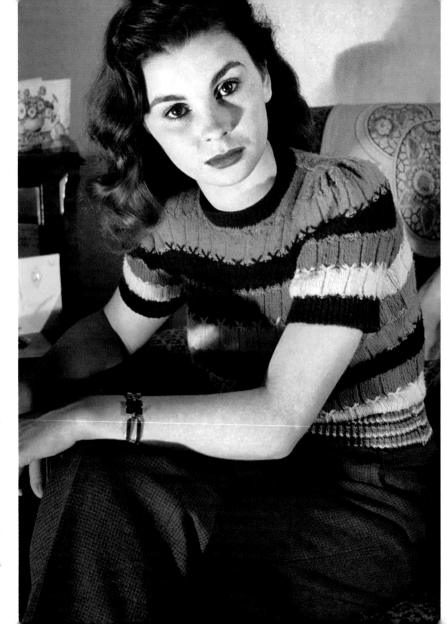

Aspiring actress

A young Jean Simmons, on her way to film stardom, dressed in a figure-hugging, knitted top and wearing her hair in the longer, more feminine style of the period.

January, 1946

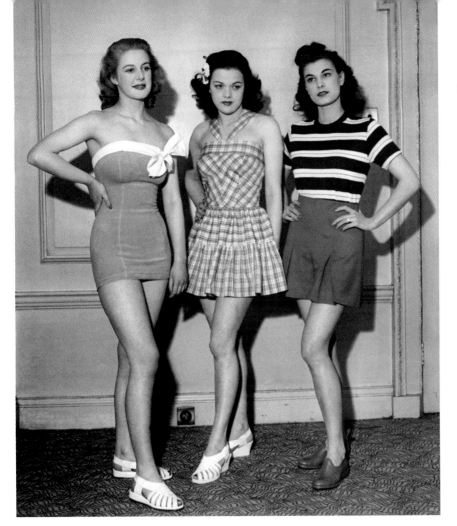

Post-war swimwear
styles: a preview of the
limited array of swimsuits
designed by Jantzen
and about to go into
production. Man-made
fabrics were gradually
becoming available again
after the shortages
caused by the Second
World War; pictured
here are three of the
new dressmaker-style
swimsuits, manufactured
using printed, water-
repellent fabrics.

April, 1947

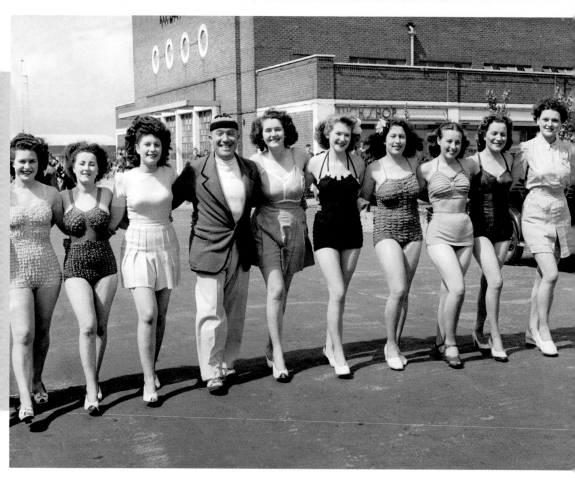

Post-war beach fashion

A line-up of ladies (and one decidedly happy-looking man) modelling a selection of the latest swimming costumes, shorts and T-shirts, suitable for figures of all shapes and sizes.

July, 1947

Dressing down for the beach ▶

Young women play around on the beach, sporting the more revealing two-piece swimming costume styles.

August, 1946

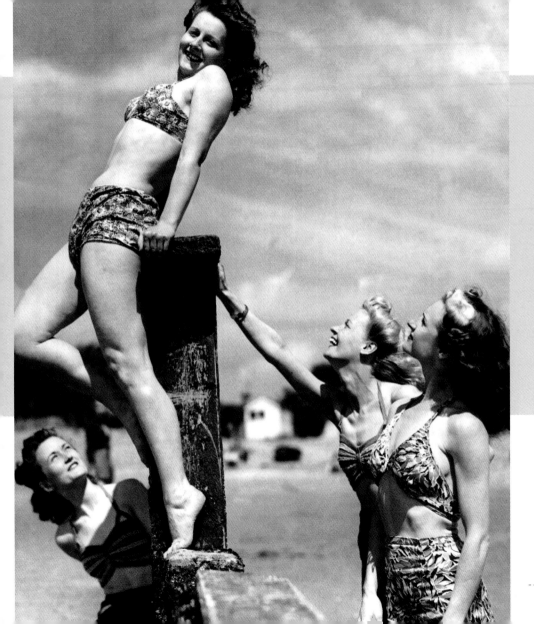

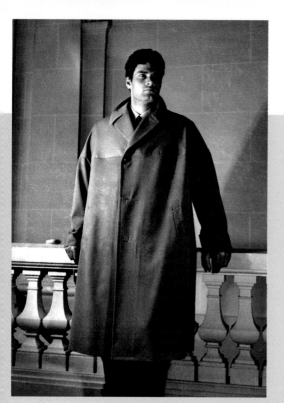

Cover up

A voluminous waterproof coat, modelled by Christian Marquand, but possibly designed to fit Orson Welles.

July, 1947

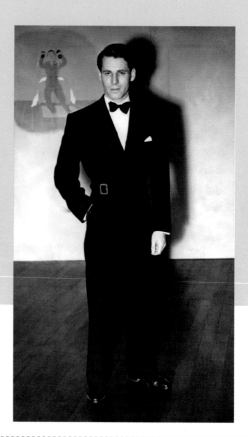

Military overtones

A month-long exhibition of modern menswear, held at London department store Austin Reed Ltd. Hints of the war remained in the masculine styles of the late 1940s: a midnight blue evening suit, with a military-inspired, battledress blouse jacket.

May, 1947

Post-war optimism

Post-war bold designs: by contrast, these bright, striped and checked dresses, showing off the fuller-style skirts, were a sign that the shortages created by the Second World War were beginning to ease.

March, 1948

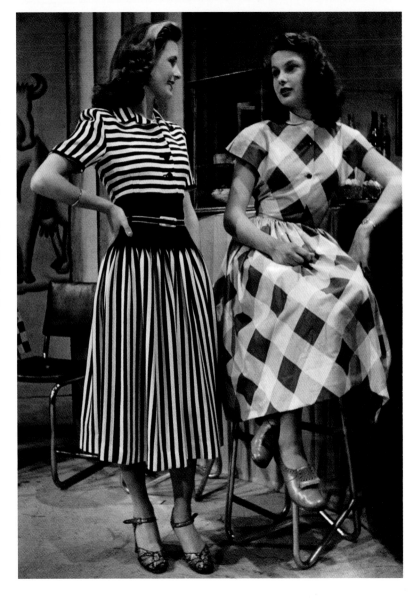

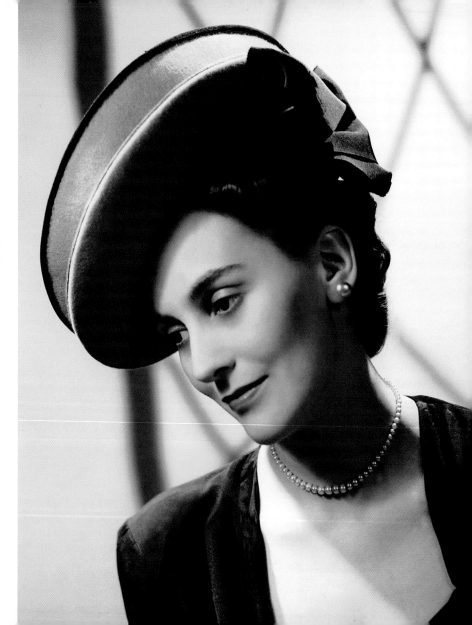

Chocolate box hat
Another stylish hat
design by Hugh
Beresford, from his
Town and Country
collection, worn with
a pearl necklace
and large, matching,
studded earrings.
March, 1948

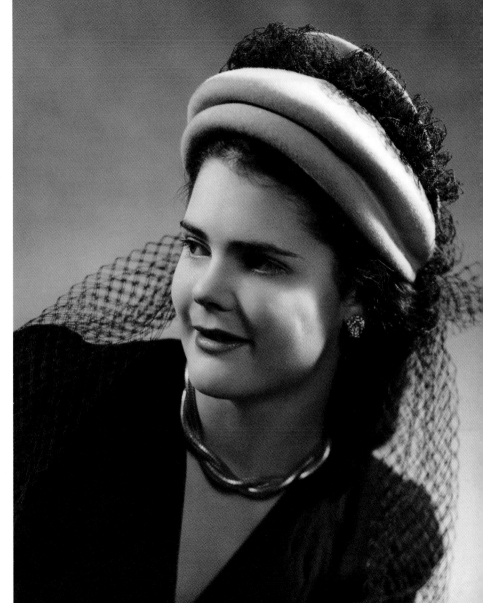

Brimming over
The double rolled brim is an unusual feature of this Town and Country hat, designed by Hugh Beresford in Windsor grey and trimmed with navy blue voile. The addition of the twisted metal choker adds a stylish touch.
March, 1948

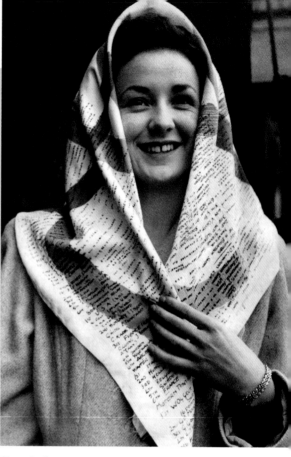

Student dress – Italian style

Rosso Giovanni, 23, a university student from Turin, Italy, studying economics, in London to show off the uniquely Italian version of the cap and gown, typically worn by students at British universities.

September, 1948

Olympic times

A decorative scarf, designed to commemorate the London Olympic Games of 1948: the pattern consisted of the names of all the winning members of the teams, together with their times, and was rushed into production by a London fashion house, who had to wait until the last moment to finish off the list of names.

August, 1948

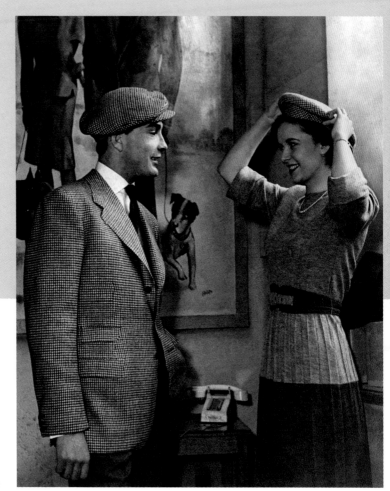

Wool and tweed
Couple wearing matching tweed hats to complement the gentleman's tweed jacket and the lady's pleated, two-tone, wool dress.
1949

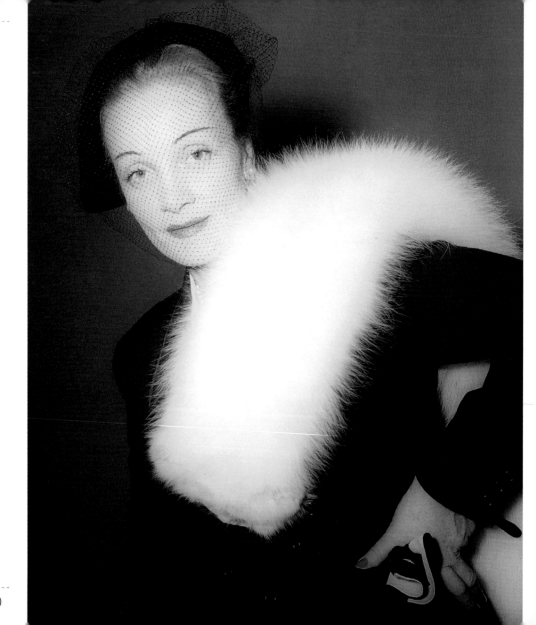

◄ Hollywood glamour
The striking Hollywood film star Marlene Dietrich, resplendent in a tailored outfit, complete with obligatory white fox fur stole, on her arrival in England.
June, 1949

Straight lines ►
French pencil skirt designs: (L) with a twist, a button-through short overskirt worn over a longer, straight skirt, and teamed with lace bustier and unusual hat; (R) cropped, button-through jacket, trimmed with fur on the sleeves and collar, worn with a long, slim skirt, and accessorised with a fur muff and hat.
1949

Creased up ▶

A colourful, crease-resisting head scarf, designed by a Manchester company to be pushed into a handbag and pulled out hours later, still fresh and crisp.

July, 1949

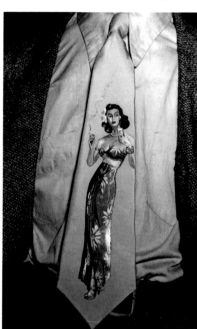

Looking forward

A hint of the 1950s New Look starts to appear in these late 1940s Royal Ascot outfits: longer, fuller skirts, cinched tightly at the waist with large belts, with the wider silhouette echoed in the long coats that complete the look.

June, 1949

Loose ties

The fashion for paintings of curvaceous ladies, originally seen in the form of aircraft nose art on American Second World War bombers, transferred successfully on to men's ties in the late 1940s.

September, 1949

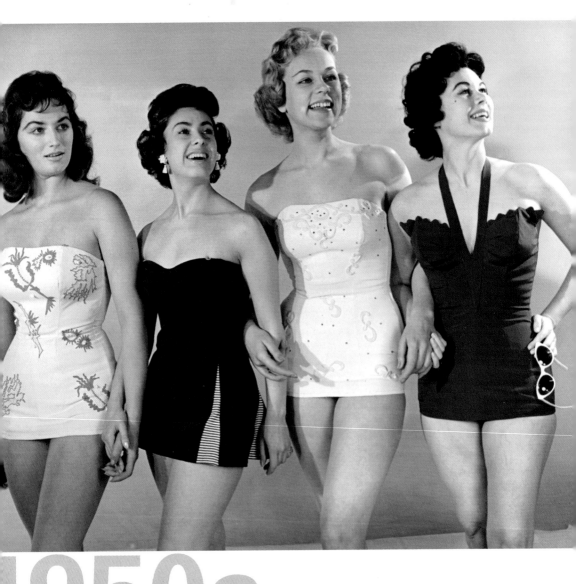

1950s

◄ Corset costumes
A selection of one-piece
swimming costumes in
a corset style, all with fitted
bodices and slight skirts.
c.1950s

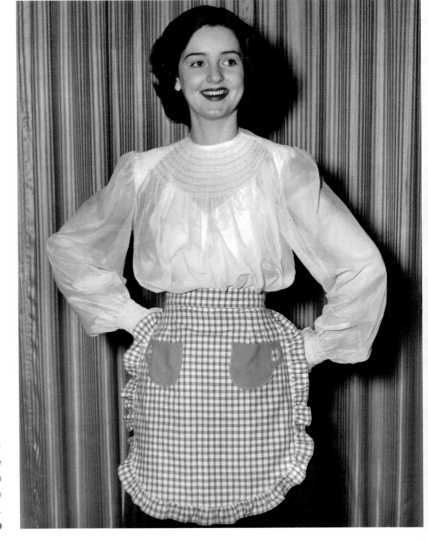

Housewives' choice ▶
A must-have item for the
well-dressed housewife: a
gingham, checked apron with
matching 'teacup' pockets.
May, 1950

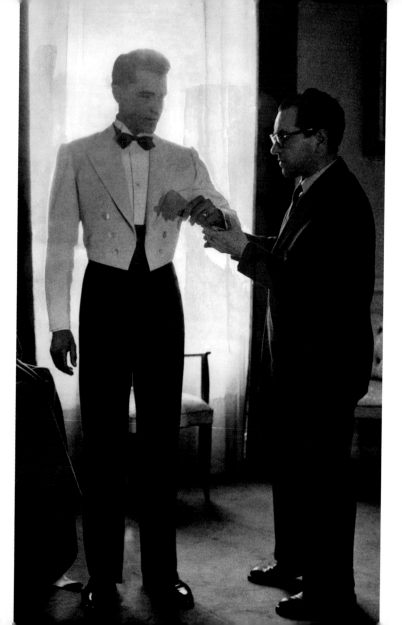

◀ **Formal dinner jacket**
A formal white dinner jacket decorated with brass buttons, teamed with a crisp, white shirt and bowtie: the matching cummerbund completes this classic military 'mess-jacket' style.
March, 1951

French fashion collection ▶
Dresses by Paris-based fashion house Maison Paquin, at a fashion show held at Ciro's nightclub in London. The models flew in from Paris to show off the new winter collection of 50 gowns and hats.
November, 1950

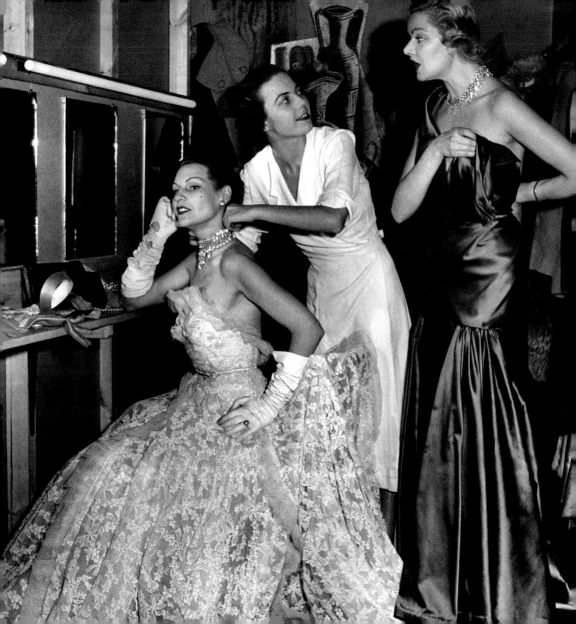

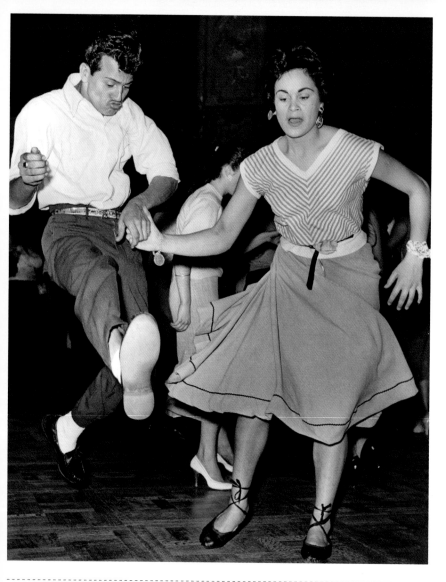

A young couple demonstrate the craze of rock 'n' roll dancing at the Lyceum Ballroom in London: flared, full skirts gave the girls the freedom to move easily and demonstrate their dancing skills.

c.1950s

Animal attraction ▶
Model Maria Hansen showing off the latest in animal-print beachwear: a slinky, strapless, zebra-print bikini.

c.1950s

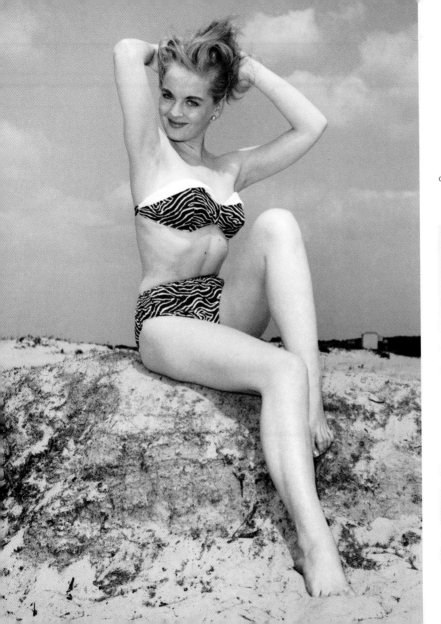

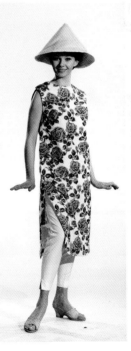

Beach outfits

A floral-patterned beach dress with side-slits, teamed with cropped trousers and Oriental-style hat (the latter could possibly also be used as a lampshade).

c.1950s

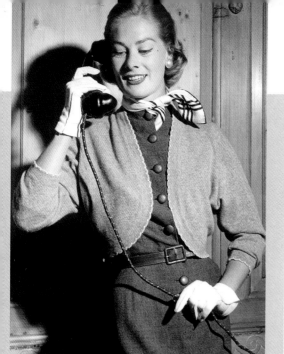

Two teenage girls wearing pretty cotton summer dresses in checked and spotted designs.

November, 1951

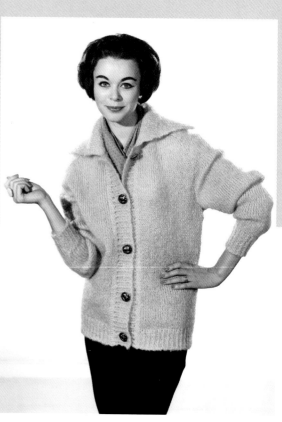

Bolero snug

The bolero shrug, designed to keep the shoulders warm on chilly autumn evenings: finished with a pie crust edging, repeated on the cuffs, worn over a button-through dress, and accessorised with white gloves and scarf.

c.1950s

Marvellous mohair

A stylish mohair jacket, with large collar and chunky feature buttons: worn with a scarf and plain, slim skirt.

c.1950s

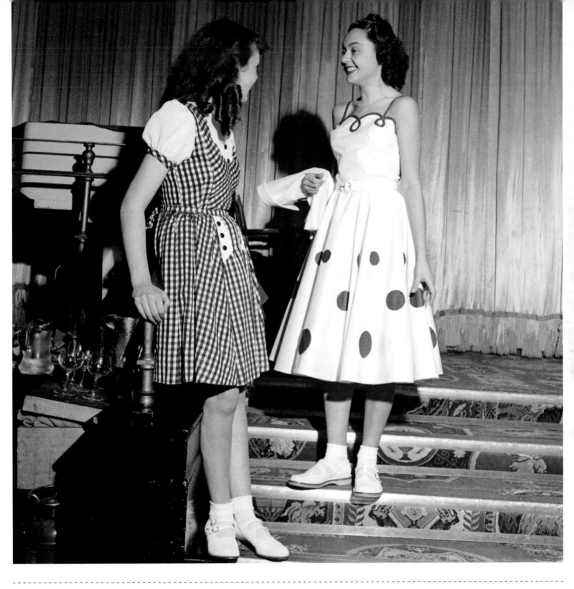

All tied-up ▶

A novel use for gentlemen's neckwear, this three-piece swimming costume, made entirely from ties, was used to exhibit them at a Manchester men's fashion show.

October, 1951

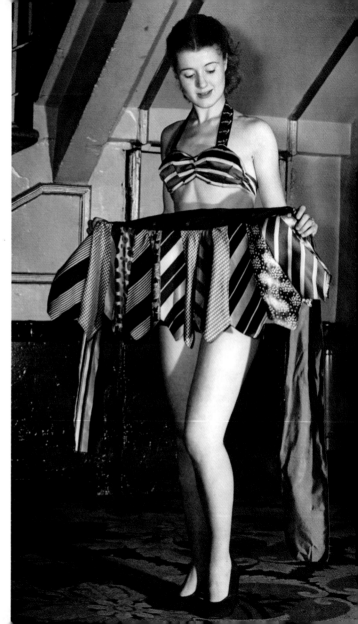

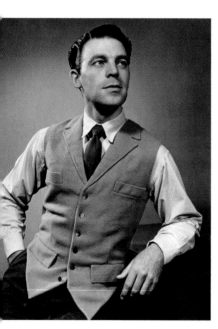

Dapper waistcoat

A dapper, brushed fabric gentleman's waistcoat worn with a shirt and tie and contrasting, dark coloured trousers.

December, 1951

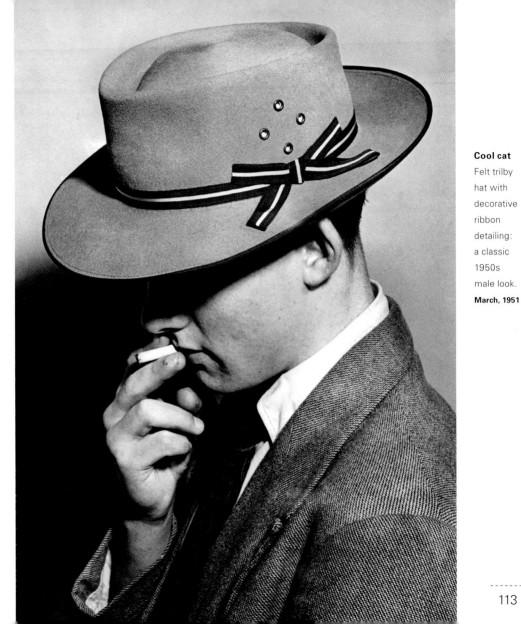

Cool cat
Felt trilby
hat with
decorative
ribbon
detailing:
a classic
1950s
male look.
March, 1951

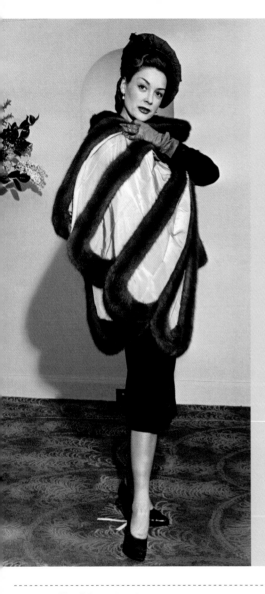

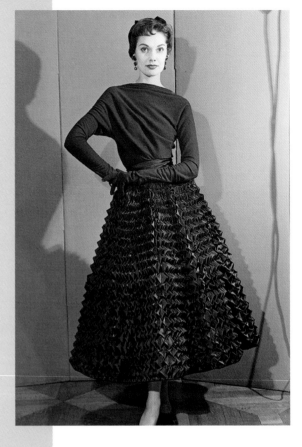

◀ Wild mink stole

A glamorous wild mink stole on pleated taffeta, worn with matching hat and long leather gloves.

February, 1951

◄ De Givenchy elegance
An outfit by De Givenchy, on display as part of the designer label's fashion show: a full ruffled skirt with crimped detail, worn with a long-sleeved black top and matching gloves.
November, 1952

London Fashion Fortnight
Two models, in mid-summer heat, modelling both summer fashions and winter coats, in Park Lane, as part of London Fashion Fortnight: (L) a coat in snow-white, shorn lamb fur fabric with large buttons, worn with a floppy-brimmed hat; (R) yellow doeskin shorts, worn with a short-sleeved blouse and accessorised with a scarf worn around the neck.
June, 1952

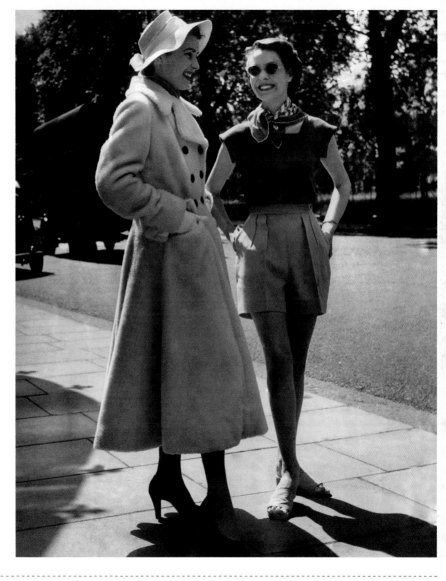

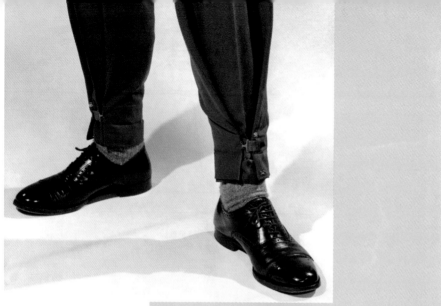

Daring shorts ▶
An extremely brief
pair of checked
shorts, worn with
a long-sleeved T-shirt
and kitten heels:
a daring look for
the mid-1950s.

1954

Built-in bicycle clips
A quirky design idea to solve
a practical problem:
how to prevent trousers
from becoming caught in a
gentleman's bicycle chain?
Answer: built-in bicycle clips.
July, 1954

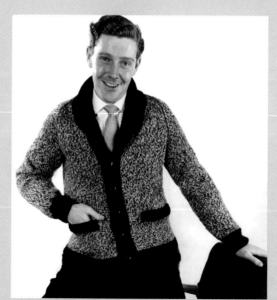

Chunky men's
◀ knitwear
The latest fashion
in men's cardigans
to knit yourself:
a knitting pattern
feature, showing off
this chunky man's
cardigan in flecked
wool, with plain
edging around the
collar and cuffs.
October, 1955

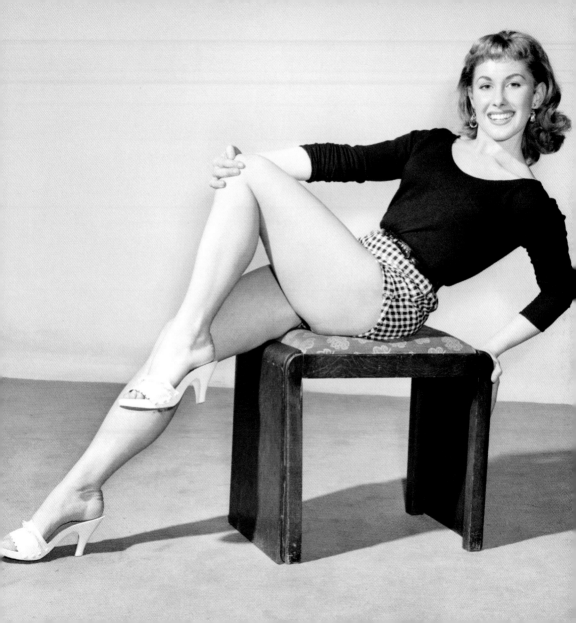

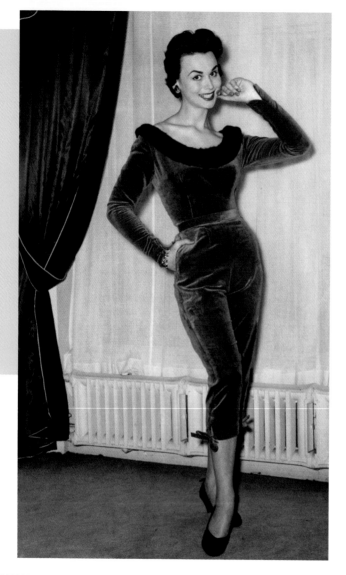

◀ Principal boy

Perfect for an appearance in pantomime: a velvet, one-piece jumpsuit with cropped trousers, fastened by bows at the calf, and trimmed in black around the neckline.

August, 1954

Tweed overload ▶

Men's 1950s fashions: loose-fitting, tweed overcoat, worn with matching tweed trousers and classic brogues.

June, 1953

Jersey girl ▶▶

Fitted jersey suit with matching, three-quarter-length swing coat, edged with black trim, and teamed with a small hat and black gloves.

August, 1954

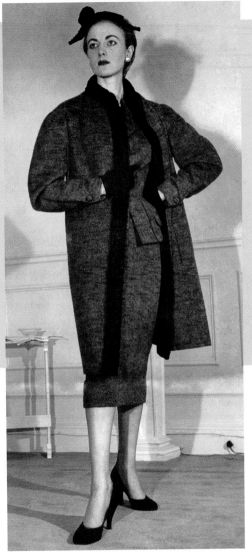

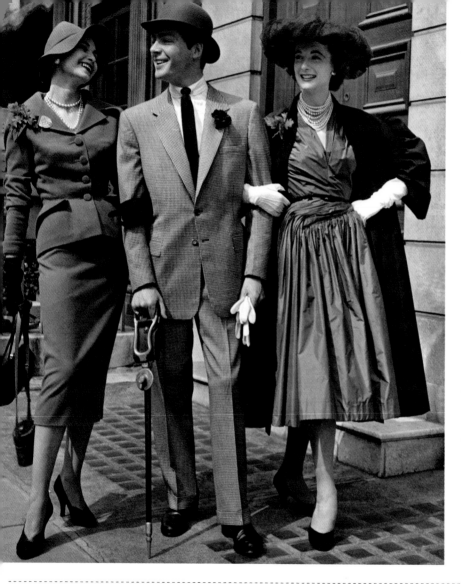

Ladies' Day at Epsom: every member of the Incorporated Society of London Fashion Designers was represented by a model wearing the designer's personal choice of an outfit from their current collections. L–R: Avril from the fashion house of Michael, wearing a pencil skirt with matching jacket; actor Guy Des Rochers, wearing a formal tweed suit; and Deidre, wearing a gathered dress with loose pleated full skirt, teamed with a contrasting swing coat and wide-brimmed hat, both outfits by Ronald Paterson.

June, 1954

Pancake day ▶

An eye-catching, wide-brimmed velvet hat, designed by Ronald Paterson.

July, 1954

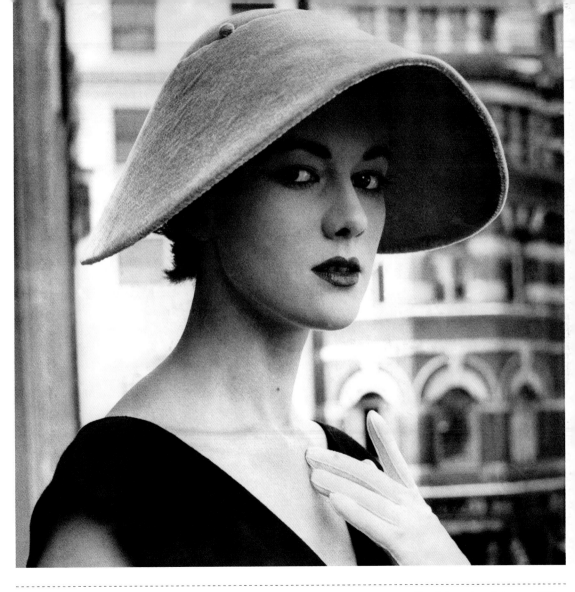

Biker girl

The outfit that every Vespa-riding, girl-about-town should be seen in: a Scoot suit, worn with sensible ankle boots, and designed to keep the rider warm and dry.

November, 1954

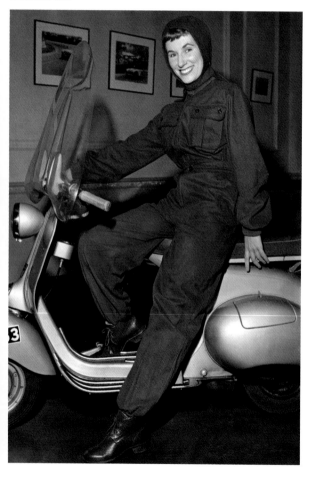

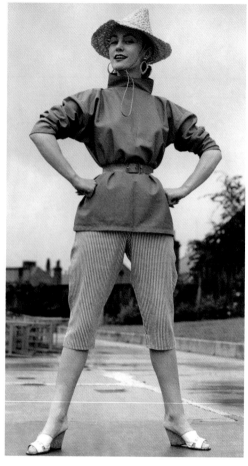

Chinese accents

A Chinese peasant-inspired outfit: tunic top, cinched in tightly at the waist with a matching belt, worn over striped, knee-length shorts and finished off with a straw sun hat.

June, 1954

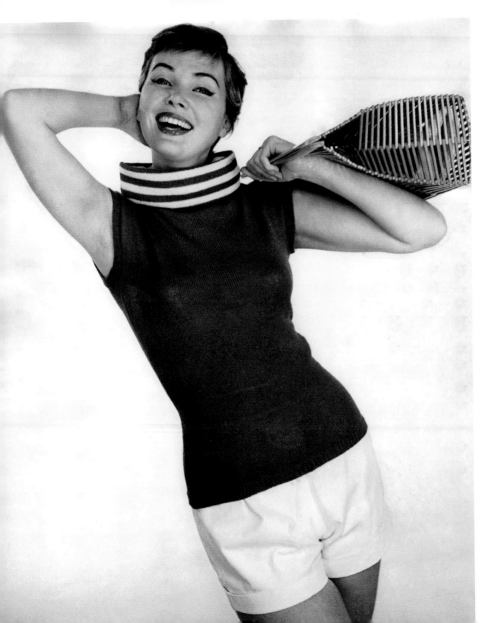

Hepburn inspired

A tight-fitting knitted top, with unusual striped collar, teamed with cotton shorts: a fashion shoot promoting knitting patterns employing an Audrey Hepburn look-alike.

June, 1956

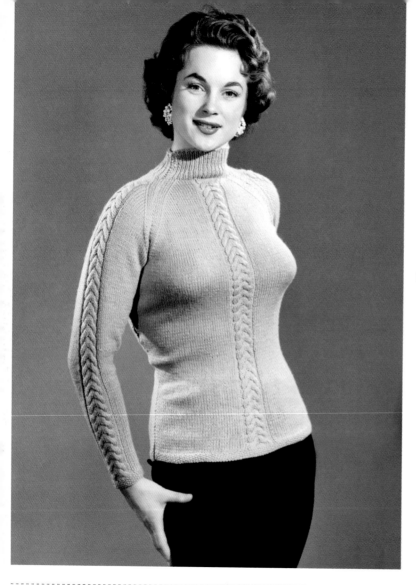

◀ Figure-hugging knitwear
Curvaceous figures were
emphasised with the help
of figure-hugging knitwear,
such as this jumper with
a cable-knit design.
1955

New look ▶
A classic example of the New
Look: dress with gathered
bodice, button detailing and
knee-length, full skirt with belt
to accentuate a slim waist.
February, 1955

Stitched up ▶▶
Tight woollen sweater,
teamed with tapered trousers
with stitching detail around
the pockets and on
the seams, worn
with espadrilles.
June, 1955

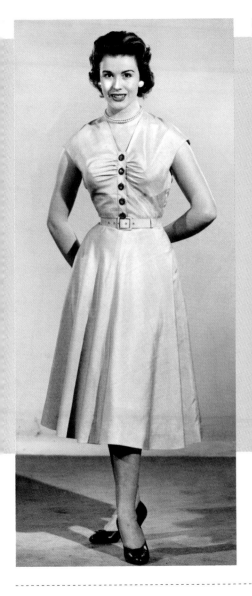
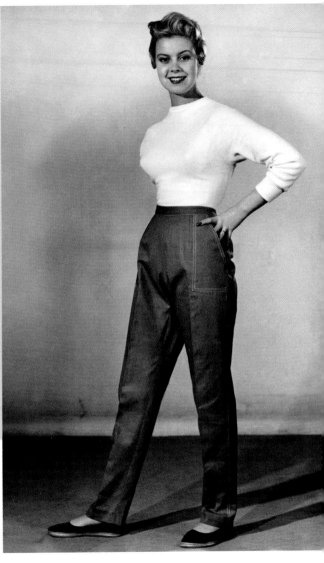

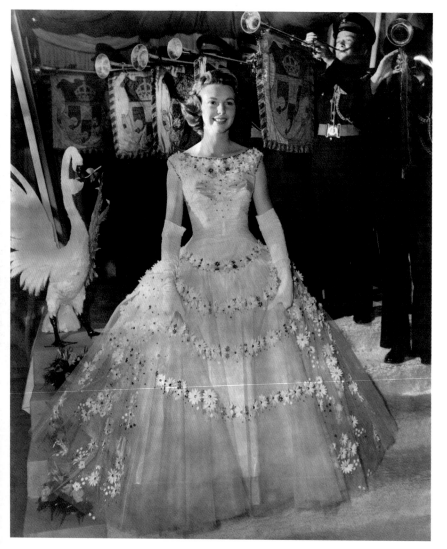

◀ **Deb of the year**

A fanfare of trumpets greets Jill Carter, the *Daily Mirror* Deb of the Year, arriving at The Debutantes' Ball held at the Mayfair Hotel, dressed in a suitably glamorous gown decorated with an intricate daisy design.

31st May, 1957

Bird's nest ▶

Hats on show at the Associated Millinery Designers Show at the Dorchester Hotel: a white fur hat with matching stole, with, somewhat inexplicably, a blackbird, complete with a baby in its 'nest' attempting to land on the hat, while other members of the 'flock' appear to be clinging to the stole.

November, 1956

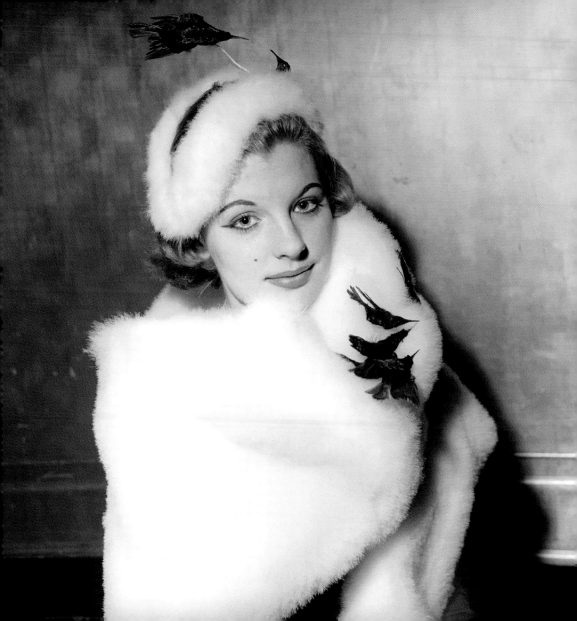

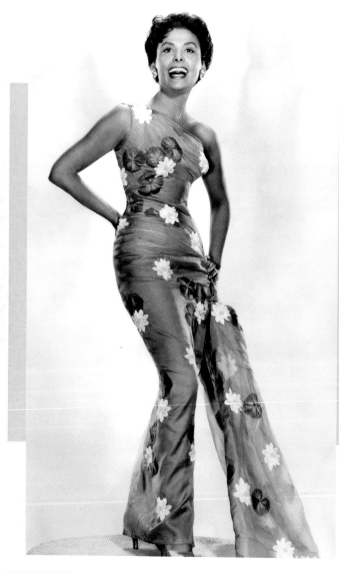

◀ **Hello kitty**

Popular singer Lena Horne, wearing a flared, off-the-shoulder catsuit with flower detailing.

1956

Fitted basque ▶

A fitted, basque-style top and matching jacket, worn over white, tapered trousers: designed by Marcel Fenez, for the fashion label Fontana of Rome.

December, 1957

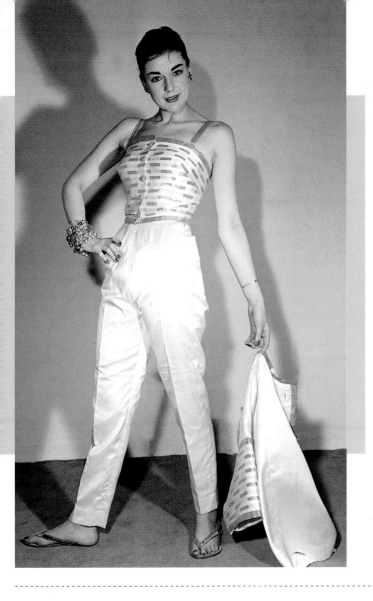

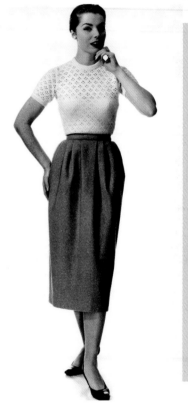

Crocheted top

Crocheted, fitted top worn with a long, over-the-knee skirt, loosely pleated from the waist.

September, 1957

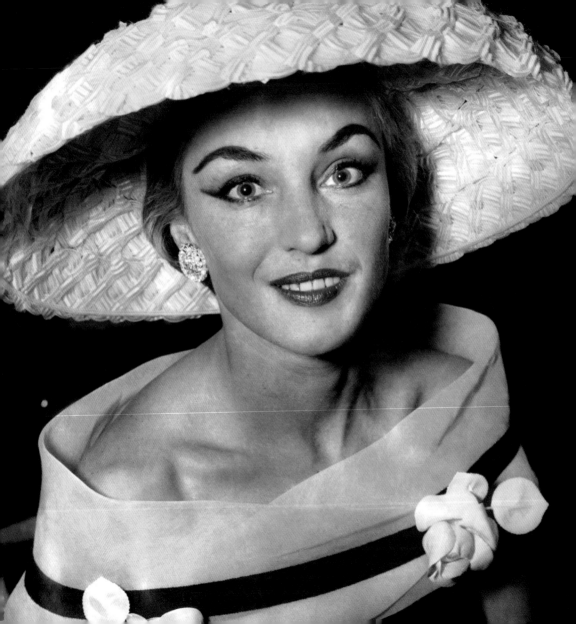

Coolie hat

◀ Large white, crinoline-inspired straw hat: worn with black dress with off-the-shoulder, white organdie collar with petal detailing.

January, 1957

Fitch fur coat ▶

This dramatic, floor-length, fitch fur (polecat) coat would be perfect for that starring role in *Doctor Zhivago*.

January, 1957

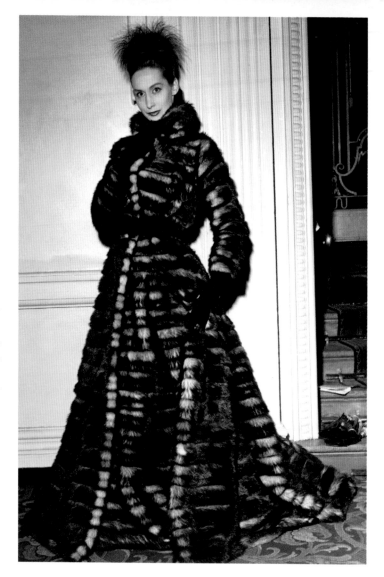

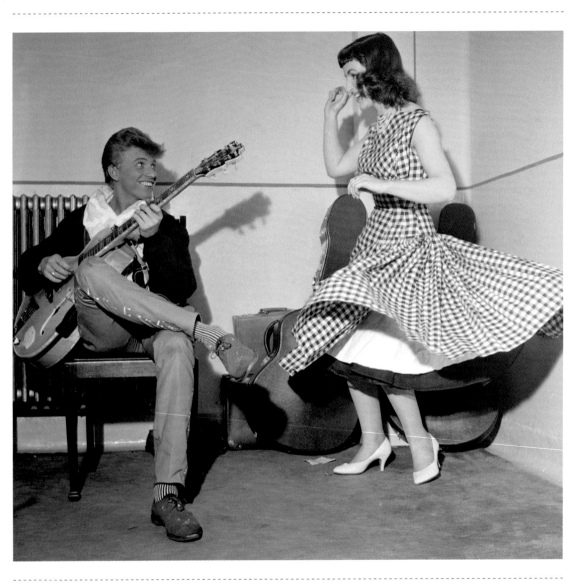

◄ Stealing the limelight

British rock 'n' roll singer Tommy Steele, at the height of his fame and dressed in typical 1950s male fashions, plays his guitar as a female fan dances for him.

June, 1957

Scooter style ►

A checked, cotton, all-in-one catsuit, belted at the waist and cropped at the knee: the ideal outfit for taking a spin on a Vespa scooter.

June, 1957

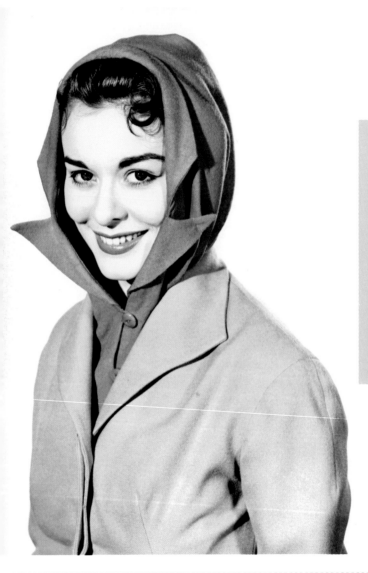

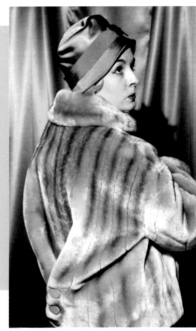

◄ Hat and scarf combo

An unusual and extremely practical accessory: a hat and scarf combined, ideal for those wet and windy days.

1958

Budget-priced fur

A new, budget-priced fur called 'The New Look In Real Fur', produced by Swear and Wells, being launched at a fashion show held in the Savoy Hotel, London. The fur cost around £25, making it an affordable luxury item for many women.

March, 1958

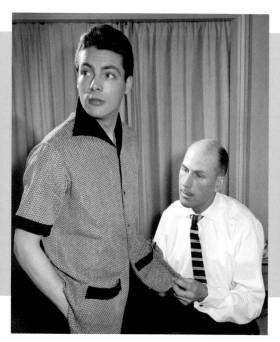

Suits you, sir

A tailor making alterations in his workshop:
preparing new designs in men's casual shirts.

December, 1957

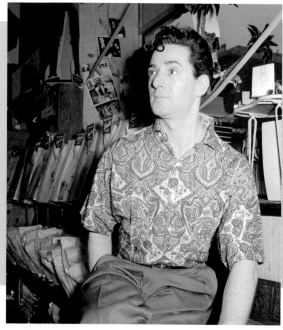

Shirt for a leading man

A Rock Hudson look-alike models a Paisley-print
short-sleeved shirt: one of the shirt designs to
be found at Glasgow's Esquire Shirt Boutique.

1958

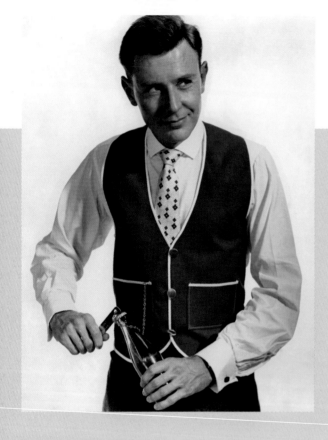

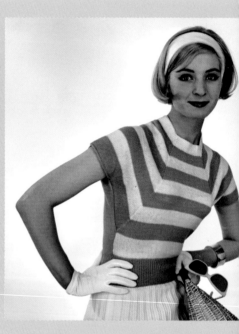

Dandy waistcoat

A dark waistcoat with contrasting piping detail and brass buttons, worn with a plain white shirt and patterned tie: the perfect outfit for the aspiring cocktail waiter.

August, 1958

Striped styles

Short-sleeved knitted top, worn with pleated skirt, Alice band and short, white gloves.

March, 1958

Model Barbara Pinney demonstrating
the versatility of woollen tights, worn,
in this case, as a headscarf.

January, 1959

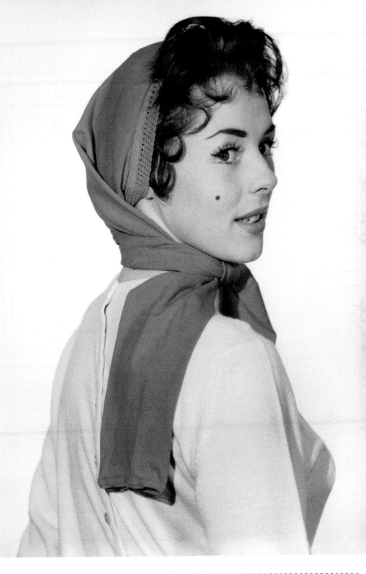

'A'-line dress

A classic, 'A'-line dress with a full,
stiffened skirt, worn with white gloves
and accessorised with an Alice band.

April, 1959

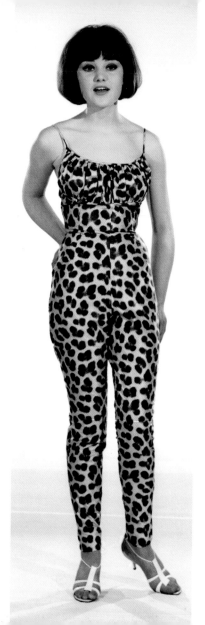

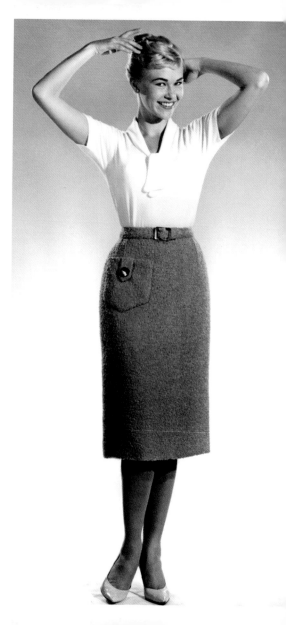

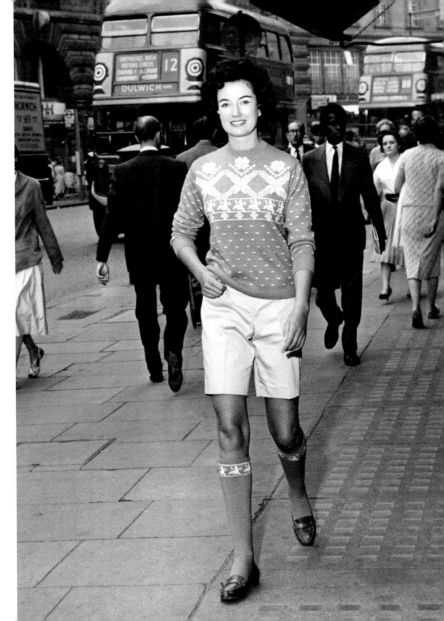

◀◀ Animal magic
A striking leopard-print, full-length swimming costume, perfect for making a splash at the beach.
1959

◀ Pencil sharp
Belted wool pencil skirt with patch pocket, teamed with a plain white blouse finished with integral scarf, tied loosely at the neck.
October, 1959

Short and sweet ▶
Patterned wool jumper, with matching socks, worn over thigh-length shorts: an eye-catching outfit to wear out shopping in Regent Street in London.
September, 1959

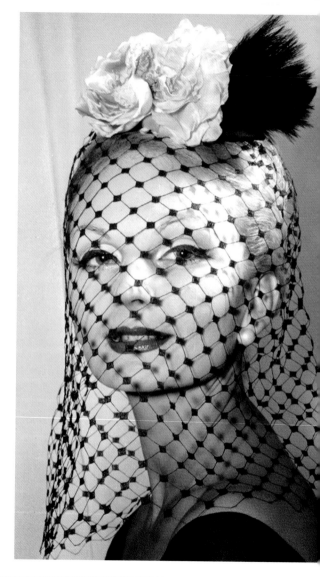

Cagey ladies

Two variations on a pillbox hat made of flamenco velvet:
(R) a cuffed bow effect and (L) a flower decoration.
The detachable veiling could also be worn separately
to complete a cocktail outfit. Both hats were among
the Model and Twenty Plus millinery collection,
shown by Gina Davies in London.

October, 1959

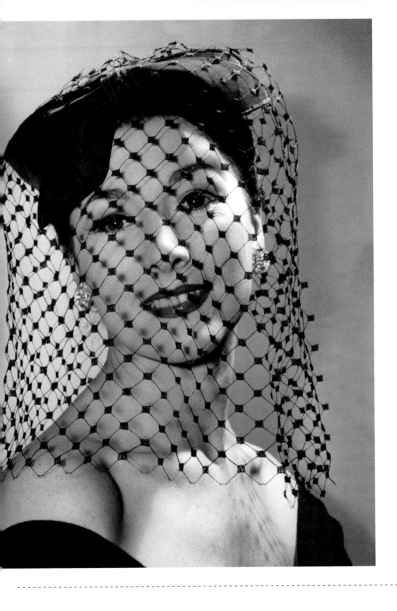

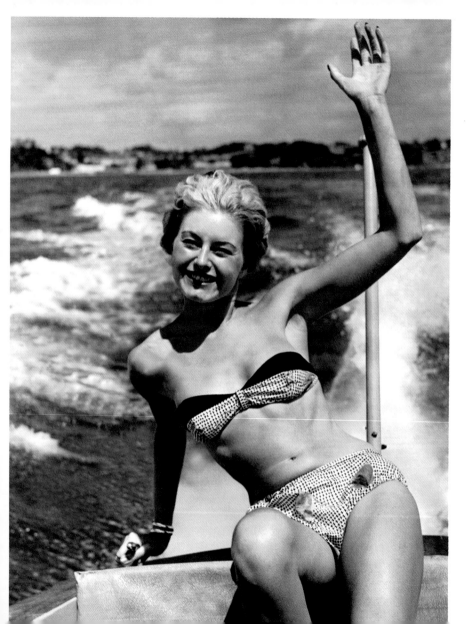

Deck check

A checked,
strapless bikini
with black detailing:
the speedboat was
an optional extra.

July, 1959

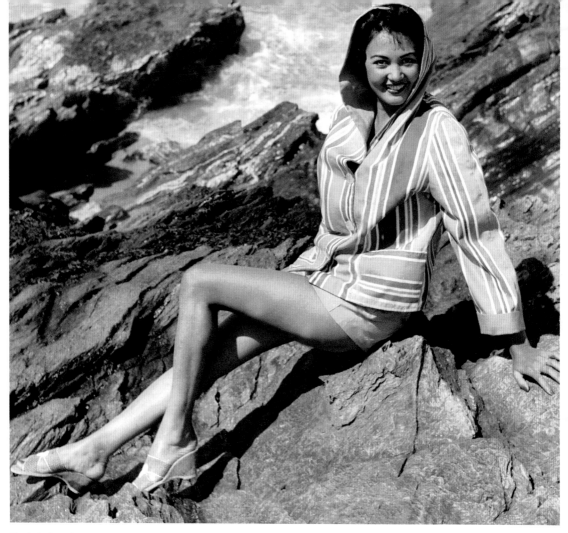

Deckchair stripes

A striped, hooded jacket worn with matching shorts: perfect for sitting on the beach and blending in with the deckchairs.

August, 1959

- -

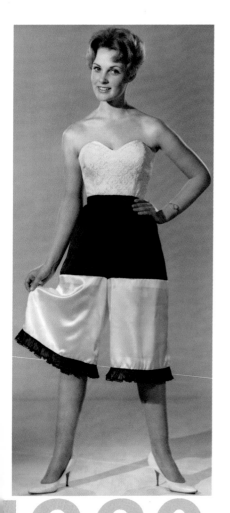

◂ Satin culottes

Black and white satin culottes, trimmed with black lace and worn with a white lace basque.
September 1960

Fine contrast ▸

Models in contrasting black and white outfits. L–R: space-age catsuit, designed by Hildebrand, and made from crushed, synthetic black patent leather, with matching black boots and contrasting wide, white belt; a white, gabardine belted jacket with matching, long flared skirt, designed by Harbro, worn with a colourful blouse and tie, and topped off with a wide-brimmed, floppy hat.
c.1960s

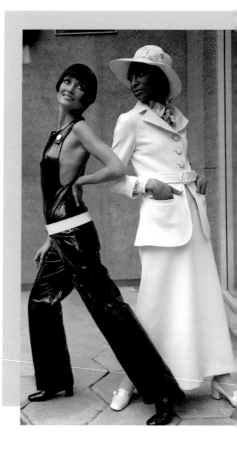

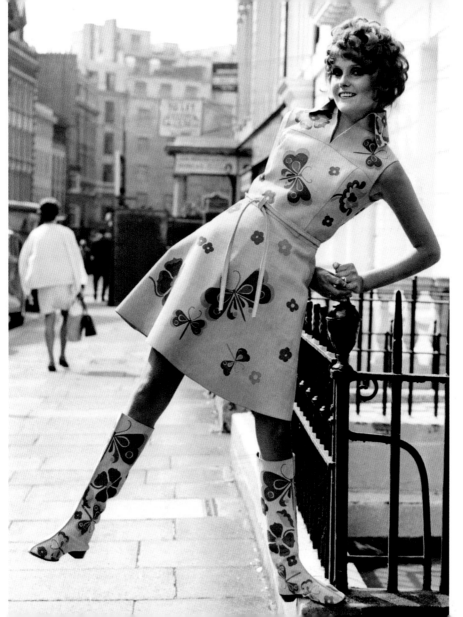

Bold butterflies

A suede mini-dress with large collar, bold butterfly design and matching boots, designed by the Royal College of Art.

c.1960s

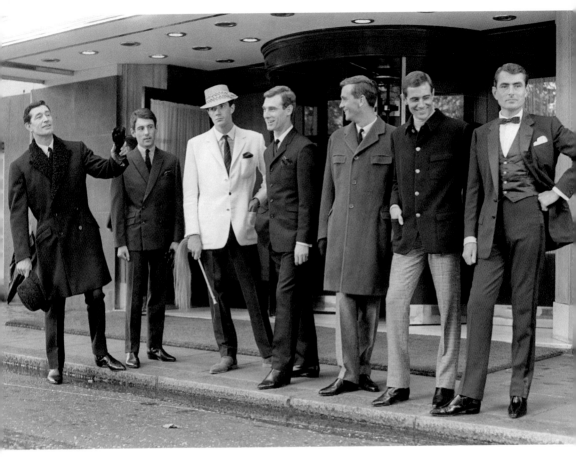

Gentlemen about town

A selection of men's suits, coats, jackets and evening wear, designed by Hardy Amies, being modelled outside a London Hotel.

1962

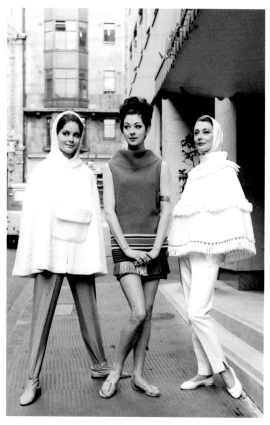

Cape crusaders

The cape became the must-have item every girl wanted in 1962: white hooded cape with large patch pocket, worn with ski pants (L) and white woollen, tasselled cape, worn with tapered trousers and headscarf (R). The girl in the middle, wearing a dainty mini-dress, looks somewhat under-dressed.

1962

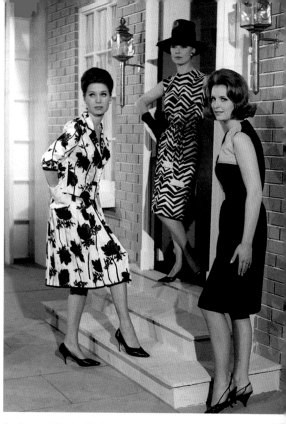

Amies and Hartnell trio

New dress styles by fashion designers Hardy Amies and Norman Hartnell, being shown in Hanover Square, London. L–R: flower-print, two-piece suit; animal-print shift dress; and black dress with contrasting bodice detail, each with stylish kitten heels.

c.1960s

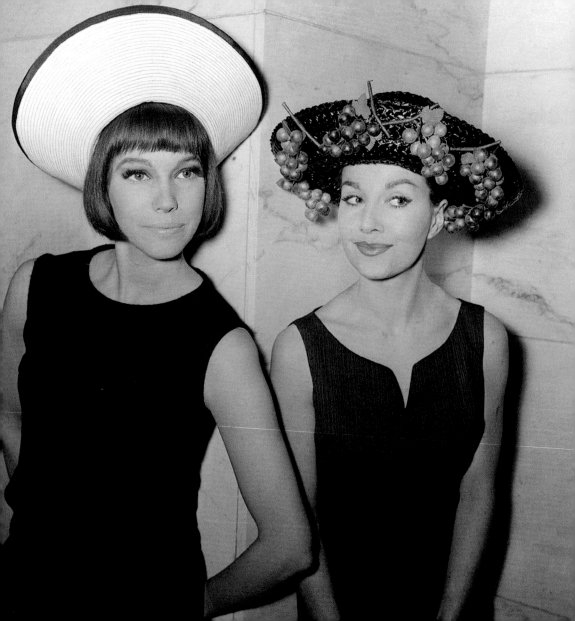

Hats off

 Millinery styles. L–R: plain cream, straw hat, with black trim; and dark straw hat draped with decorative bunches of grapes: both worn with timeless, sleeveless black dresses.

1963

Mop-tops ▶

The early clean-cut image of The Beatles: jackets, ties, button-down shirts and mop-top haircuts.

1963

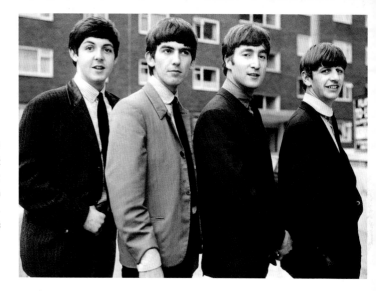

Mod Invasion

Groups of Mods, wearing the regulation parka anoraks, gather on their scooters in Hastings, on the south coast of England. Running battles between groups of Mods and rival gangs of Rockers proved to be a headache for the authorities during the 1960s.

1964

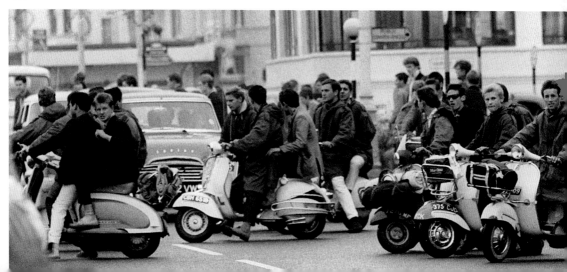

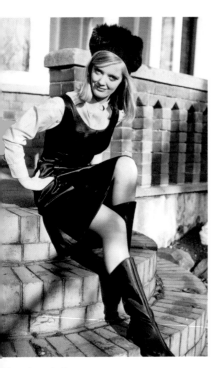

Leather-clad

Teenager Glynne Geldart sets male pulses racing wearing a short, black, leather dress with matching black boots and fur-trimmed hat.

January, 1964

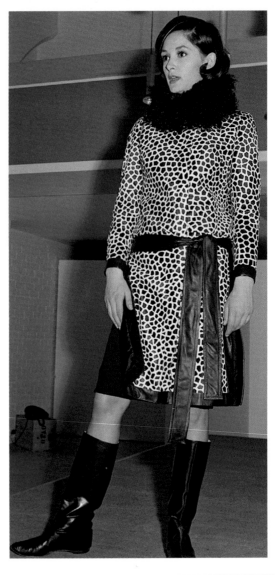

Big-cat
◀ prints

A wrap-around leopard-print dress, designed by Mary Quant: belted loosely at the waist and worn with a fringed black collar and knee-high boots.

c.1960s

Fashion
trendsetters ▶

Fashion designer Mary Quant, sporting one of the new, geometric hairstyles created by celebrity hairdresser Vidal Sassoon. Quant's style epitomised the look of the 1960s.

November, 1964

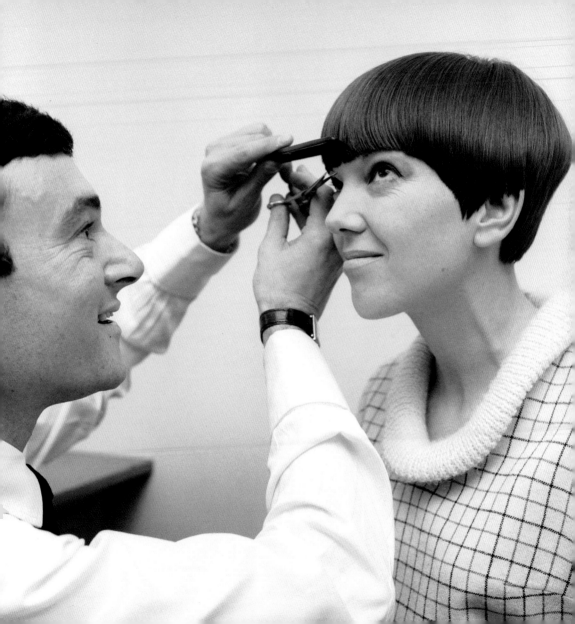

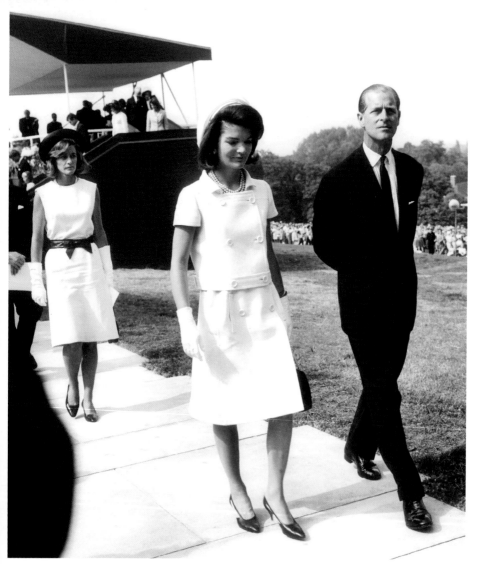

Iconic figure

The iconic figure of Jackie Kennedy, dressed in one of her classic, trademark, two-piece suits, walking with Prince Philip at Runnymede for The Kennedy Memorial Stone ceremony, in memory of her late husband, American President John F. Kennedy.

May, 1965

Nautical influences
Striped, burnt orange and gold sleeveless cotton blouse, teamed with matching peaked cap: perfect for those lazy summer days spent on the yacht.

c.1965

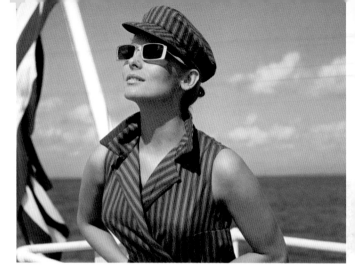

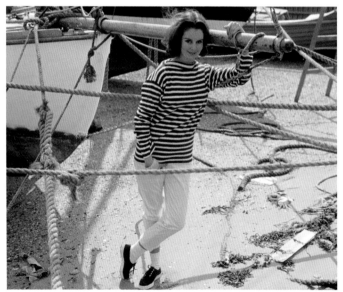

Deck hand
Striped black and white, long-sleeved T-shirt, worn over cropped white trousers with black, canvas deck shoes.

c.1965

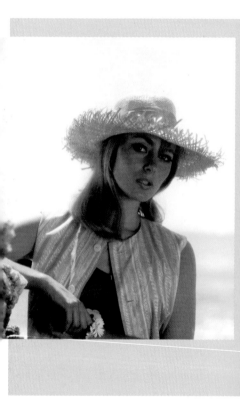

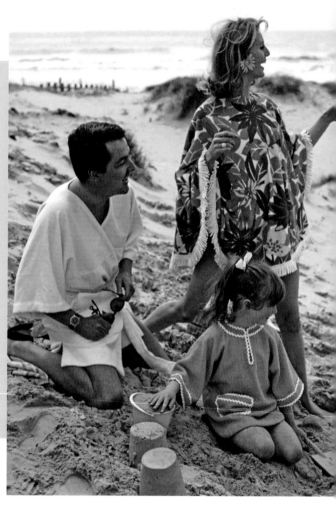

Beach bum

Frayed, wide-brimmed straw hat with yellow band,
teamed with sleeveless gold-yellow blouse
and worn over brown, floral-patterned swimsuit.

c.1965

◀ **Family beachwear**

What the family of the 1960s wore to the beach: ponchos in a variety of styles, colours and sizes, and short bathrobes that looked as though they had been 'acquired' from the local hotel.

c.1965

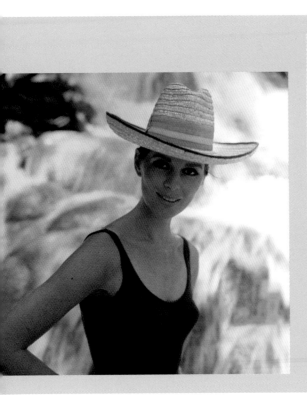 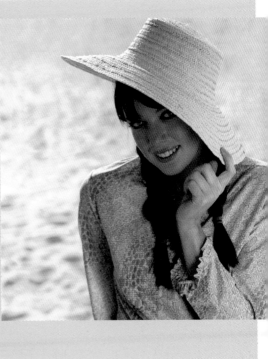

Sun, sea and shade

Purple one-piece swimming costume, worn with large, sombrero-style straw hat with ribbon detailing, ideal for keeping the sun from your face.

c.1965

Heads-up

Gold and white patterned blouse, topped off with a large Oriental-style straw sun hat: perfect beach babe attire.

c.1965

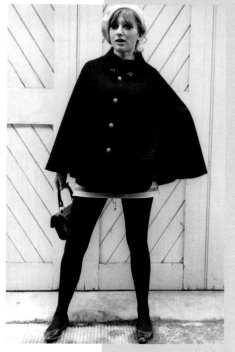

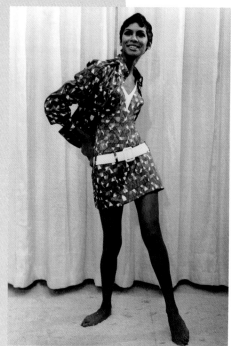

French actress
and blonde
bombshell
Brigitte Bardot,
during a scene
from *A Day In
September,* shot
in North Berwick,
Scotland: there
weren't many
people who
could make
thigh-high rubber
waders look
sexy, but Bardot
was definitely
one of them.
September, 1966

Cop cape
A black cape with
brass buttons and
chain fastening,
modelled on standard
police-issue garb,
worn over a striped
miniskirt and black
tights, topped off
with a white beret.
December, 1966

Mini magic
Patterned mini-dress
designed by Svend,
with low-slung waist
and belt, worn
with matching
jacket – always
complimentary on
tall, slim figures.
October, 1966

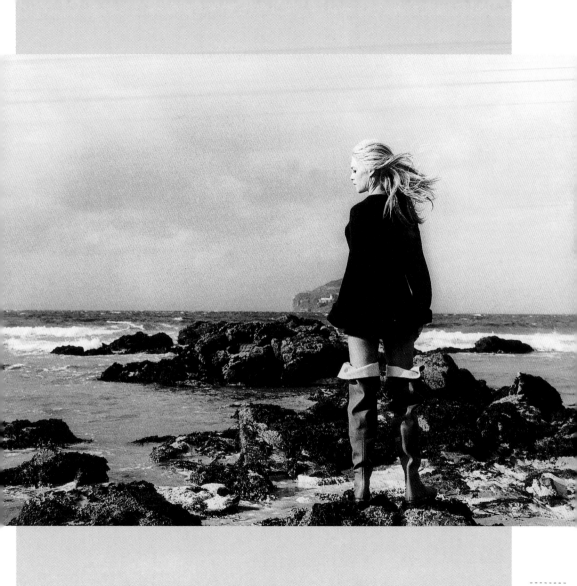

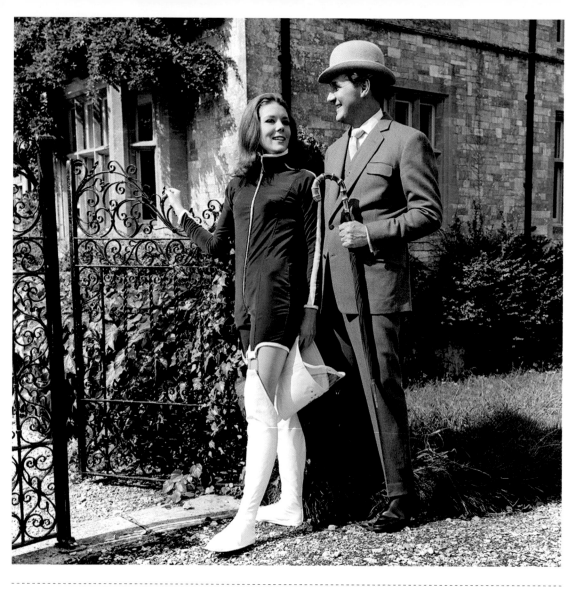

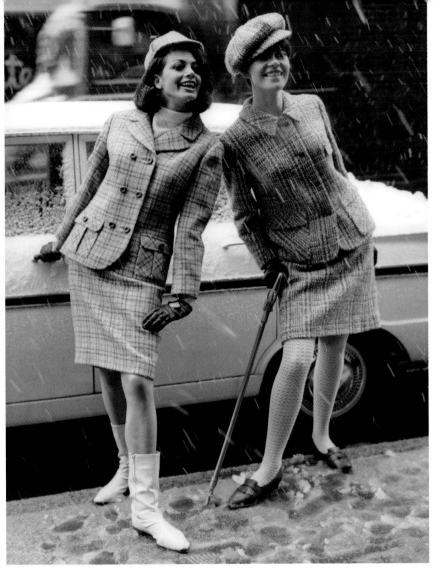

◀◀ **The Avengers**

Diana Rigg and Patrick Macnee, stars of the cult television series *The Avengers*: Rigg, wearing a short black catsuit trimmed with white piping and teamed with detachable, thigh-length boots, became an object of desire for many a Sixties' schoolboy as a result of her appearances in the show, while Macnee was always sartorially elegant in suit and bowler hat.

1966

◀ **Country tweeds**

Checked country tweed suit designs, worn with matching hats, woollen tights, short boots and flat shoes.

April, 1966

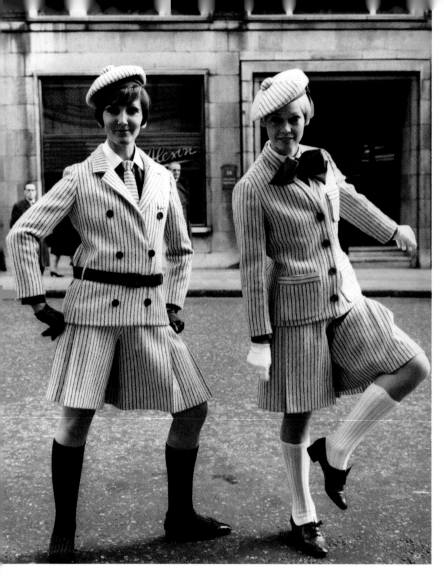

◀ Pin-striped culottes

Suits being shown as part of Dior's spring preview, held at their London boutique: red and white, or navy and white, pin-striped suits with pleated culottes, worn with matching caps, ties and large bows, tied at the neck.

March, 1966

Mini Me ▶

The Mini that received the Op-Art treatment from an enthusiastic owner, armed only with a pair of scissors and a quarter-of-a-mile of stick-on plastic. The car was up for sale at a cost of £385: the model, wearing a matching black and white mini-dress, counted as an optional extra.

March, 1966

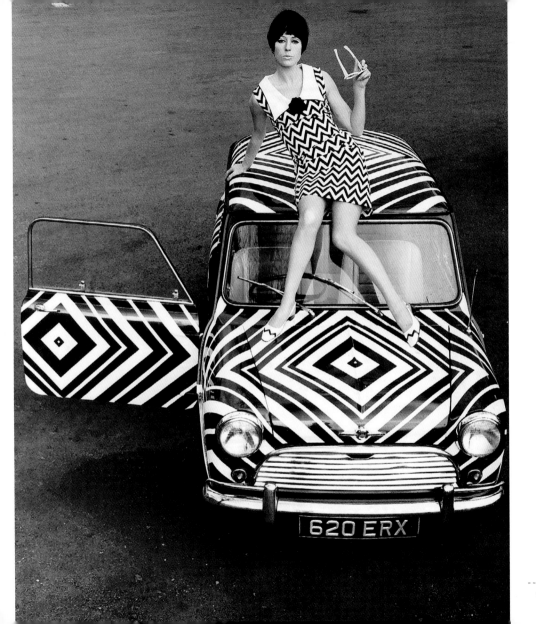

Fine and dandy

Men's fashion designer Lord John launched a Regency look for spring 1966, featuring South African pop star Beau Brummel (real name Mike Bush), modelling a double-breasted suit with black satin lapels, crisp white ruffled shirt, lace cravat, leather gloves and cane. Beau Brummel Esquire And His Noble Men released the single *I Know, Know, Know* in 1965 to a lukewarm response. The dandy singer later returned to South Africa and set up a naturist valley in the Northern Transvaal.

July, 1965

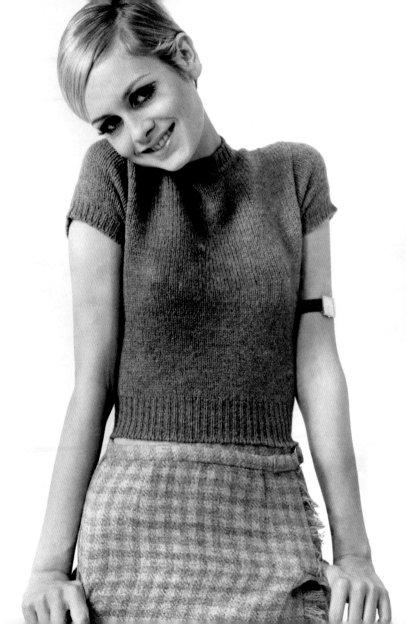

Elfin looks

Twiggy, the elfin model who was *the* face of the Swinging Sixties, modelling a short woollen top worn over a checked kilt, accessorised by an arm watch.

October, 1966

Rolling Stones' soft style

The Rolling Stones pictured in Green Park, London, prior to their departure for America where they were due to appear on the *Ed Sullivan Show*. The Bad Boys of the British music scene led the way in setting 1960s fashion trends, here sporting an impressive collection of fur coats, velvet jackets, floppy hats and jewellery.

January, 1967

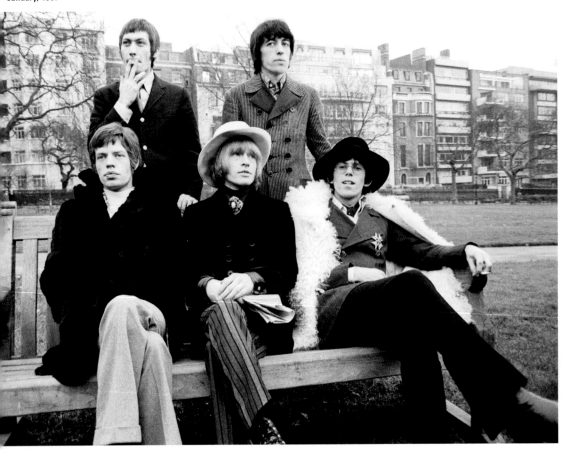

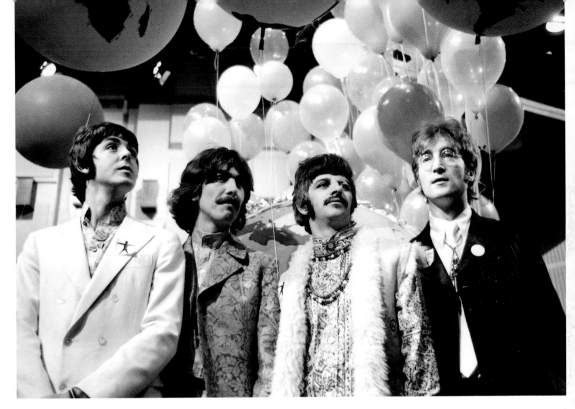

All You Need Is Love

And how much the image had changed in just four, short years: the Fab Four were now at the forefront of the 1960s hippy culture and dressed accordingly. The band is seen here at a press call for *Our World*, the first live global television link. Broadcast to 26 countries and watched by 400 million people, the programme was transmitted via satellite on 25th June, 1967. The BBC had commissioned The Beatles to write a song for the UK's contribution: 'All You Need Is Love', written by John Lennon and credited to Lennon/McCartney, was first performed by the band at this event and released as a single the following month.

June, 1967

Love-in at Woburn ▶

The 'Three day non-stop happening' that was Woburn Abbey's Festival of the Flower Children blossomed with multi-coloured hippies, such as this individual, resplendent in flowered hat and crazy sunglasses, ubiquitous paisley shirt and a bead necklace. Is this man now an accountant?

August, 1967

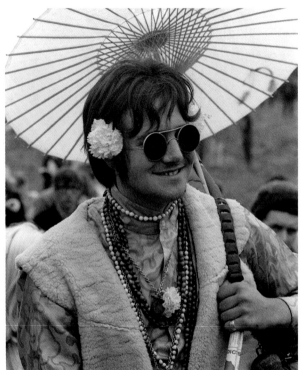

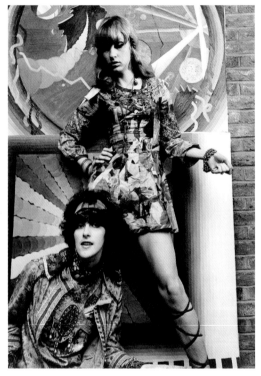

Festival fashion

A hippy in full regalia – sheepskin jacket, strings of beads, paisley shirt, sporting sunglasses, a flower tucked behind one ear and holding a parasol – joins the throng as hippies congregate in the grounds of Woburn Abbey, the stately home of the Duchess of Bedford, for the three-day Festival of the Flower Children.

26th August, 1967

Riot of colour

Hippy fashion expressed in bold, layered prints, beads, headscarves and sandals.

August, 1967

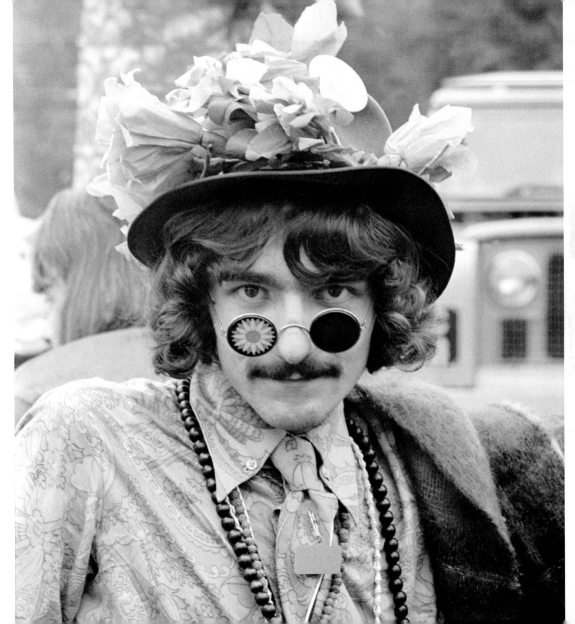

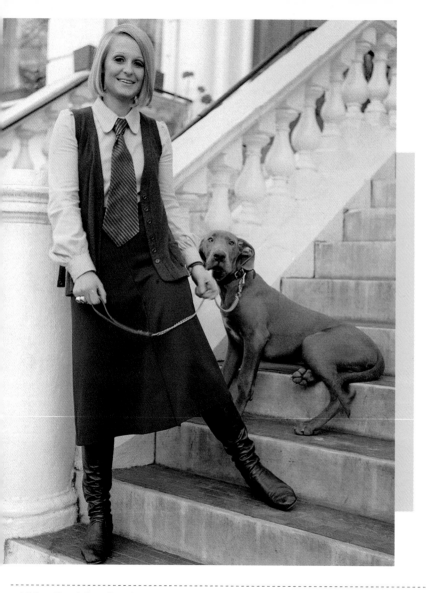

◀ Biba Barbara

Founder of the famous
fashion label Biba, Barbara
Hulanicki models her own
maxi skirt, worn with blouse
and tie, woollen waistcoat and
black boots, outside her home
in Kensington, London.

December, 1967

Spangly silver Lurex ▶

A roll-neck shirt in silver lurex:
silver was apparently the
trendy colour for men, making
this outfit suitable for either
a casual function or for more
formal party wear (or possibly
a walk-on part in *Star Trek*).

December, 1968

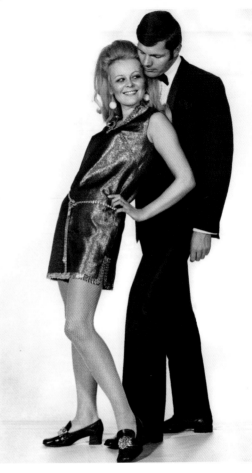

Sequins and rhinestones

A silver tunic dress, shimmering with sequins around the neckline and side-slit (L), worn with a loosely tied rhinestone belt and chisel-toed shoes, trimmed with sequin rosettes; and (R) dark, formal dinner suit, with satin lapels and matching stripe down the trousers.

December, 1968

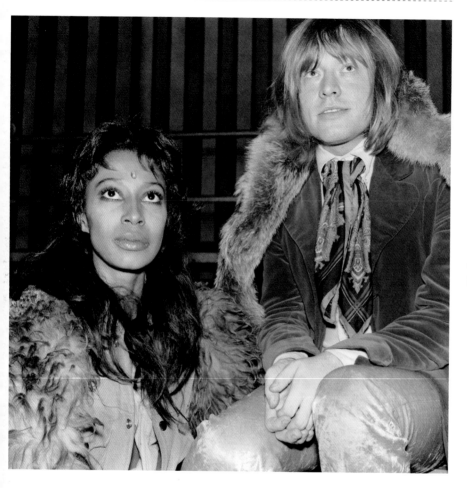

◀ Velvet and fur
Wrapped in fur and crushed velvet, the Rolling Stones' Brian Jones takes time out during shooting of the band's film *Rock 'n' Roll Circus*, which turned out to be his final public appearance with the Stones. He is pictured with model Donyale Luna, who played the part of the fire-eater's assistant in the film.
December, 1968

Fashion clash ▶
The Rolling Stones, in all their late-Sixties pomp and wearing a fine selection of rock star regalia, launch their *Beggars Banquet* album in the regal elegance of the Elizabethan Room at London's Gore Hotel.
5th December, 1968

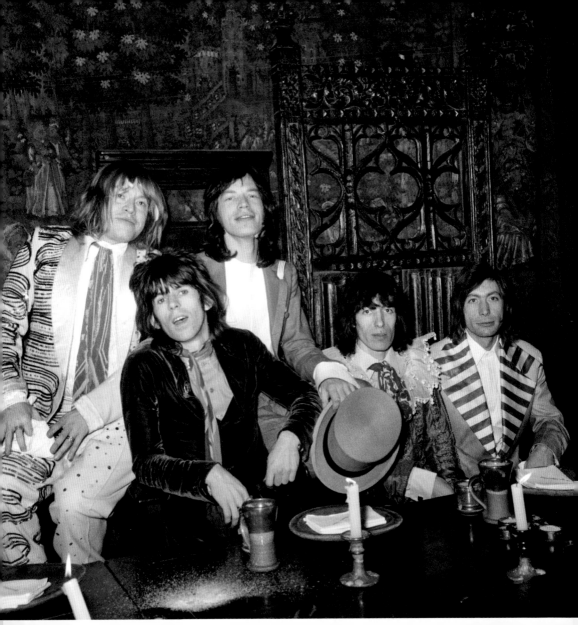

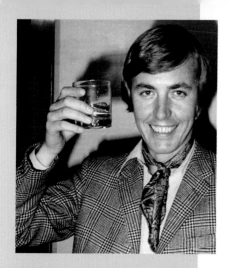

Dee-jay

Popular BBC DJ, Simon Dee, another well-known celebrity of the Sixties, seen here sporting a fashionable cravat, was sacked by the Corporation and subsequently went on to sign a new contract with rival television company LWT.

October, 1969

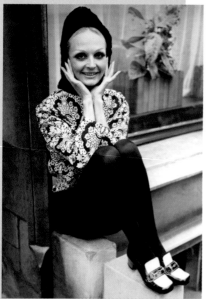

◀ Brocade tunic

Black and white brocade tunic outfit designed by Clive, with black fur hem and hood, worn with two-tone, chisel-toed shoes.

October, 1969

Stripes Pour Elle ▶

The Pour Elle spring and summer collection showcased at the trendy La Valbonne nightclub in London featured this eye-catching black and white striped mini-dress in chenille velvet, with wide collar and button detailing.

November, 1969

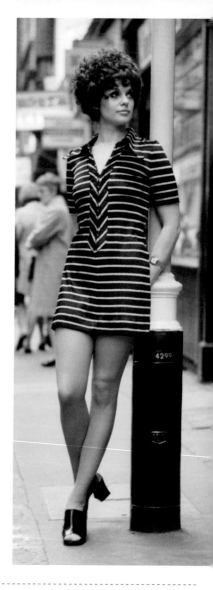

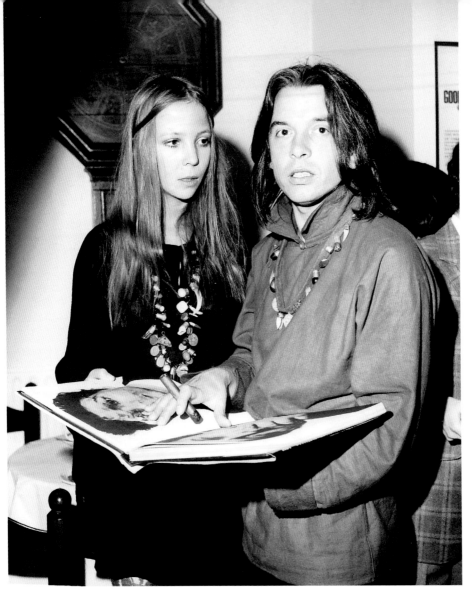

Bailey's book

Celebrity fashion photographer David Bailey shows a copy of his book *Goodbye Baby And Amen* to his girlfriend, model Penelope Tree. Bailey has continued to be an influential figure in fashion photography up to this day.

1969

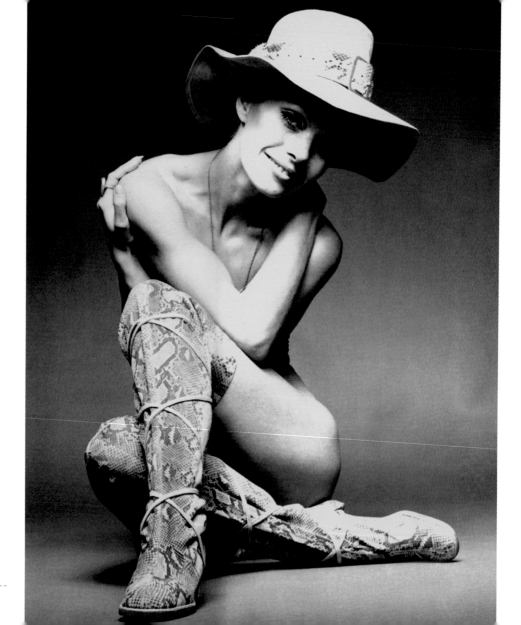

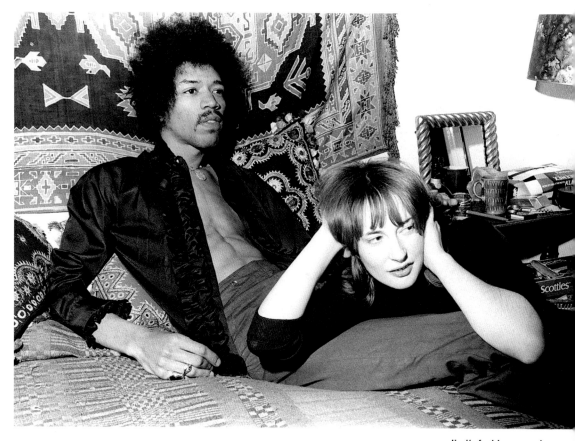

◄ Solely snakeskin

Python-print suede boots designed by Gaby and
a python-print hunter's hat are a bold fashion statement,
although a few additional items of clothing would have
been needed to complete the look.

September, 1969

Jimi's fashion experience

Iconic rock guitarist Jimi Hendrix, at home in his London flat, with
girlfriend Kathy Etchingham. The star's satin frilled shirt, open
to the waist, helped to cultivate his cool, rock star image and his
personal style became even more flamboyant, with silk jackets,
exotic waistcoats and brightly coloured flared trousers.

1969

**Full-length
tweed**

A fashion show
at the Mayfair
Hotel, London
featured this
full-length
checked tweed
coat, worn with
breeches and
sweater in camel
colour wool (R),
partnered with a
matching tweed
coat and trouser
suit worn with
fur beret (L).
c.1970s

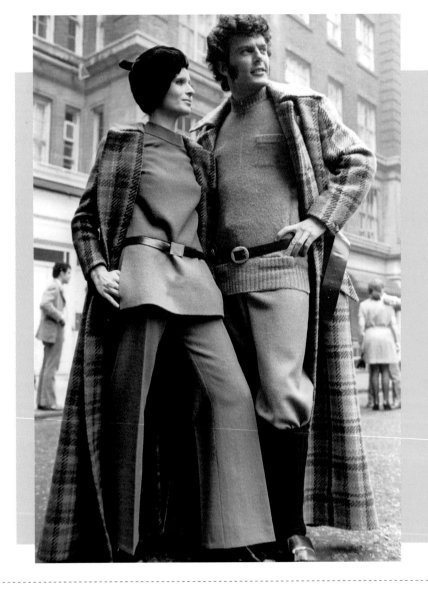

His 'n' hers sheepskin

Matching styles: flat-fronted trousers for men and women, worn with unisex sheepskin coats.

c.1970s

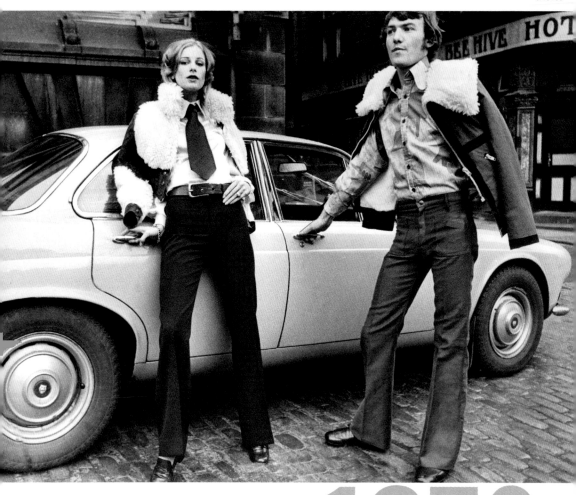

1970s

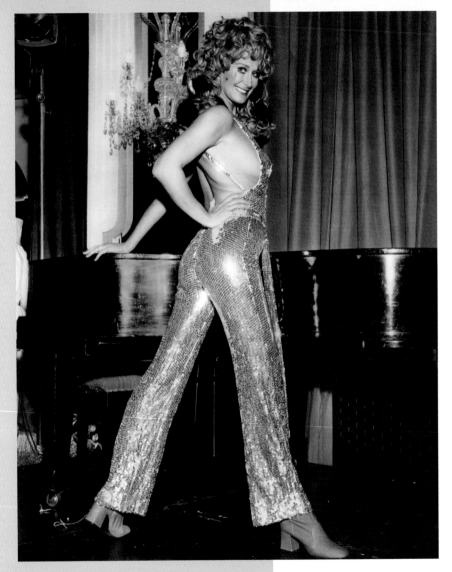

◀ Dancing Queen
A clinging, sequined gold catsuit, designed by Gina Fratini, for disco divas everywhere.
October, 1970

Ooh La La! ▶
Florence Fossorier, aged 19, stopping the traffic in Paris, France, wearing black hot pants with chunky belt, long-sleeved black T-shirt, black beret and knee-high boots.
c.1970s

Paris match ▶▶
Another image from the same Paris fashion shoot: Marina Weiss wearing tartan, dungaree hot pants, over-the-knee boots and stockings.
c.1970s

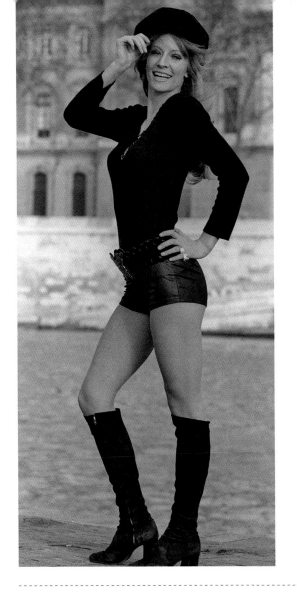

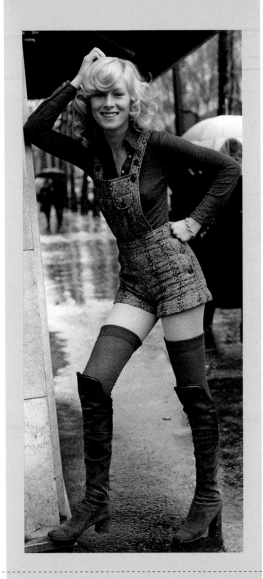

◄ Scarlet woman

Pillarbox red trouser suit comprising short bomber jacket trimmed with sheepskin on the collar and cuffs, worn with matching, red flared trousers and white, patent leather shoes.

c.1970s

On safari ►

Safari suit in light coloured denim with flared trousers. The long, pageboy haircut was a popular hairstyle of the 1970s, popularised by American actress Kate Jackson in the popular television series *Charlie's Angels*.

c.1970s

World Cup fever ►►

Hat designer label Marida shows off its autumn/winter 1970 collection, complete with a Mexican World Cup football theme. The collection included a 'Viva Bobby Moore' hat and sombreros covered in World Cup coins. Model Stacey Maisoneuve flies the flag, however, wearing a jersey beret with Union Jack streamer, teamed with an equally patriotic T-shirt.

May, 1970

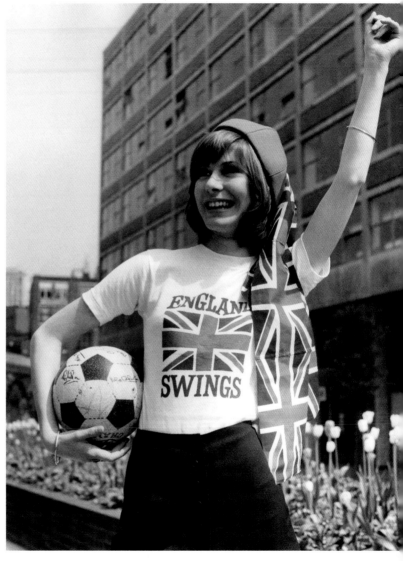

Skimmer style ▶

A versatile skimmer coat with the zip-up front: the hood could be worn down
as a cowl collar, or up for extra warmth; teamed with black, patent leather boots.

October, 1970

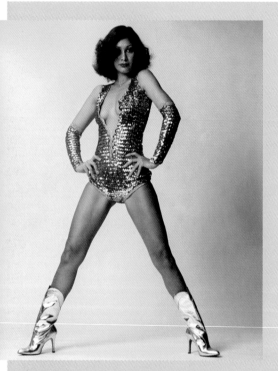

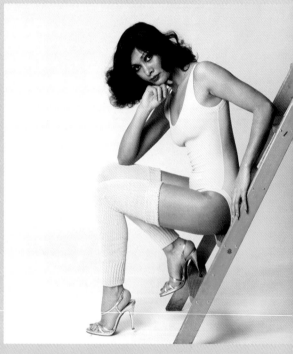

Disco diva

Sequined gold leotard with matching long sleeves, worn with
gold, calf-length boots: a quiet, understated outfit; perfect
for dancing queens everywhere.

c.1970s

Gym bunny

The gym craze started to take off in earnest in the 1970s and this
pink leotard teamed with matching leg warmers exemplified it;
the gold stilettos could, however, have proved to be something
of a handicap on the treadmill.

c.1970s

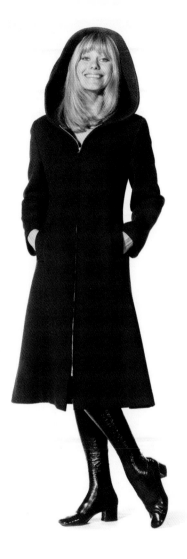

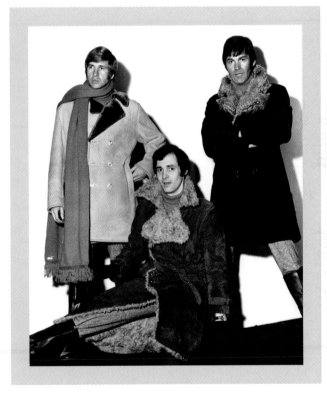

Winter warmers

This selection of warm, men's winter coats in suede and sheepskin, trimmed in fur were on display at the The Imbex '70 International Menswear Exhibition held at Earls Court, London.

March, 1970

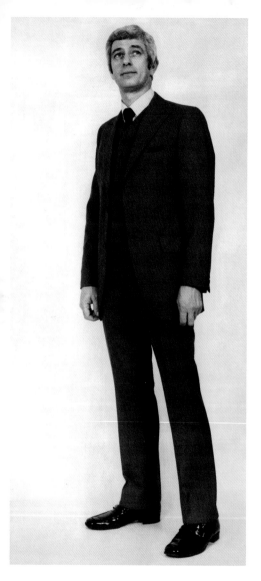

European invasion

British clothing manufacturers started to face stiff foreign competition in the early 1970s. This three-piece men's suit, imported from Yugoslavia, was on sale for only £7.

December, 1970

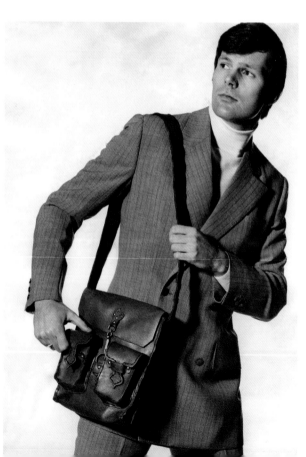

Crimplene nightmare ▸

The Manstyle International '71 Menswear Fashion Show, held at the Piccadilly Hotel in London, showcased some fashion nightmares. Frank Zappa look-alike model Michael Mundy never did live down the humiliation of having to wear this white, crimplene evening smoking dress, designed by Mr Fish.

March, 1970

◂ Man bag

The new accessory for the businessman about town: men's handbags. The idea, to save the shape of men's suits from being ruined by bulging pockets, made perfect sense. The designer, however, hadn't reckoned on the conservatism of the average 1970s man, who would rather have been seen dead than carry a handbag.

May, 1970

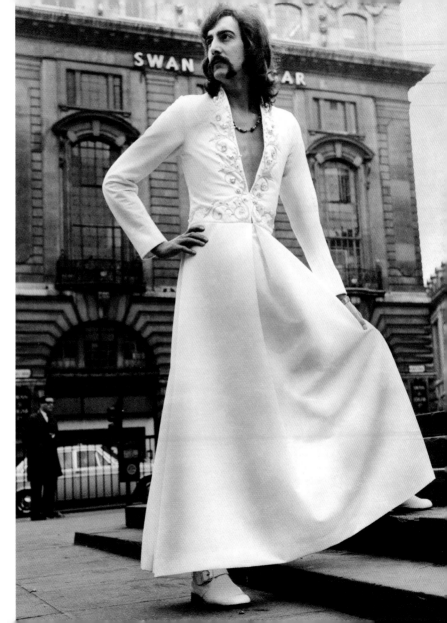

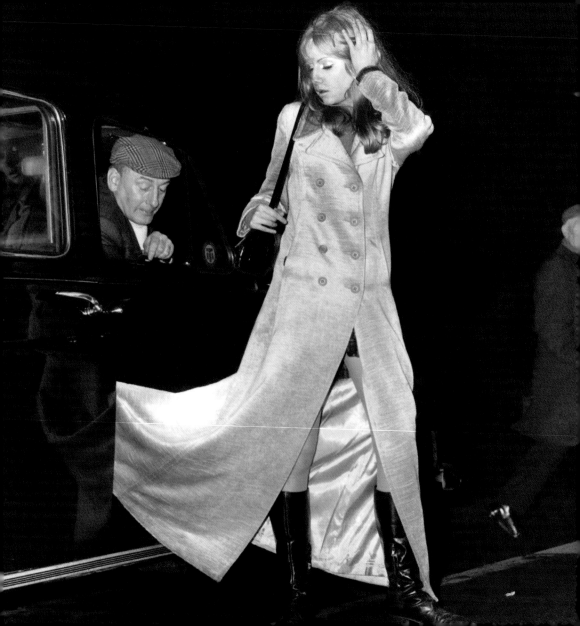

Maxi versatility

Bold, paisley-print, maxi-dress: another of the two-way designs with detachable skirt, a popular trend of the early 1970s.

September, 1970

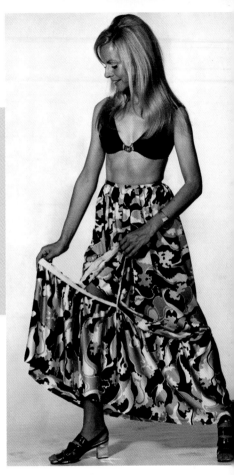

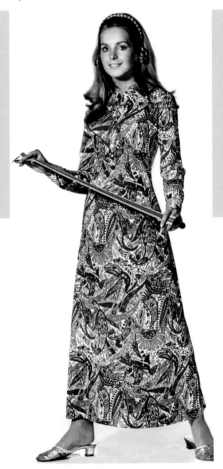

◀ Hazard warning

Who knew a coat could be dangerous? The fashion for maxi-coats revealed many hazards for the incautious wearer, leading The British Safety Council to issue a statement, warning girls to 'Take them up before they trip you up.'

January, 1970

Two-way skirt

A clever design that made the most of this bold-patterned maxi skirt: with a quick tug, the flounce could be removed, leaving the wearer with a versatile, knee-length skirt instead.

July, 1970

Indian influences ▶

Paisley print midi-dress with wide, bell sleeves made from Indian cotton bedspread material, worn with flip-flop sandals.

1970

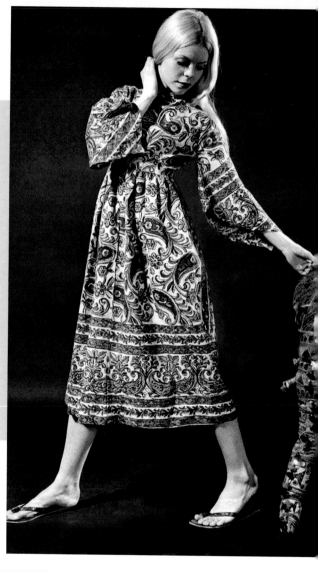

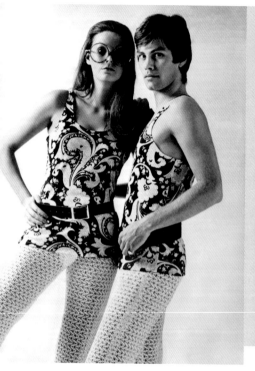

Unisex outfits

Flowery vests worn with low-slung leather belts, over open-knit leggings were possibly a more successful look for her than for him.

January, 1970

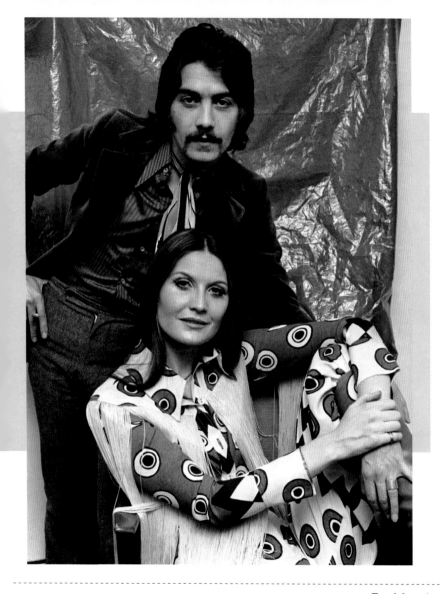

It couple
Fashion designer Jeff Banks and his wife, pop singer Sandie Shaw, formed a glamorous partnership in the 1970s. Jeff sports a velvet jacket, worn with a cravat, while Sandie wears a bright, patterned blouse with long tassel detailing.
January, 1970

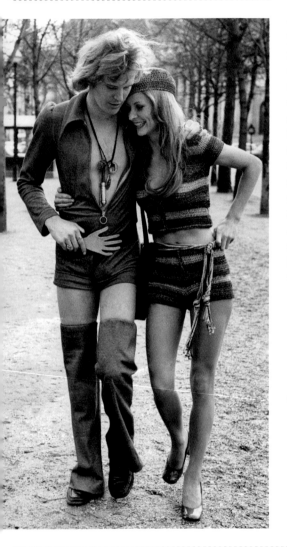

◄ Hands off!

Paris fashions: British model Vicki Hodge wearing a knitted, multi-coloured top with matching shorts and beret, designed by Loris Azzaro; Luthje Reinhard probably still has nightmares about this shorts-jumpsuit combo, with detachable trouser legs, accessorised with a metal belt in the shape of a hand, also designed by Loris Azzaro.

1971

Unisex wedding ►

This unisex wedding took place at Kensington Registry Office in London. The bride and groom both wore identical outfits: blue dungaree suits, white polo neck jumpers, large white hats and furry shoulder bags. The bride is the one on the right, without the beard (allegedly).

August, 1971

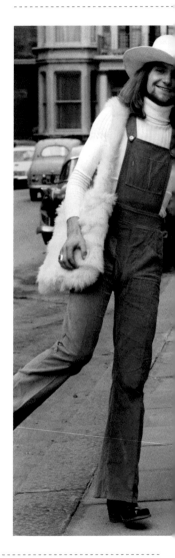

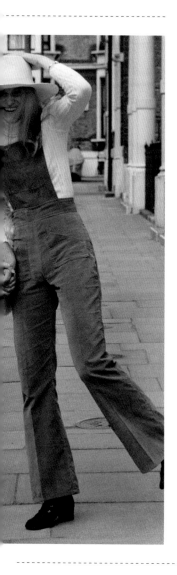

Bowie family outing ▶

Pop star David Bowie with wife Angie and three-week-old son Zowie (in pram). Even Bowie, the master of image reinvention, might prefer to forget this particular look: voluminous Oxford bags, loose Turkish cotton shirt and floppy felt hat.

June, 1971

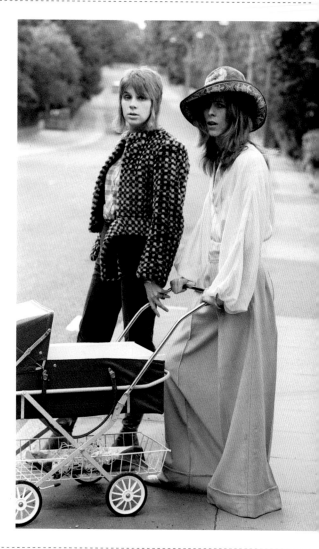

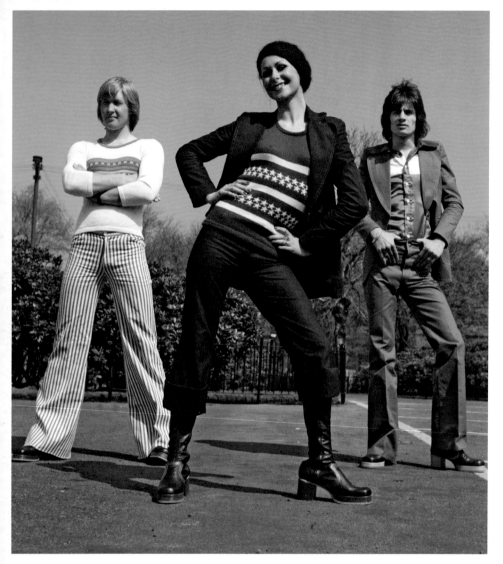

Glasgow ◄ trends
Glasgow leads the way, championing several Seventies fashion trends that many people were hoping to forget, including flared trousers, wide-collared, shiny shirts and two-tone platform shoes.
April, 1972

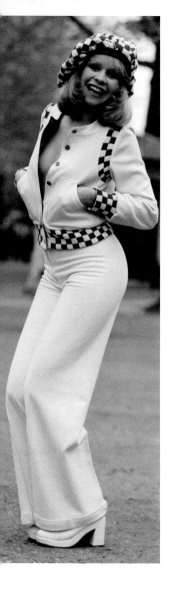

◄ Fashion winner?

Model Jo Howard (who later married Rolling Stone Ronnie Wood), modelling ready-to-wear fashions by Cacharel, at the Autumn Fashion Fair in Paris, France: white Oxford bags and blouson-style jacket with chequered detailing, worn with matching checked floppy hat.

April, 1972

Cool Bianca ►

Bianca Jagger, then wife of Mick Jagger, elegant in a white trouser suit, black blouse and bowler hat, with silver topped cane: even when she was only pictured arriving at an airport, Bianca always gave off an air of cool sophistication.

July, 1972

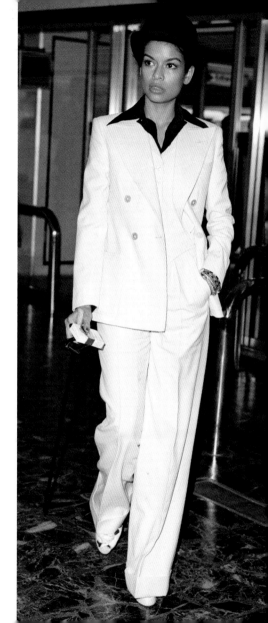

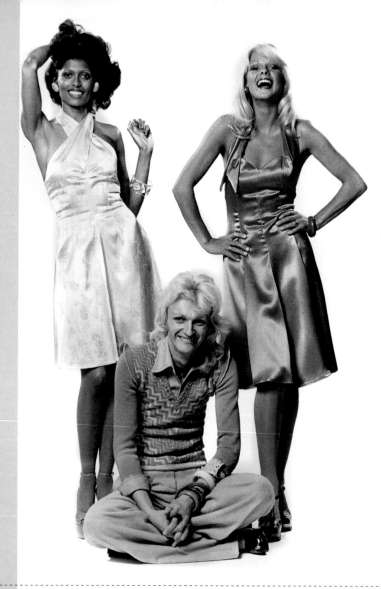

◄ Sexy satin

Designer Brent Sherwood (seated) showing off two of his creations: red satin dress with double halter neckline and flared skirt, a style called 'Marilyn' (R); and pale lilac satin party dress, with a cross-over halter top (L).

October, 1973

Skin-tight satin ►

Turquoise satin, V-neck smock top, teamed with skin-tight, long Bermuda shorts: a slinky look, as long as the wearer didn't try to sit down.

October, 1973

Platform soles ►►

Two examples of metallic, patent leather platform shoes, which were the height of fashion at Royal Ascot in the mid-1970s.

June, 1973

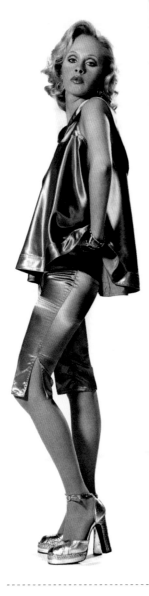

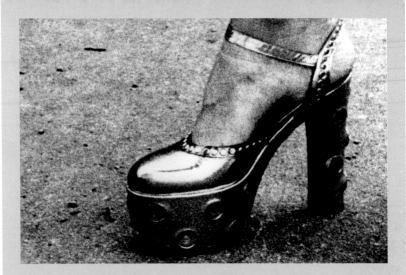

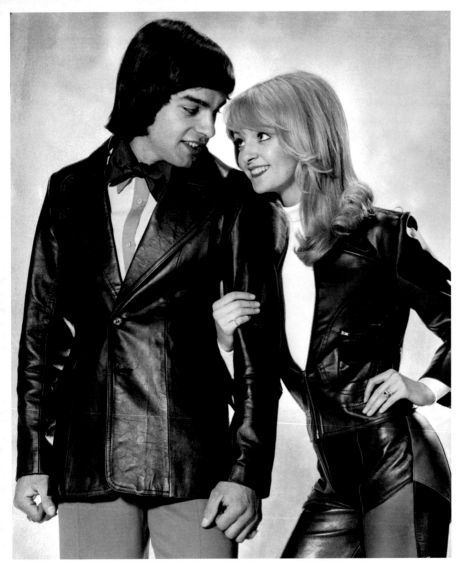

◀ **Sober leather**

Woolworth's leather jacket with wide, rounded lapels, worn with an over-sized bow-tie (L), partnered with two-tone PVC bomber jacket worn with matching trousers (R). Not the coolest styles for the normally sophisticated hide. **1973**

Star man (and woman) ▶

Pop stars David Bowie and Lulu, who worked together when Lulu recorded a version of Bowie's track *The Man Who Sold The World*. Bowie wears leather bomber jacket, knee-length, wide trousers and platform boots; Lulu is in a more understated outfit: check waistcoat, worn over a plain blouse and tweed trousers. **December, 1973**

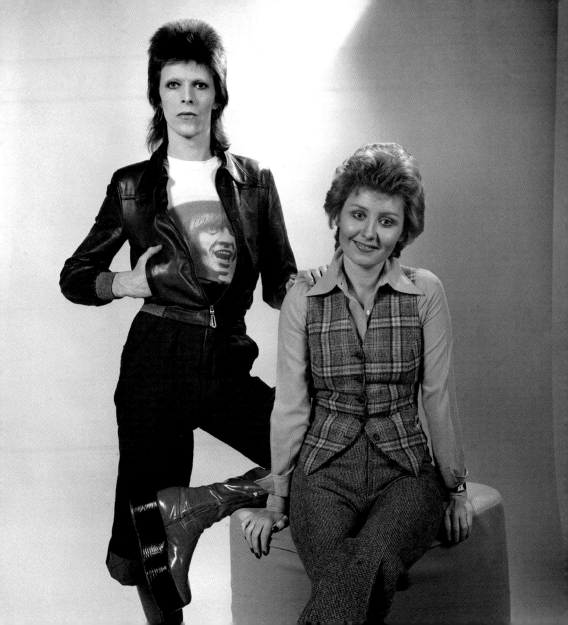

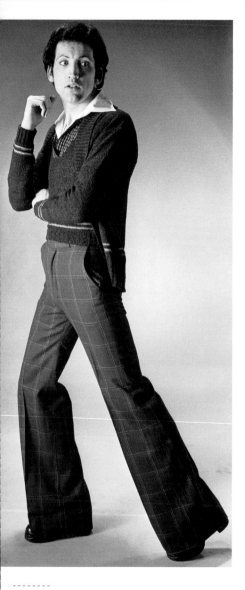

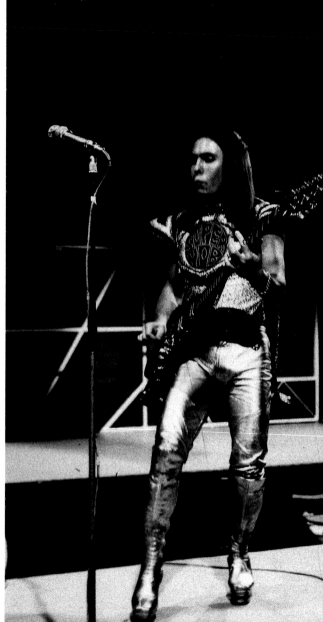

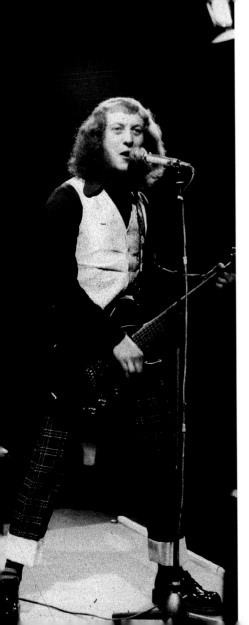

◀◀ Fashion lapse
Knitted cardigan with
matching tank top,
worn over checked
shirt and flared, bold-
check trousers from
a decade of fashion
confusion.
1973

◀ Glam are us
Slade, purveyors of
Glam Rock, rehearse
at the studios of *Top
of the Pops*. Noddy
Holder (R) and Dave
Hill (L) epitomised
the band's style
with an eclectic mix
of glitter, spandex,
tartan trousers,
platform shoes and ill
considered haircuts
– a look so bad it was
almost good.
1973

Mad mix ▶
Slim-fit tweed jacket
over dark trousers,
low cut sweater, white
shirt, platform shoes
and bow-tie – extreme
fashion *faux pas*.
1973

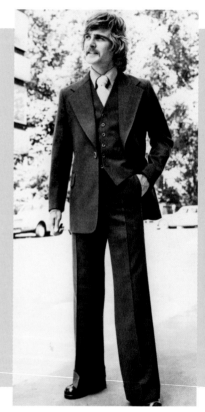

Blue jean baby

Wrangler flared jeans were *the* brand to be seen wearing in the 1970s: what you chose to wear with them, however, was up to you.

September, 1976

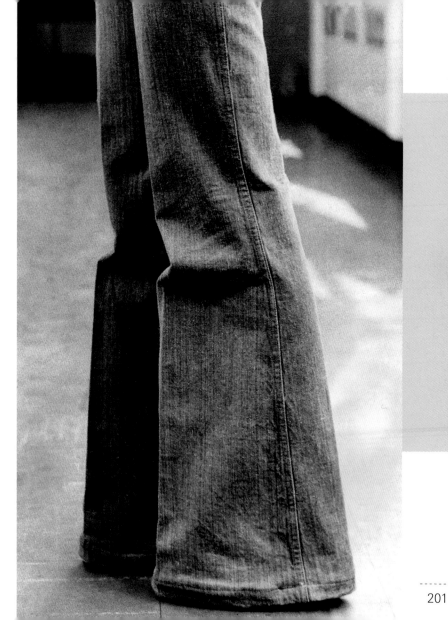

◀ Suits and booted
The new look, three-piece suit, designed by Hardy Amies for Hepworths, sported wide jacket lapels and flared trousers with turn-ups.
1974

Full flares ▶
Wide flared denim jeans – the wider the better – were *the* fashion look of the 1970s.
May, 1974

Jungle jump

A gaudily floral, all-in-one, halterneck jumpsuit, worn with a chain belt.

June, 1974

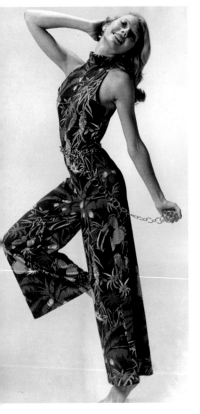

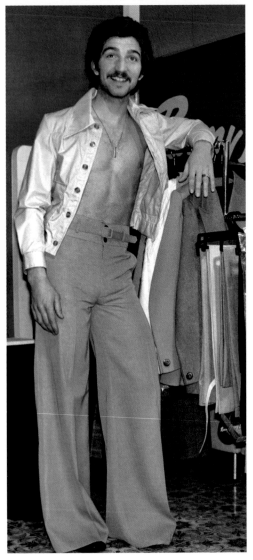

◀ **Fashion own goal**

Graeme Souness, of Middlesborough Football Club, wears macho male fashions – 1970s-style. High-waisted baggies and a cropped, satin bomber jacket, left open to the waist, are worn with a relatively discreet gold medallion.

February, 1975

Vitally Vidal ▶

Hairstyles created by celebrity hairdresser Vidal Sassoon, pictured here admiring his handiwork. L–R: one-eyed wave; flat-top, Afro-style; and bob with fringe.

February, 1975

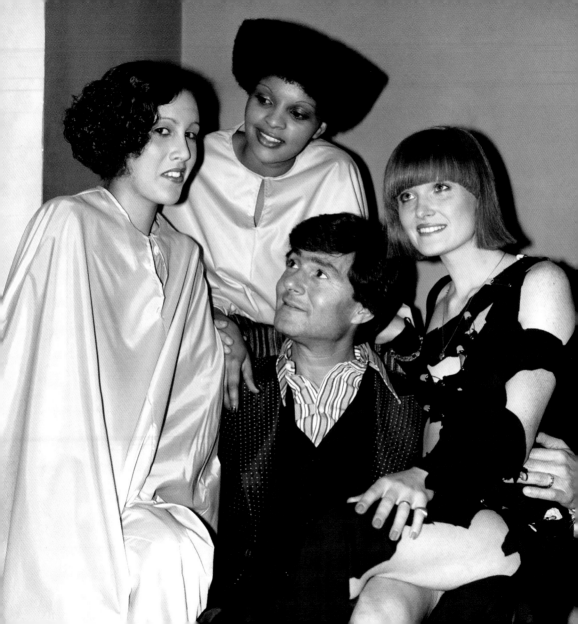

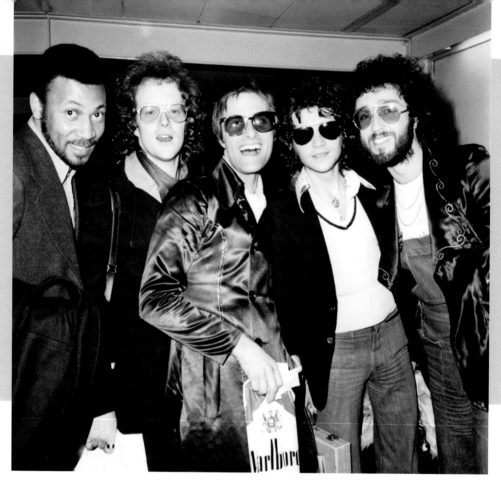

Style rebels

Pop star Steve Harley (C) and his band Cockney Rebel, sporting typical mid-1970s rock star style: satin jackets and shirts, wide lapels, flared jeans and over-sized sunglasses – indoors.

February, 1975

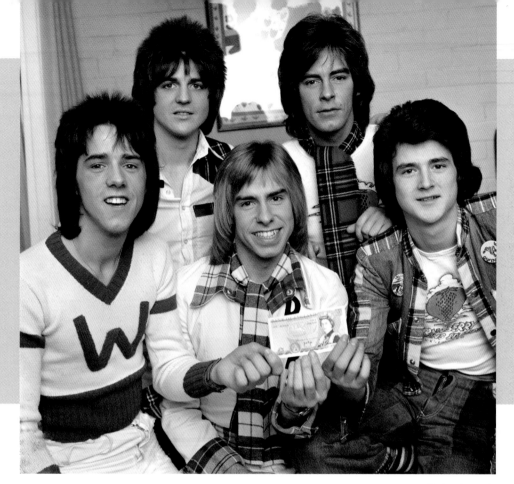

Tartan travesty

The Bay City Rollers, *the* boy-band of the 1970s, who introduced the world to the delights of tartan fashion: short, wide trousers, cropped at the shin, worn with long, striped socks, college jumpers, tartan scarves and feather-cut hairstyles. The look was, sadly, copied by legions of teenage girl fans across the country.

March, 1975

Socks appeal

Seventies sock styles included white nylon stretch socks with clown face motif (right leg) and patriotic Union Jack socks (left leg), both worn with teetering, platform sandals (and nothing else).

March, 1975

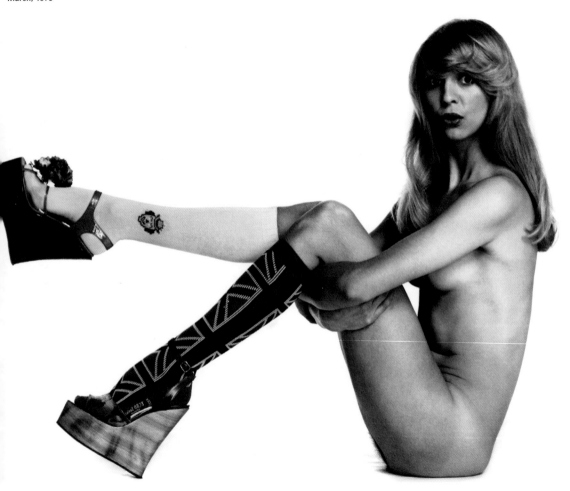

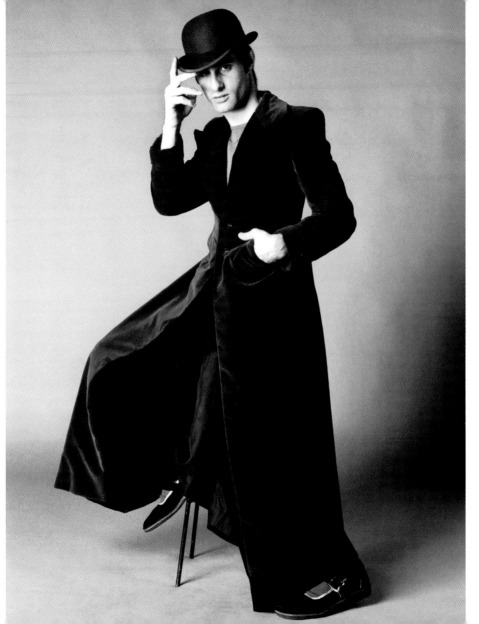

**Come up and
see me**
Steve Harley,
lead singer with
Cockney Rebel,
at the height of
the band's fame
in the mid-1970s,
strikes an artful
pose in a floor-
length, broad
lapelled velvet
coat and smart
bowler hat.
March, 1975

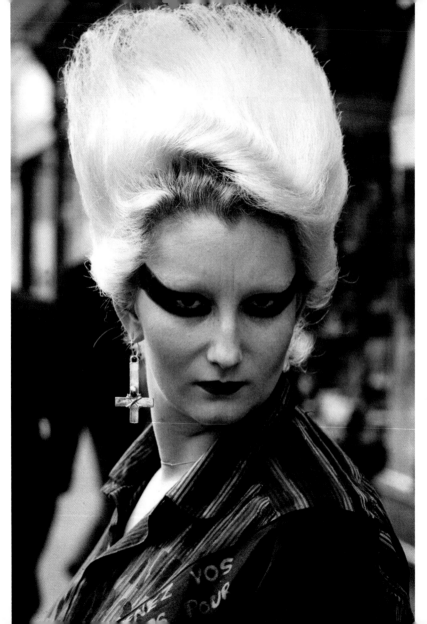

Punk Queen
Pamela Rooke, known as Jordan, the self-appointed 'Queen of Punk Rockers', outside Malcolm McLaren's shop, Sex, on The King's Road, London, where she worked. She wears intimidating black eye make-up, multi-coloured hair and chunky crucifix earring, part of any aspiring punk's wardrobe for both sexes.
December, 1976

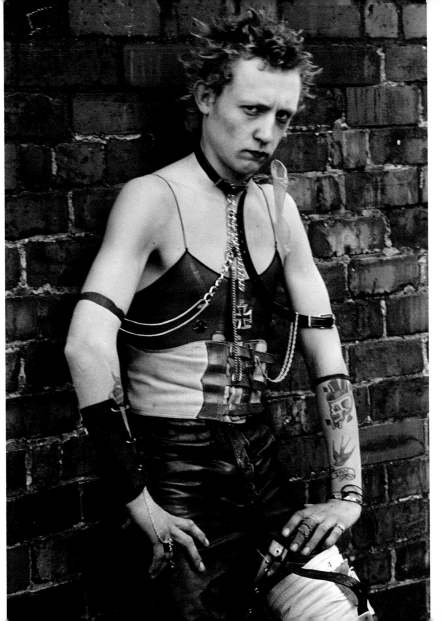

Punk regalia

Accountancy student Ian Hodge, from Woolwich in south London, who gave up studying to follow the punk lifestyle, wears bondage trousers, a gentleman's abdominal support, chains, dog leads, spiked hair – and well-practised, sneer.

June, 1977

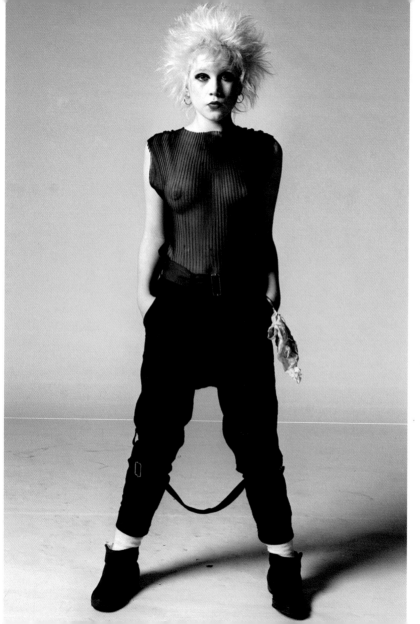

◀ **Punk princess**
Debbie Wilson,
an assistant
in Malcolm
McLaren's shop,
Sex, strikes a
bold punk pose in
spiked blonde hair,
black transparent
mesh top, black
bondage trousers
and ankle boots.
Adopting the
name Debbie
Juvenile, this
princess of punk
was a member
of the 'Bromley
Contingent', a
group of Sex
Pistols fans
who were major
innovators of early
punk fashion.
1977

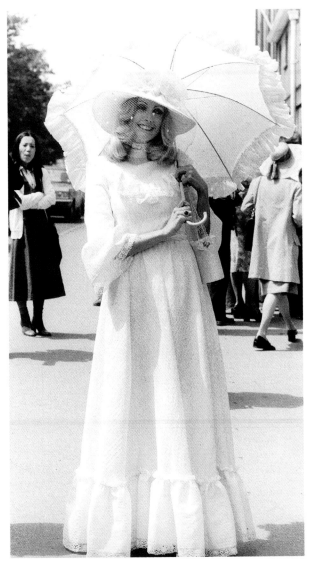

◂ Ascot winner

Ascot fashion in dreamy, soft-focus 1970s-style: a full-length, long-sleeved dress, with flounced hem and lace detailing around the yolk, is teamed with matching wide-brimmed, straw hat with lace veil, and accessorised with a parasol.

1977

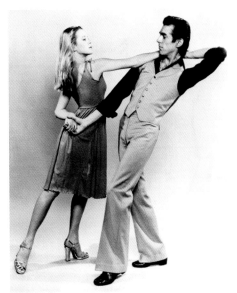

Dance fever

Dancers demonstrate the 'Tango Hustle' dance from the film *Saturday Night Fever*. John Travolta's white, three-piece suit was copied religiously and seen on dance floors around the world, as dancers of all abilities strutted their stuff in an effort to emulate the star's unique moves.

March, 1978

Wide boy

The wider jacket size, emphasising broad shoulders, was a style for both sexes. This jacket has shoulder panels in contrasting material, and is worn with shirt and cravat over matching suit trousers.

c.1980s

City slicker

The latest fashion in shirts for city types everywhere was the striped shirt with plain white collar, worn with striped tie.

c.1980s

1980s

Lotus position

Greed is good: the 1980s saw the rise of the Yuppy,
young smart professionals with money to burn on fashion and fast cars.

c.1980s

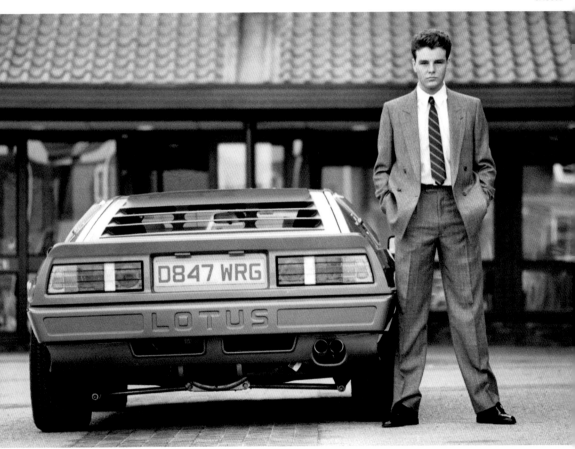

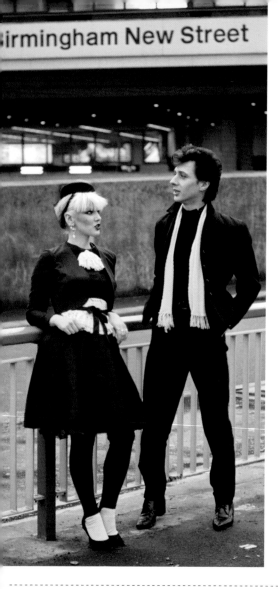

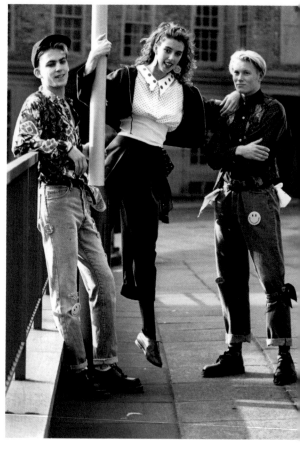

◄ New Romantics

Followers of the New Romantic style pose
in Birmingham: black and white, layered
looks teamed with frills, high heels, hats
and trendy haircuts.

March, 1981

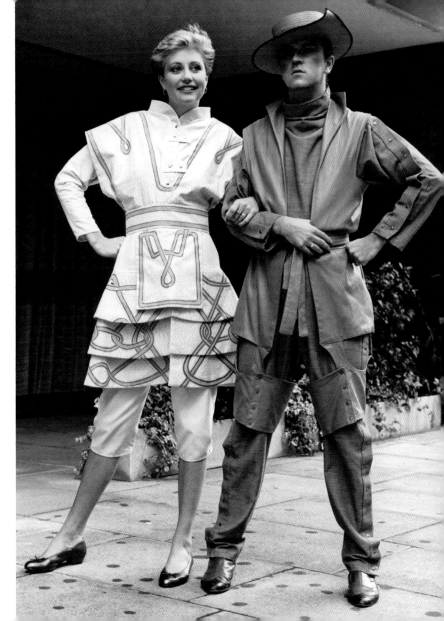

◄ Teenage kicks

For teenage boys, this was one of the trends of the period: ripped jeans and Doctor Marten boots, teamed with button-down shirts and caps.

c.1980s

Strange impresario ▶

Nightclub impresario and singer Steve Strange strikes a pose with model Gail Lawson, at the Club for Heroes in Baker Street, London. Strange, whose trend-setting, nightclub followers became known as the Blitz Kids, was showing a selection of clothes by Axiom: he wears leather jacket and trousers with button detailing and a musketeer-style hat; she wears an embroidered, layered dress with bold rope design, worn over cropped trousers.

September, 1981

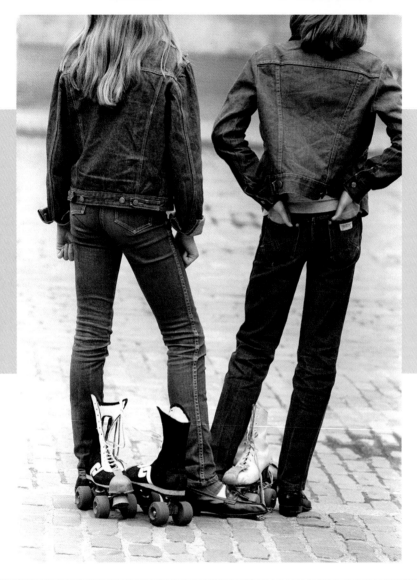

Durable denim

Denim fashion had become universal and timeless by the 1980s. These skinny jeans and denim jackets would still be fashionable three decades later.

April, 1981

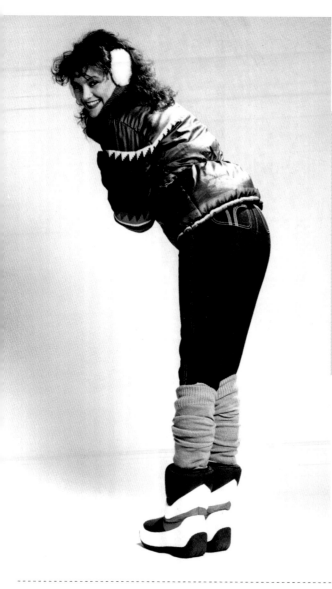

Some fashions, however, were doomed not to last: whatever happened to quilted jackets, moon boots, leg warmers and earmuffs?

January, 1982

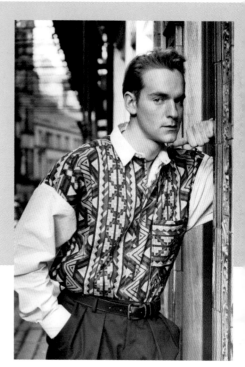

Geometric details

Casual men's shirt in a bold, geometric pattern, with plain white collar and sleeves.

c.1980s

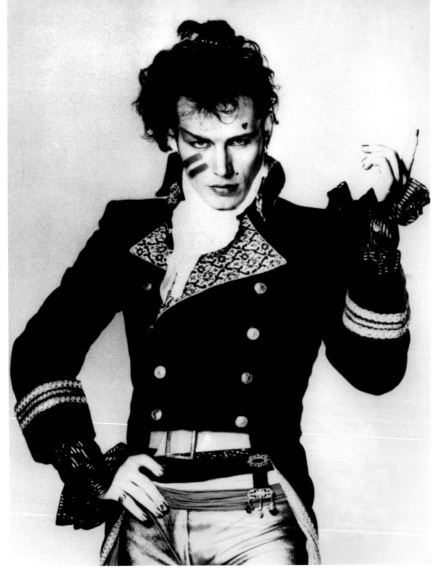

Dandy

◀ highwayman

Pop star Adam Ant, lead singer of Adam and the Ants, at the height of the band's fame. His dandy style of embroidered tunics, leather boots, lace and war paint make-up cut a dash on the early 1980s pop scene.

November, 1981

Cultured Boy

Boy George, lead singer with the band Culture Club, another famously iconic, and tortured, early-1980s pop idol.
His androgynous looks, flamboyant style and outspoken views made him perfect fodder for the tabloid press.

September, 1982

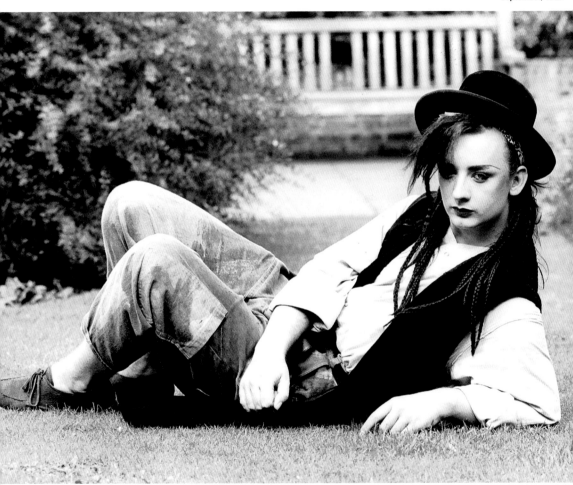

Ballet slippers

Spandau Ballet spearheaded the New Romantic movement, and created some dubious fashion styles along the way, such as baggy trousers and jodhpurs, worn with white socks and slippers.

1982

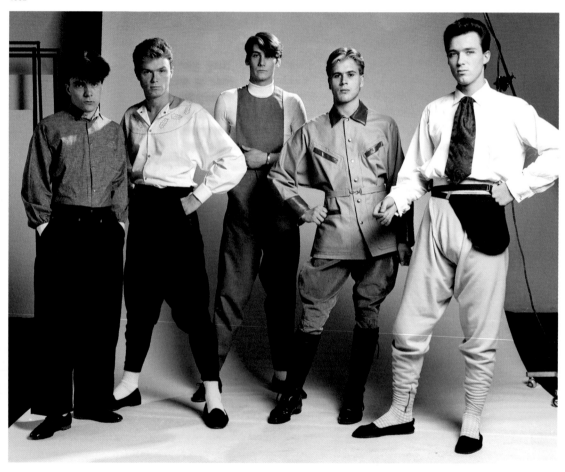

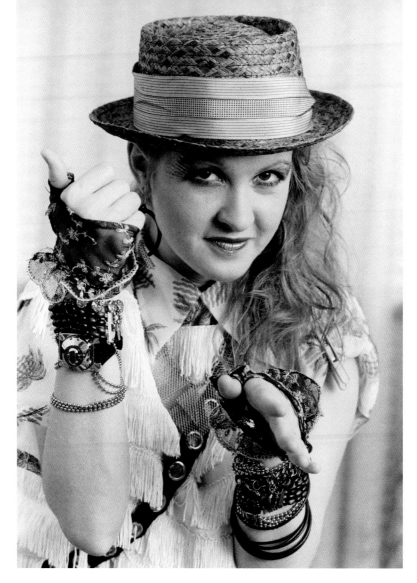

Shabby chic

American singer/
songwriter
Cyndi Lauper
gave Madonna
a run for her
money in the
eclectic fashion
stakes: lace,
frills, chains,
hats, fingerless
gloves, she wore
it all – usually all
at the same time.
May, 1984

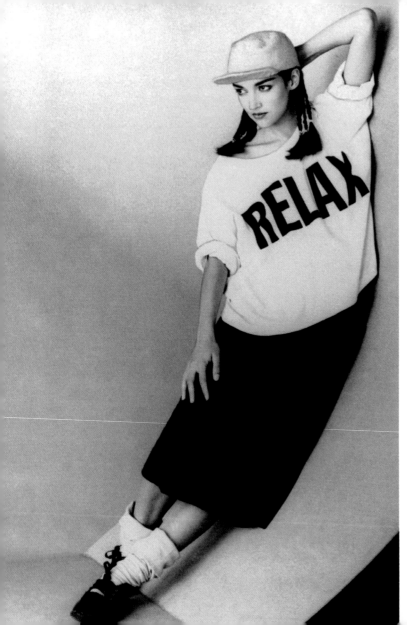

◀ Frankie says... relax

The influence of British band Frankie Goes To Hollywood, and ZTT the record company behind it, was everywhere in the summer of 1984. The single *Relax* had controversially been banned from airplay on Radio One in Britain and, consequently, went on to sell millions of copies worldwide. The publicity generated by the band's success spawned an entire fashion look into the bargain, with T-shirts and sweatshirts proclaiming various slogans appearing in high street shops everywhere. This 'Relax' T-shirt is worn with black ribbed skirt, lace-up plimsolls, sloppy socks and a baseball cap.

July, 1984

Chain reaction ▶

Chains, once the preferred punk style accessory, were given a new lease of life by jewellery firm Corocraft, as a must-have fashion item. The range of chains started with lightweight bracelets and went right up to chains both long enough, and heavy enough, to walk the dog.

June, 1983

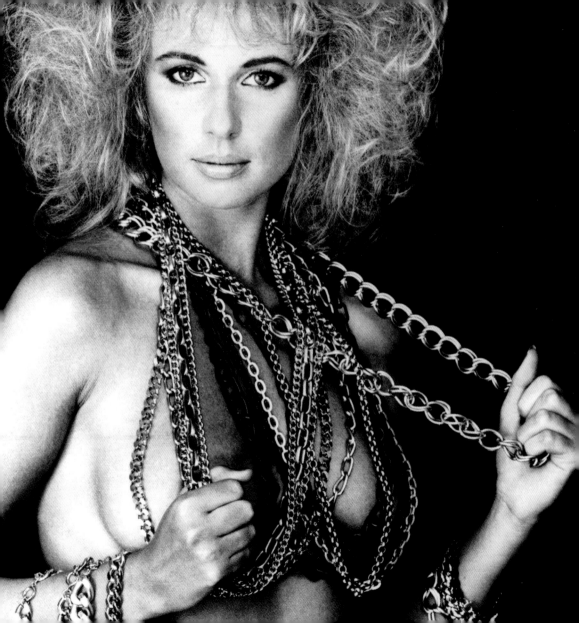

Inside out
Underwear worn as outerwear:
Shiny, black bra worn with
unbuttoned shirt and jeans.
May, 1985

I'm a tiger
The 1980s saw a leap in
lingerie sales, bought mostly
by women for themselves, as
an additional fashion accessory:
this tiger-print body stocking is
worn with matching headscarf
and chunky bead necklace.
May, 1984

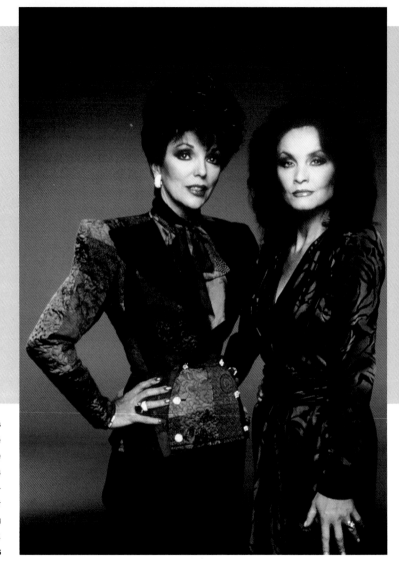

Dynasty dames

Actresses Joan Collins (L) and Kate
O'Mara, who starred together in the
1980s American television series
Dynasty, epitomised the 1980s power-
dressing style for women: shoulder
pads, fitted waists, slim skirts, teetering
heels and perfectly coiffed hair.

June, 1986

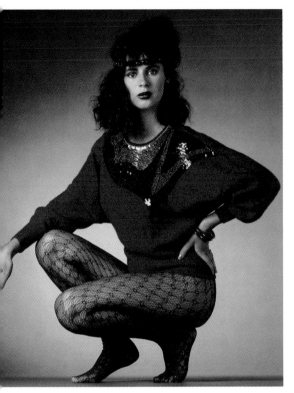

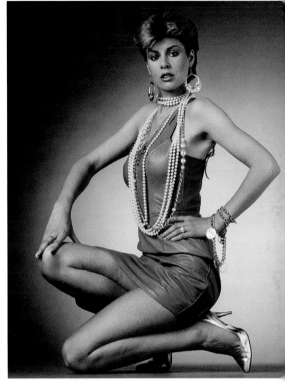

Red alert

Decorative knitwear: red batwing sweater with sequin detail, worn with red lacy tights and beaded headband. Nobody has yet mentioned to the model that she appears to have left home without her skirt.

September, 1986

Putting on the glitz

Turquoise leather mini-dress, worn with layers of pearl necklaces, chains and bracelets: it was hard to slip in through the front door at 3.00am wearing this ensemble, without rattling so loudly you woke the entire household.

1986

Miami roll-up

The American cop show *Miami Vice* was, single-handedly, responsible for the male fashion of jackets being worn with the sleeves rolled up: grey striped jacket, worn with striped shirt and silver lizard brooch.

November, 1986

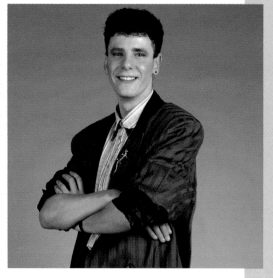

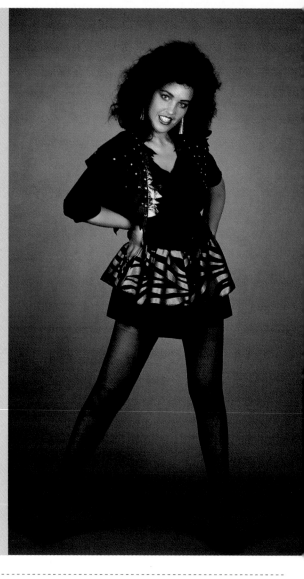

Black and gold ▶

Black and gold ra-ra skirt mini-dress, worn with black waistcoat with gold detailing.

November, 1987

Exotic exercise-wear ▶▶

Exercise-wear such as this leopard-print leotard could be unforgiving unless you had the body to go with it – thongs were definitely *not* for everyone.

January, 1987

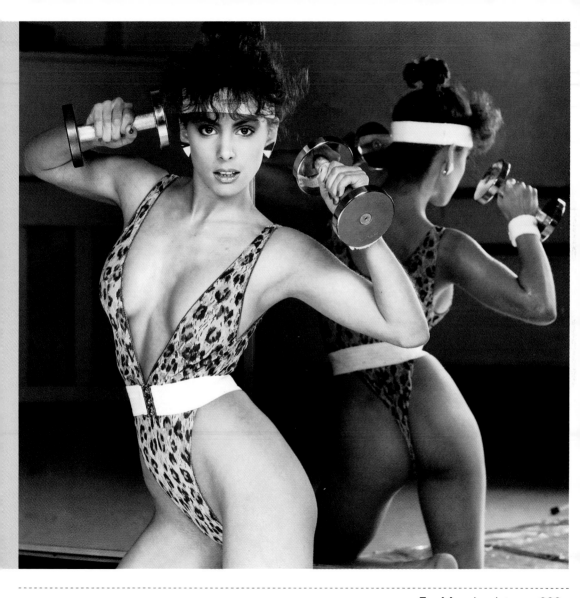

Ra-ra razzmataz

The short, flouncy ra-ra skirt, based on the cheerleader's outfit, was favoured by teenage girls. The answer to the perennial question: 'Does my bum look big in this?' was, inevitably: 'Yes!'

March, 1987

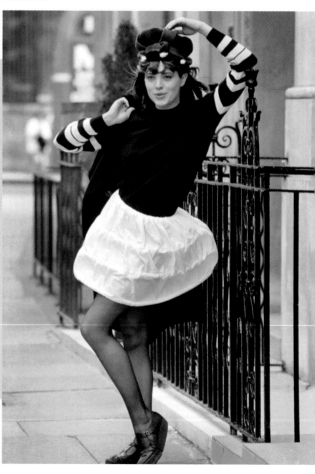

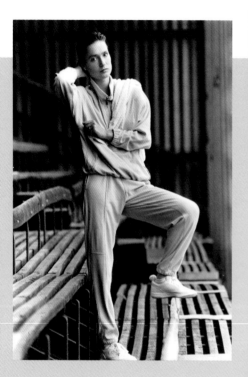

The rise of sportswear

The 1980s saw the tracksuit start to take over as *the* leisurewear garment to be seen in – everywhere, whether in training or not.

c.1980s

Lycra was *the* fabric of the decade – stretchy,
figure-hugging and versatile, it transformed the fashion
scene and suddenly everything, from exercise-wear
to evening-wear, seemed to be made of it, including
this pink lycra mini-dress worn with stilettos.

November, 1987

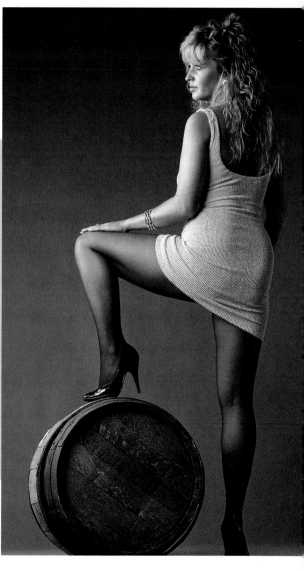

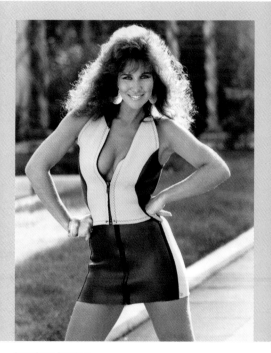

Luscious leather

Zipped leather mini-dresses were not for the faint-
hearted, but 1980s glamour model Linda Lusardi
managed to pull it off with panache.

February, 1988

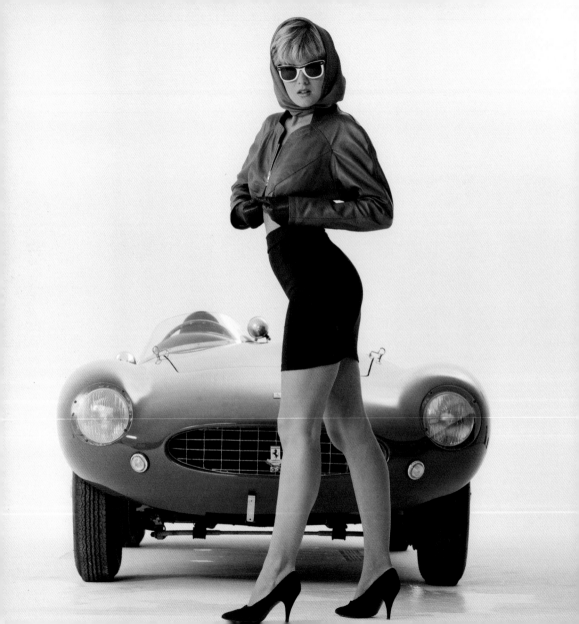

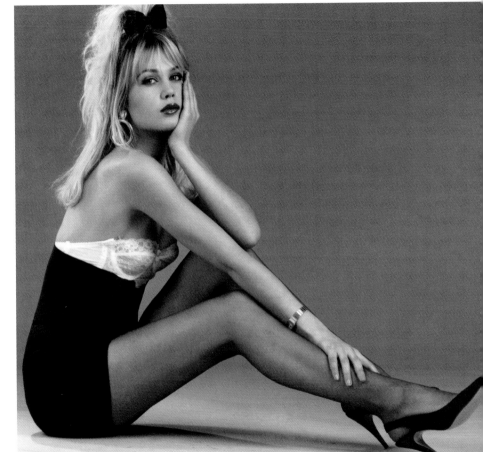

◄ Go for a spin
Cropped leather
jacket, worn with
Lycra mini-skirt
and stilettos,
accessorised
with a headscarf,
leather gloves
and sunglasses:
the perfect outfit
for taking a spin
in the Ferrari.
April, 1988

Celebrity influences
The basque, as popularised by pop star Madonna, found its way into high street fashion:
teamed here with a short skirt, high heels and big hair.
February, 1988

Fashion *in pictures* 233

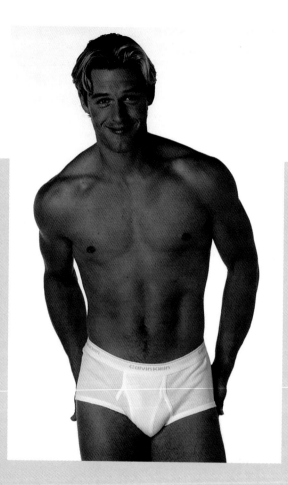

Dressing down for the 1990s

Exclusive fashion label Calvin Klein carved out an extremely lucrative market for itself in the 1990s, selling designer underwear to fashion-conscious males of all ages.

c.1990s

1990s

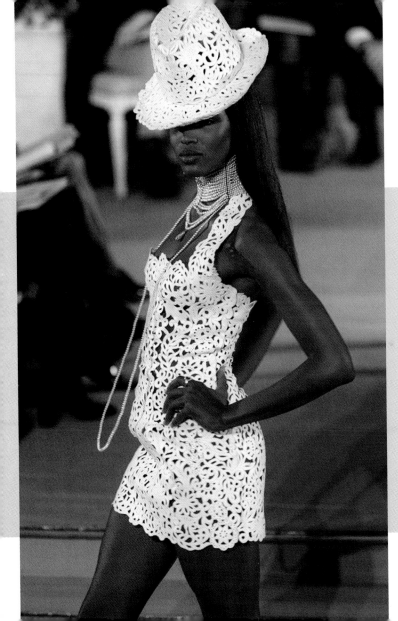

Fashion with attitude

Notoriously difficult British supermodel
Naomi Campbell, models for Christian
Dior: lace mini-dress with matching
hat, designed by the *enfant terrible* of
fashion, designer John Galliano.
1997

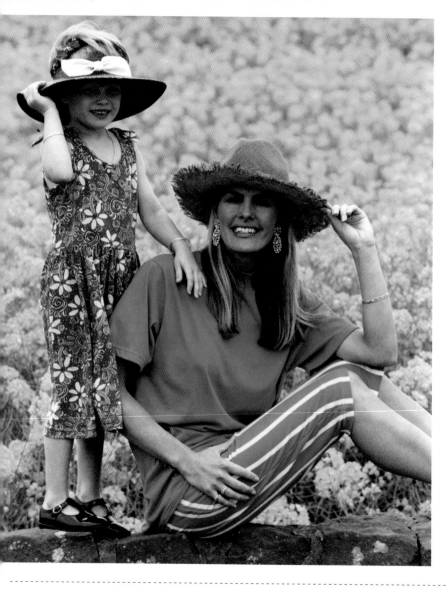

Floral plus

Designer Laura Ashley, famous for her pretty floral-print dresses, branched out into producing a wide range of styles for women and girls: traditional pink floral dress with matching hat (L); plain blue T-shirt, teamed with blue and white striped knee-length shorts and large, blue, fringed straw hat (R).

c.1990s

Walking the dog

Layered casual wear: jeans worn with patterned, cosy jackets, floppy hats and fabric shoulder bags – perfect for a stroll in the park on an autumn day.

c.1990s

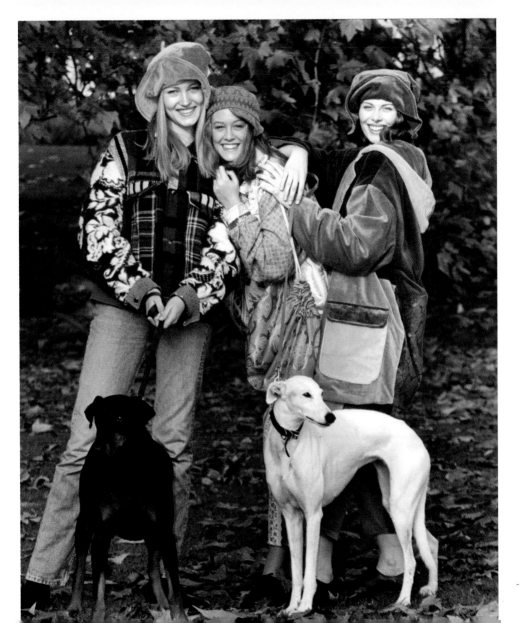

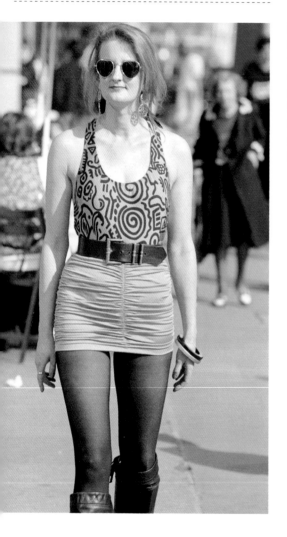

Street life

Striking street fashion for the 1990s. Gold mini-skirt worn with a wide, leather belt, black and gold patterned leotard, black tights and knee-high boots, accessorised with matching bangles, big earrings and sunglasses.

March, 1991

Mad for it

The thriving music scene in 1990s Manchester spawned its own particular brand of fashion: the slogan on this T-shirt summing up the self-assured (some might say cocky) attitude of some of the city's youth.

January, 1990

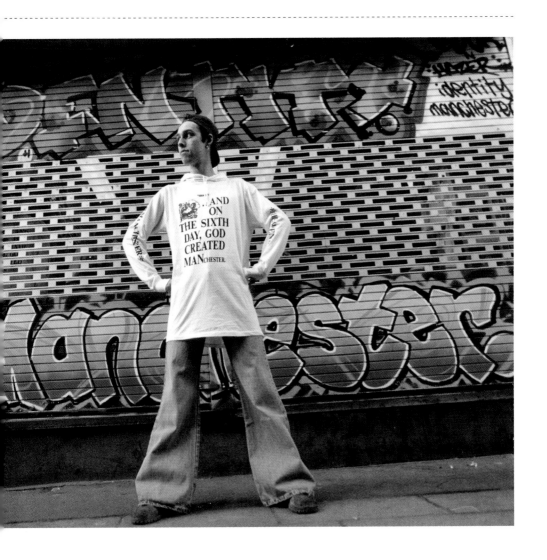

Pester power

The rise in popularity of sportswear, such as these lines by Kappa, but produced by all the major sports manufacturers, lead to a greater demand, particularly among teenagers, for expensive named brands of clothing and trainers – much to the despair of many, less well off, parents.

c.1990s

Dancing in the street
Sleeveless, figure-hugging mini-dresses, worn underneath spring coats and teamed with stilettos, shown off on the streets of London.
March, 1991

Citrus appeal
Bold, chunky jumpers in zesty, citrus colours, worn over equally bright leggings.
March, 1991

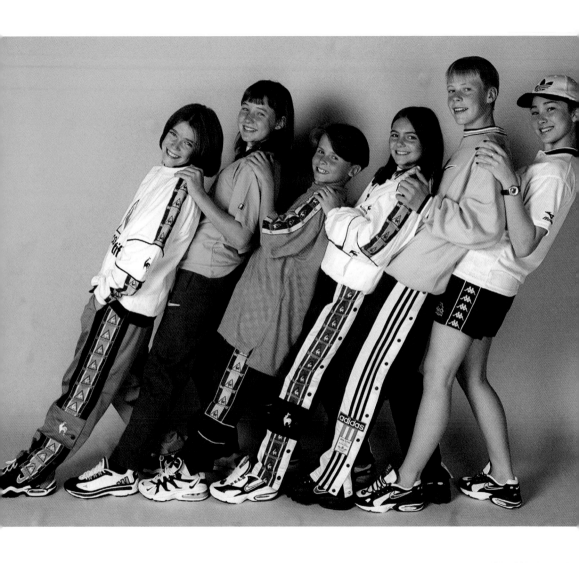

One of a kind

Zandra Rhodes, veteran fashion designer, whose career began in the late 1960s, still going strong and creating her own, unique style, in the 1990s.

March, 1991

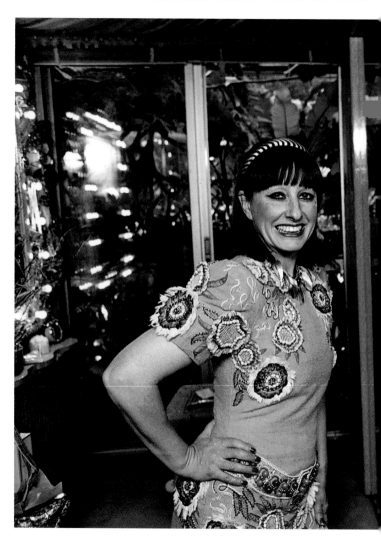

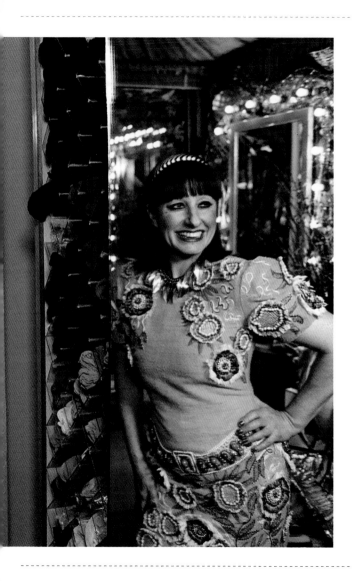

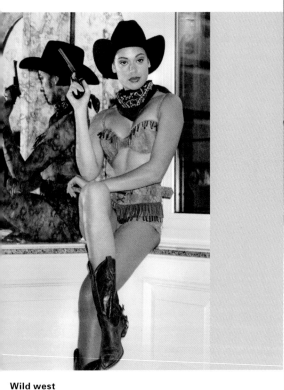

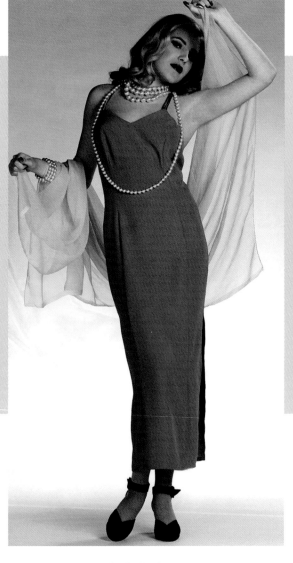

Wild west

Home on the range: suede,

fringed bikini worn with cowboy boots,

hat and neckerchief (pistol optional).

September, 1992

Film star glamour
Veronica Lake style:
split gold evening
dress, teamed with
a pale chiffon scarf,
strings of pearls and
black, strappy shoes.
November, 1993

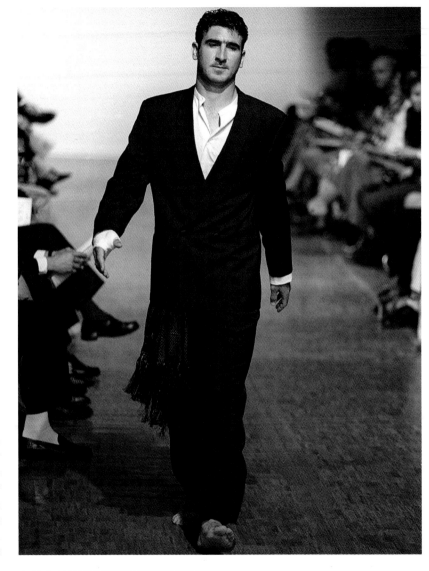

Ooh Ah Cantona
Legendary footballer
Eric Cantona, turns
model and shows off
some fancy footwork on
the catwalk, modelling
suits for Paco Rabanne.
1993

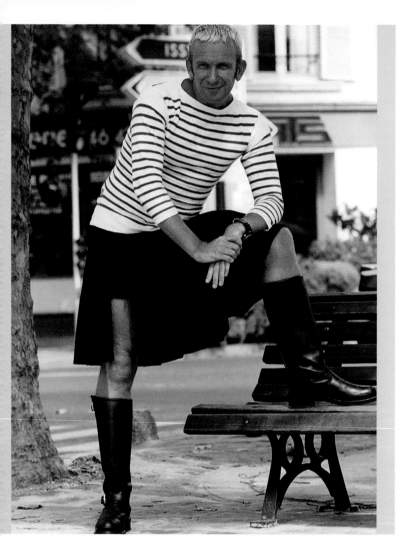

Man-skirts

Jean Paul Gaultier, fashion designer turned television presenter, wearing one of his own creations: a plain black kilt, worn with a Breton-style, striped T-shirt and black boots. Gaultier single-handedly championed the idea of skirts for men through the 1990s, but appeared to be in a minority of one when it came to men taking up the idea.

September, 1993

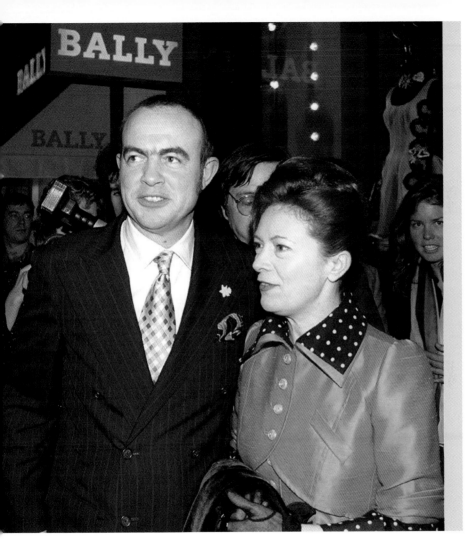

Christian Lacroix
Haute Couture designer Christian Lacroix, whose clothes are still eagerly snapped up by wealthy women worldwide, pictured with his wife at the opening of his new shop, located in New Oxford Street, London.
April, 1995

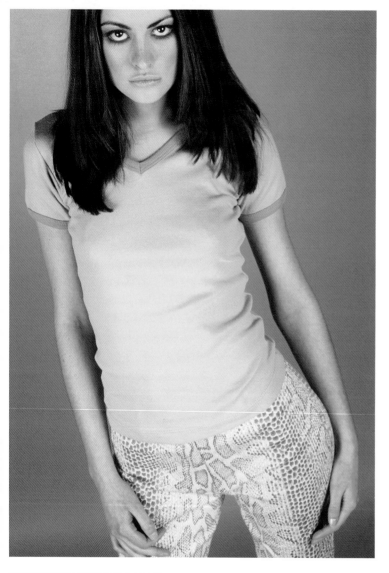

Second skin

Casual summer fashion. Green T-shirt with blue trim, worn over snakeskin pattern leggings.

February, 1996

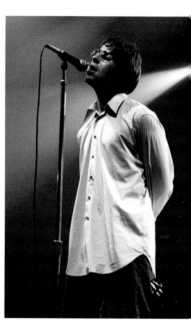

Oasis of calm

Liam Gallagher, lead singer of Brit Pop band Oasis, and a notoriously truculent, controversial figure, here in relatively calm mood, performing at a concert in the mid-1990s, wearing his signature style: loose, casual shirt worn over jeans.

January, 1996

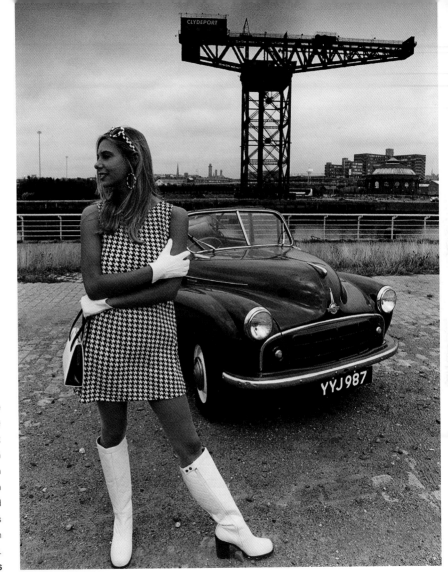

Sixties retrospective

An affectionate nod to the Swinging Sixties: black and white, dog-tooth check, mini-dress, worn with white, knee-length boots, gloves and handbag; the Morris Minor Tourer adds an authentic touch.

October, 1996

Alexander McQueen

British designer Lee
Alexander McQueen,
who had just been
appointed to the French
couture house Givenchy,
attending the opening of
the new Valentino store
in Knightsbridge, London.
McQueen, regarded by
many fashion experts as a
design genius was, sadly,
also a tortured individual
and his brilliant career
was cut tragically short
by his premature death
in 2010.

October, 1996

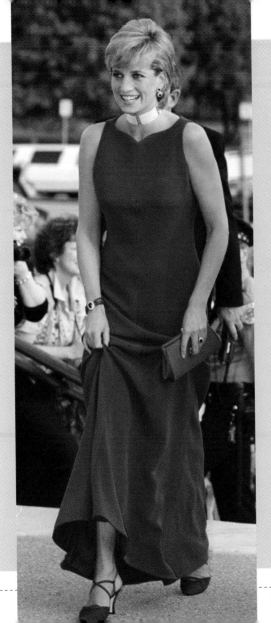

Fashion ambassador

Princess Diana, who
became a walking
ambassador for British
fashion, arriving at a gala
dinner at the Chicago
History Museum, wearing
a long purple evening
dress, teamed with
matching shoes and
clutch bag.

June, 1996

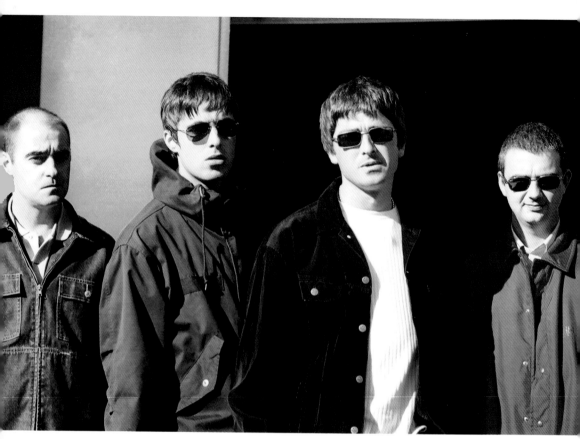

Brit Pop style

Brit Pop style as displayed by its main exponents, the band Oasis, fronted by the famously feuding brothers, Liam (second L) and Noel Gallagher (second R), whose love of parka anoraks spawned an entire fashion trend among the band's followers.

September, 1997

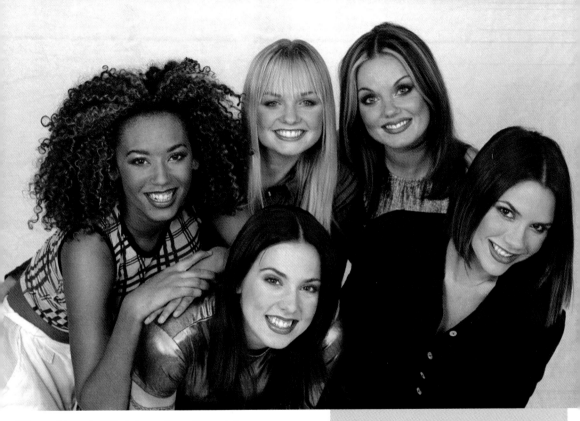

What a girl wants (What she really *really* wants)

British all-girl, pop group The Spice Girls pose for an early group
photograph, still fresh-faced and casual: a breath of fresh air in the
pop charts of the mid-1990s. Back, L–R: Mel B (Scary Spice), Emma
Bunton (Baby Spice), Geri Halliwell (Ginger Spice); Front, L–R:
Melanie Chisholm (Sporty Spice) and Victoria Adams (Posh Spice).

October, 1996

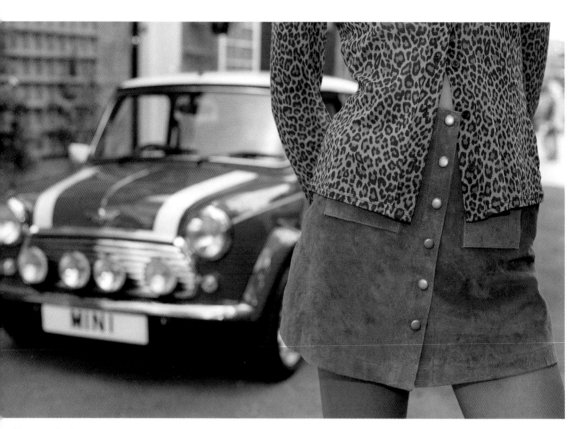

Retro revival

A Sixties-style, brushed denim, mini-skirt with brass buttons, worn with sheer, blue, animal-print blouse reflected the revival of the mini in the late 1990s.

August, 1997

White wedges

Harking back to the 1970s: summer
sandals in two styles of white leather, with
wedge heels. The multi-coloured, painted
toenails complete the fashionable foot look.

May, 1997

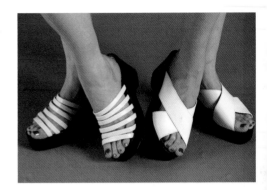

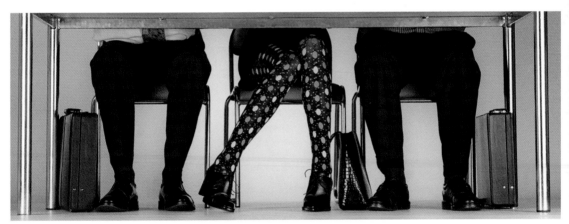

Showy legs

Colourful, bold patterned tights could give even the simplest outfit a lift, as revealed by these sheer brown tights with
multi-coloured spot pattern.

October, 1997

Bruce Oldfield

British designer Bruce Oldfield, who famously started life in a children's home and worked his way up to become a top fashion designer, at a charity fashion lunch at the Dorchester Hotel in London.

October, 1997

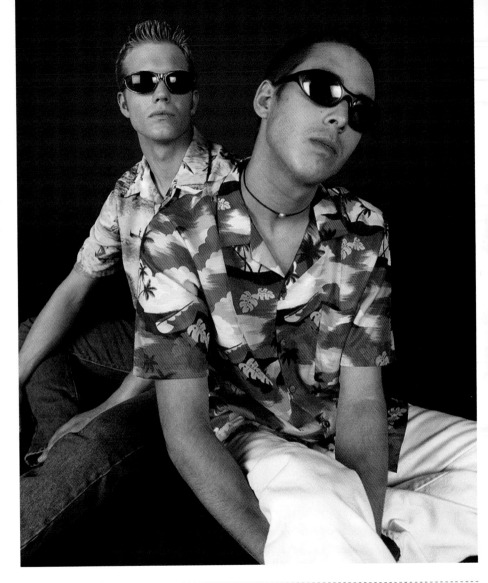

Surf's up

Loud and proud: Hawaiian-style, bold patterned men's shirts, invariably teamed with cool shades, made something of a bold statement about the wearer's lifestyle aspirations.

June, 1997

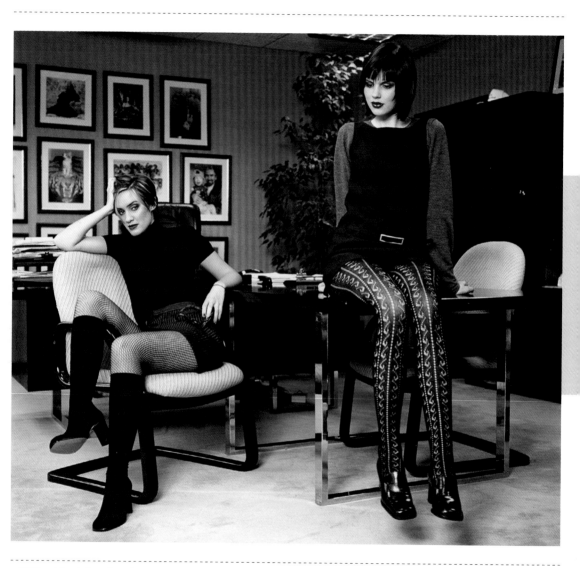

Textured tights

Boardroom style? Fishnet
tights (L) worn with mini-
skirt and knee-length boots;
textured black tights (R) with
a swirls and stripes pattern.

October, 1997

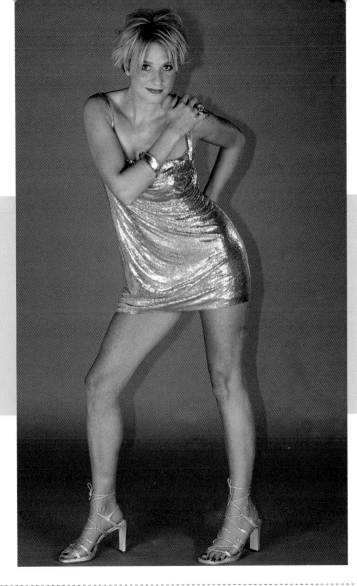

Foiled again

The baby-doll style silver
mini-dress, worn with strappy,
silver sandals was a hard look
to carry off, without looking
like an oven-ready turkey.

November, 1997

Girl Power

Less than two years after their first appearance, The Spice Girls had became *the* 1990s pop phenomenon, by appealing to young girls everywhere with their relentless message of 'Girl Power' which, roughly translated, meant being independent, feisty and in charge of your own destiny. The band's style had also evolved into a strong, yet still appealing, mixture of sophisticated and sexy: chic suits and dresses, accessorised with sexy lingerie – girls cheered, boys just looked scared…

April, 1998

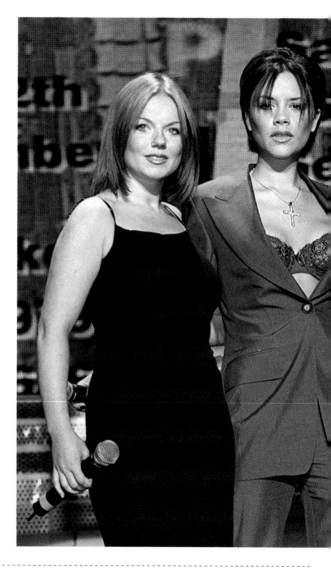

Fashion *in pictures*

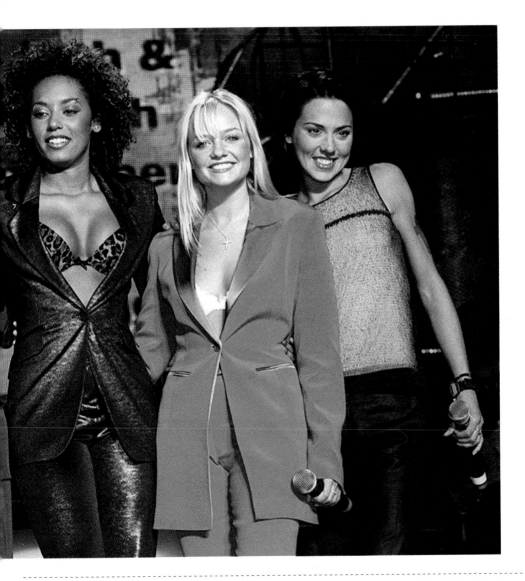

Grande Dame

Vivienne Westwood, the Grande Dame of British fashion, arriving at the Victoria and Albert Museum in London, to attend the opening of an exhibition paying tribute to her fashion designs, wearing, as you would expect, one of her own designs: a cream, flounced satin evening dress with full skirt.

November, 1998

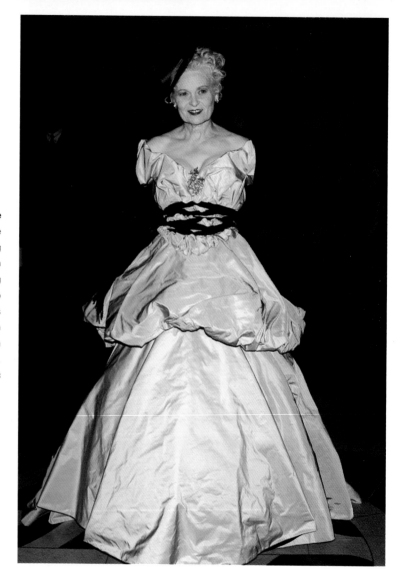

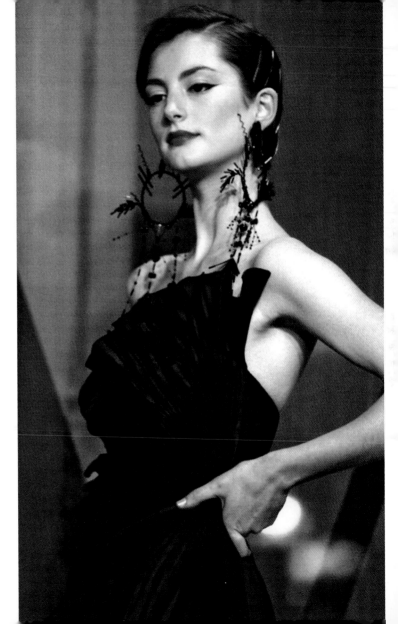

Valentino collection

A Valentino creation on
the catwalk at Paris Fashion Week:
black strapless evening dress
with pleated, fan-shaped bodice.

1998

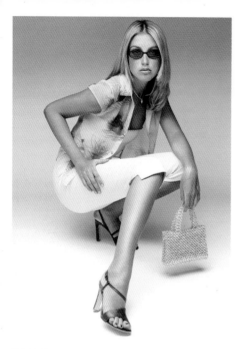

Ice cool

Late 1990s fashion majored on fun, casual styles, such as these white Capri pants worn with pale blue, patterned blouse over matching,pale blue strapless top and strappy sandals.

May, 1998

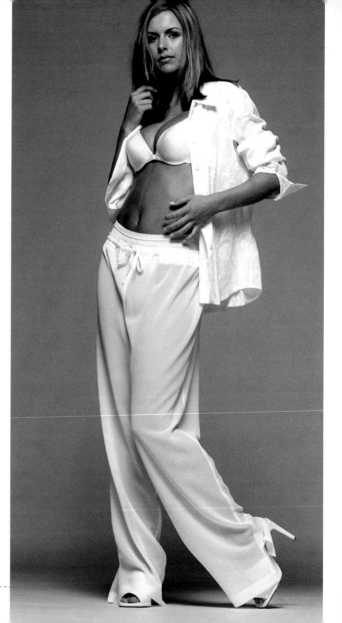

Sheer bliss

Loose, comfortable styles were *de rigueur* in the late 1900s: wide, diaphanous white trousers, partnered with a silky white shirt and yellow bra.

July, 1998

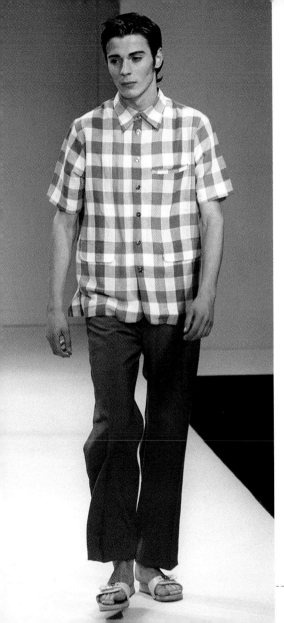

Country casual

A catwalk show during London Fashion Week for the Designworks label, showed the latest styles in menswear, including this gingham-style short-sleeved shirt worn over cropped brown trousers.

1998

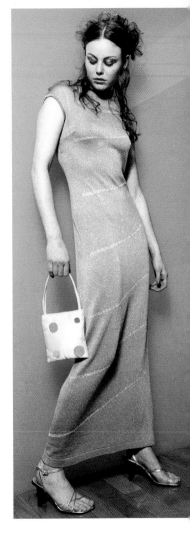

Spots and stripes

Simple, floor-length, peppermint green dress with diagonal white stripes, worn with gold sandals and spotted handbag.

December, 1999

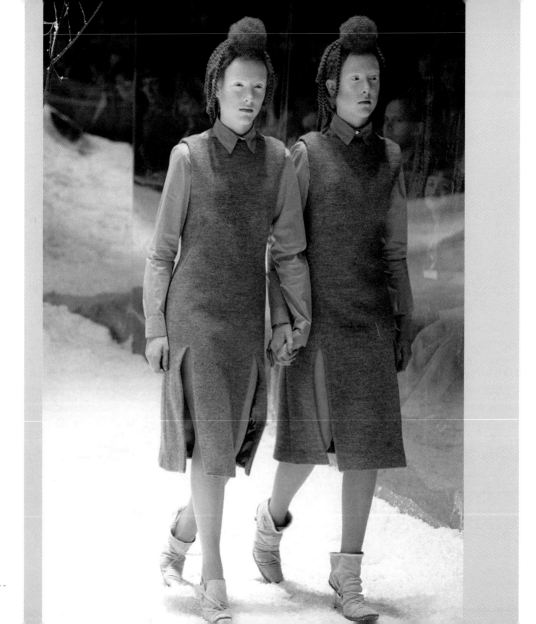

Sassy supermodel

Kate Moss, the hugely successful supermodel and bad girl of British fashion. Clever and controversial, with a taste for 'challenging' boyfriends, she's seen here at Paris Fashion Week, modelling a white, Chanel sequined dress with plunging neckline.

1999

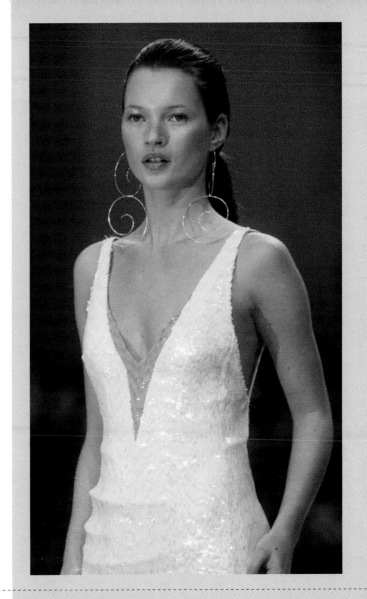

Twin set

Plain and simple taupe jersey shift dresses by Alexander McQueen, on the catwalk at a fashion show to exhibit the innovative designer's latest collection.

1999

Fresh as a daisy

The natural look was promoted at the end of the 20th century: a simple lemon-yellow summer skirt and white camisole top. Natural, understated make-up in pale, pastel shades emphasised the innocent, fresh-faced image. **July, 1999**

Trendy trainers

The fashion for training shoes, comfortable footwear that could be worn by everyone, lead to an explosion of choice on the High Street, as every major fashion chain produced its own lines of trainers, in an effort to undercut the competition.

January, 1998

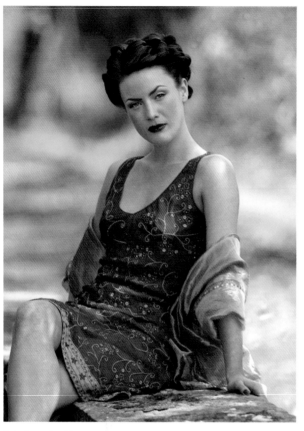

Ethnic embroidery

An ethnic-style red dress, embroidered in a floral pattern,
worn with a matching shawl, slung around the shoulders.

May, 2000

2000s

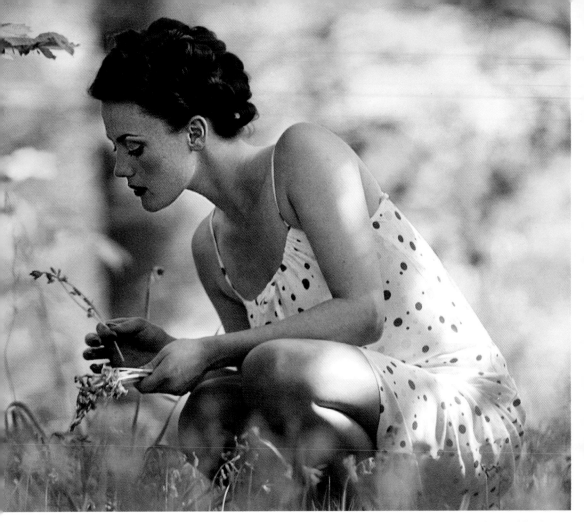

Dressed for the sun

A fresh look for a new millennium. A simple white sundress, with multi-coloured
spot pattern, perfect for a stroll in the bluebell wood.

May, 2000

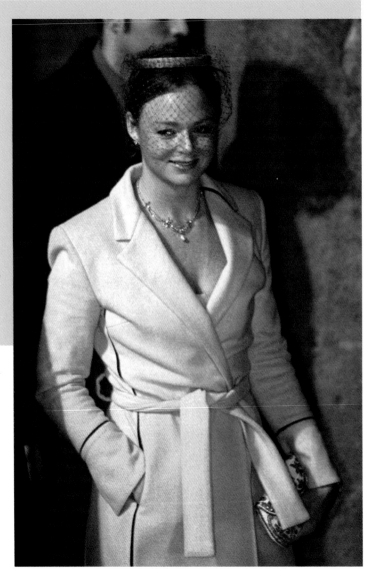

A chip off the old block

Stella McCartney stepped out of the shadow of her famous father, Sir Paul McCartney, to become a hugely successful fashion designer in her own right: seen here at the christening of Rocco Ritchie, son of Madonna and Guy Ritchie.

December, 2000

Posh and Becks – the brand

The ultimate celebrity couple of the 2000s: pop star Victoria Beckham (a.k.a. Posh Spice) and her footballer, superstar husband, David Beckham. The couple have marketed themselves skillfully for over a decade, and turned their individual celebrity status into a lucrative brand that now encompasses a carefully chosen range of products: everything from Victoria's fashion label, to brands of perfume, sportswear, underwear and watches, now carry the cachet of the Beckham endorsement.

July, 2000

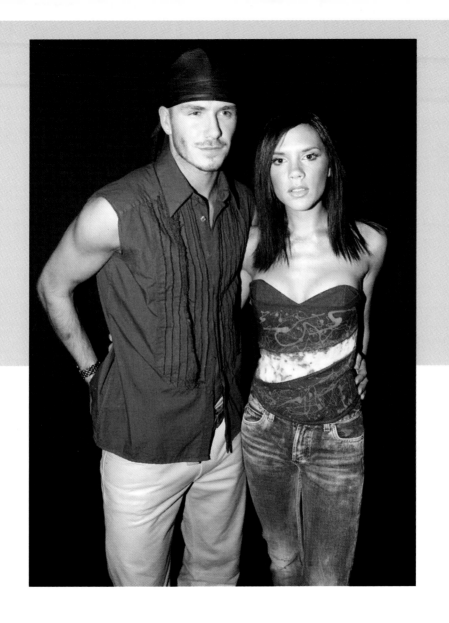

Off-the-shoulder number

Sheer black, off-the-shoulder blouse, with purple flower motif, worn over the ubiquitous jeans with a purple scarf tied at the waist.

August, 2002

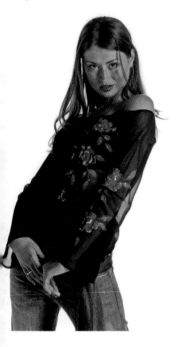

Pastel shades

Pleated pastel cord jacket with matching, hip-hugging trousers.

2002

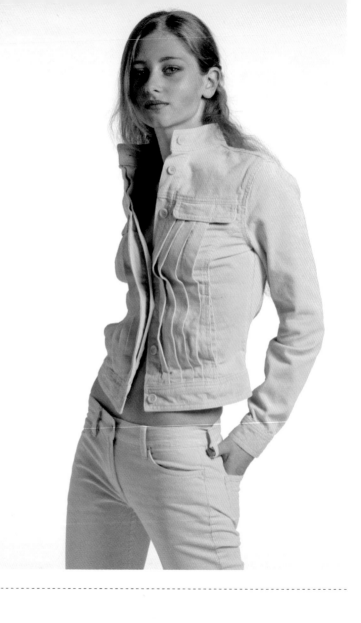

Cream and beige

Cream cropped, woollen ballet top, worn with low-slung, cream jeans, teamed with beige scarf, belt and shoes.

February, 2002

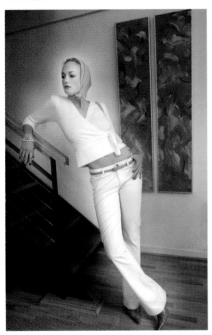

Pretty as a peach

Peach, halterneck handkerchief top, with flower motif, worn with jeans and woven tassel belt.

June, 2002

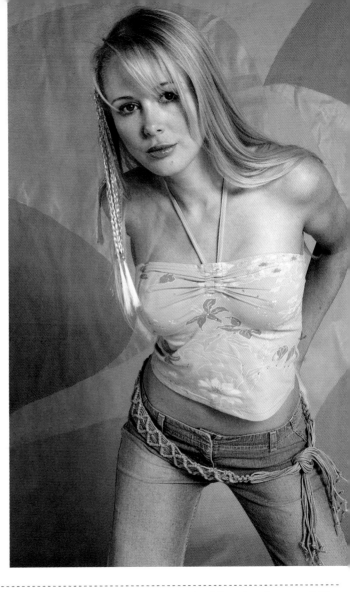

Man-style

The universal casual look for men everywhere: a T-shirt and jeans worn with white trainers. The curtain of hair was optional for delivering smouldering looks.

July, 2003

Day or nightwear

This flimsy salmon pink lace dress with ribbon detailing would also double as a nightie.

2003

Waspy

Cropped black polo neck sweater, worn with denim mini-skirt and striped yellow and black tights.

October, 2003

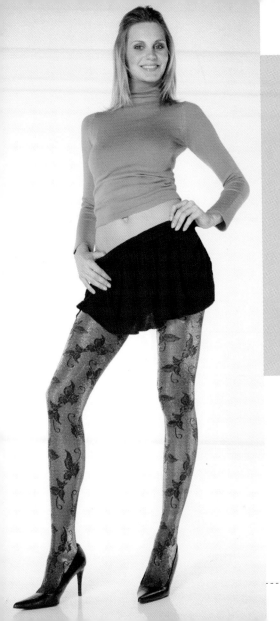

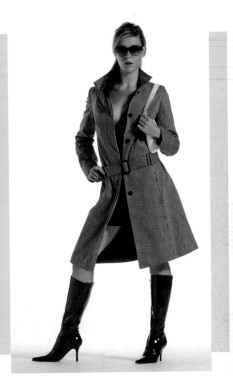

Let it pour

Simple, stylish and practical: grey raincoat with belt, worn over black mini-dress and knee-high boots, teamed with an impractically small, white handbag.

2003

Shiny

Green, cropped polo neck jumper, teamed with a black pleated mini-skirt and sheer, black patterned tights, worn with stilettos.

October, 2003

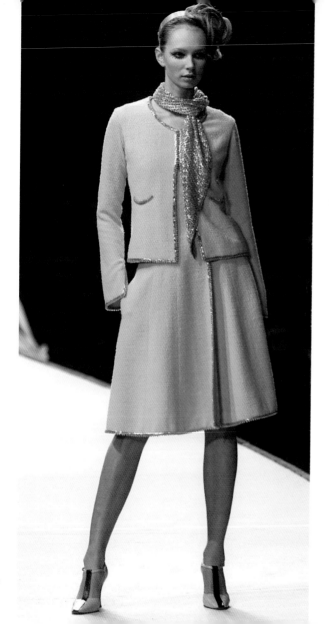

Classic Chanel

A lime-green, two-piece suit, edged in
pink, with matching sequined scarf is a
classic from the renowned Chanel range.

c.2000s

Skimpy and sexy ▶

Revealing, sexy and fun styles were
introduced in the new millennium, such
as this cute cropped, textured pink jacket
trimmed with denim, worn with denim
mini-skirt and matching pink scarf,
tied at the waist.

2004

Rain or shine ▶▶

Practical could also be alluring. This
taupe gabardine raincoat is worn over
rolled up jeans and saucy red
stiletto sandals.

2004

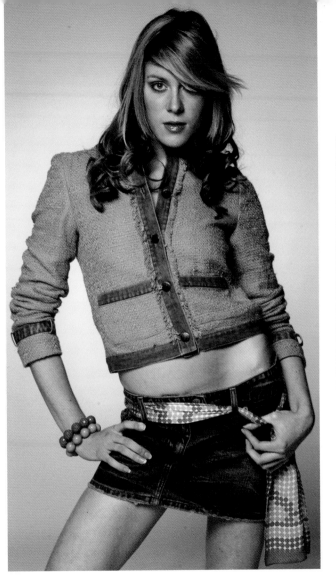

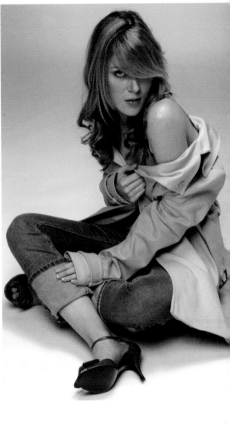

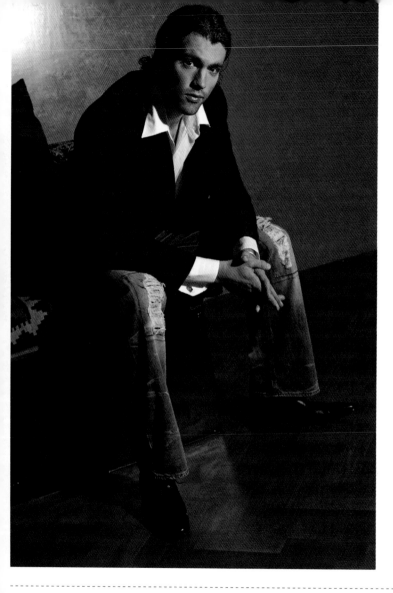

Full bodied

Red-blooded male smoulders in claret red jacket, crisp white shirt and distressed jeans.

December, 2004

Summer smart ▶

Smart yet casual, this beige, lightweight summer suit, worn with open-necked light blue shirt over a plain T-shirt, is teamed with brown belt and brown suede shoes.

May, 2004

Don't give up the day job ▶▶

Celtic football player Neil Lennon tried his hand at modelling suits but, although the cult of celebrity will sell most things, Lennon's appeal as a male model was fairly limited.

September, 2004

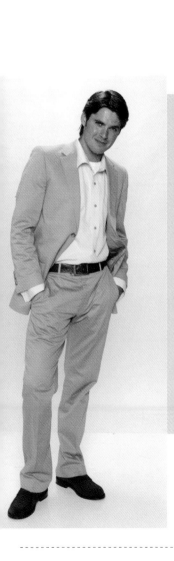
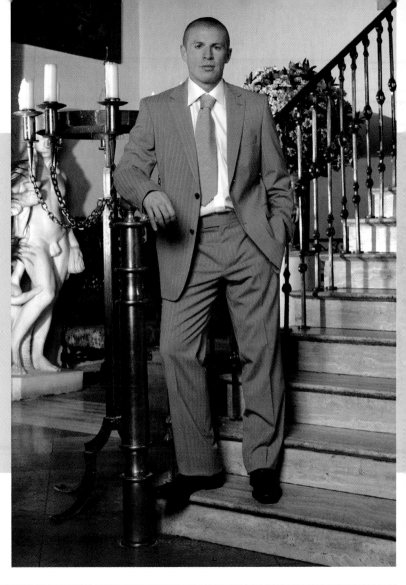

Winter warmers

Tweed, check three-quarter-length coat, with diamanté buttons, worn with plum coloured, high-heeled boots.

October, 2004

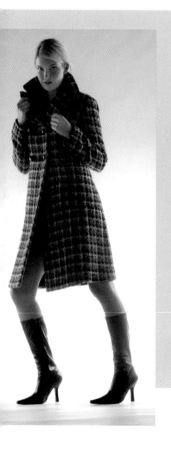

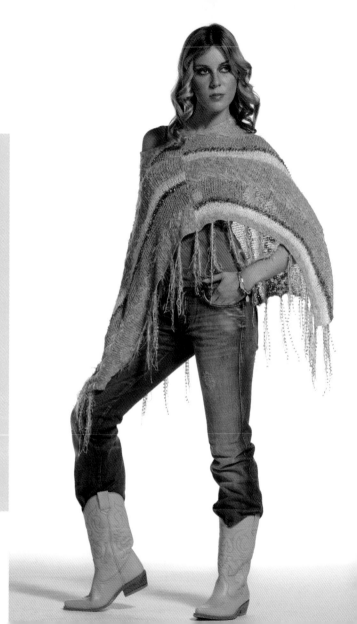

Period poncho

A retro touch on a modern outfit: a 1970s-style tassled poncho is worn with faded jeans, matching cowboy boots and pink vest.
August, 2004

Gossip girls

Royal Ascot Fashion, courtesy of gossip columnists working for the *Daily Mirror* newspaper, known collectively as 'The 3am Girls': here, they wear a selection of floral dresses and matching hats.
June, 2004

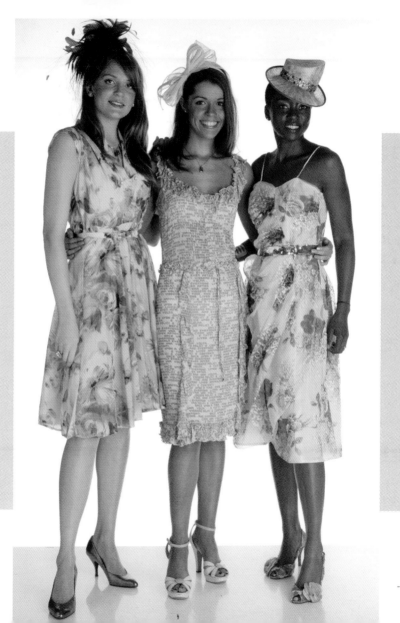

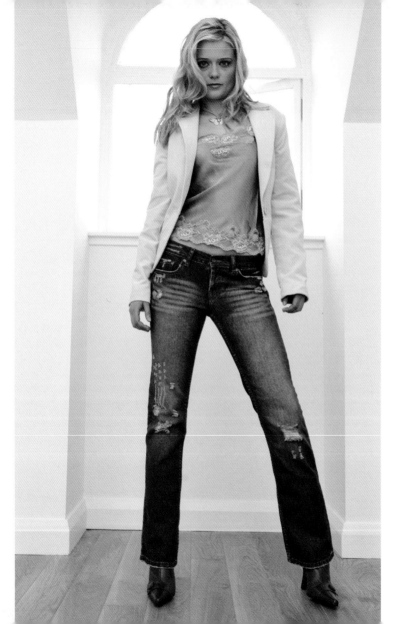

Cream corduroy

Corduroy jacket, teamed with lacy camisole top and worn over fashionably distressed jeans.
September, 2004

Check in

A smart, yet slightly less formal look for the office: grey, wide checked suit worn with a V-neck jumper and slip-on shoes.
July, 2004

Greek goddess
Brown bikini
worn with silver,
knee-high boots,
silver chain belt
and sunglasses:
a striking, if
somewhat
impractical,
outfit for running
around on a
Greek island.
July, 2004

◀◀◀ An evening out

Evening looks for the smart professional: peach chiffon dress worn with beige shawl, gold belt and clutch bag (R); grey, large check suit worn with plain shirt and gold and white striped tie (L).

July, 2004

◀◀ Fashion lectures

College Attire: grey velvet jacket, worn over shirt and faded jeans, teamed with a baseball cap (L); denim mini-skirt, worn with white crocheted poncho and cowboy boots (R).

August, 2004

◀ Backpacker essentials

Student fashion essentials: grey baggy trousers with deep pockets, worn with a light grey, long-sleeved T-shirt and carrying a small backpack.

August, 2004

Elegant lace

Effortlessly elegant, a black lacy strapless dress, with fitted corset-style top and A-line skirt, worn with black stilettos.

September, 2004

◀◀ Young gun

Pop star Will Young, wearing a two-button grey suit, with a plain white shirt and waistcoat with button detail and brown shoes, arriving at the *Elle* Magazine Style Awards.

February, 2006

◀ Sporting endorsements

Sportswear manufacturers continued the tradition of courting well known sporting celebrities to endorse their products: PUMA launched a new training shoe, with support from the Celtic football players Kenny Miller (L) and Aiden McGeady (R).

November, 2006

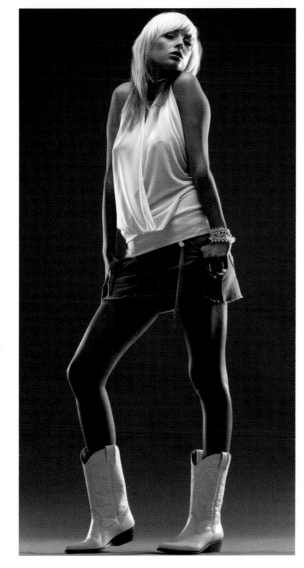

Cool cowboy boots

Denim mini-skirt and white, wrap-around top, worn with white cowboy boots.

January, 2005

Men's summer shorts

Summer male fashion in the 2000s was epitomised by outfits such as this brown T-shirt and knee-length, denim shorts, worn with flip-flop sandals and canvas bag with shoulder strap.

July, 2006

Summer festival fashion

T in the Park Festival fashion: Combat trousers, parka anoraks, and, the essential must-have item – a pair of wellies – (the ones shown here are spotless and have obviously been nowhere near a muddy festival site).

June, 2006

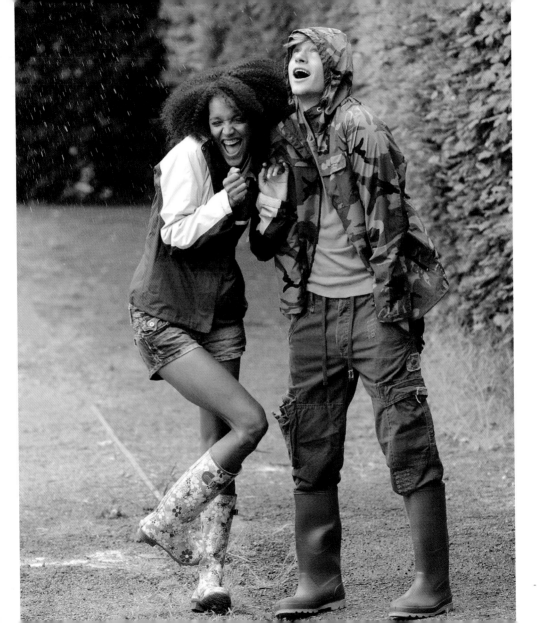

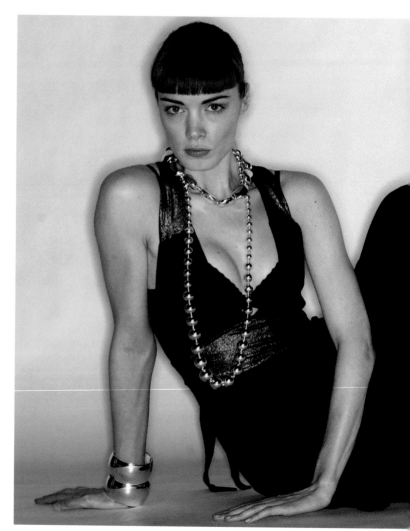

Heavy metal

Black halter-neck top,
worn with leggings,
metallic finish stilettos and
chunky, burnished necklace.

April, 2007

Gym kit

The major sportswear manufacturers continued to cater for the huge market created by the fitness craze, using their customers to advertise their own particular brands, such as this black Adidas tracksuit with pink stripes and logo.

December, 2008

High Street fashion ▶

The 2000s saw many established high street department stores employing established designers to produce high quality, affordable, up-to-the-minute fashion, for customers who wanted to look good, on a budget. This black, knee-length, short-sleeved dress was on offer at Marks & Spencer.

February, 2009

The rise of Primark ▶▶

Affordable style, but at what cost? The fashion chain Primark grew rapidly, selling budget clothing, sourced cheaply and made in simple designs and fabrics, in only the most popular sizes, such as this stylish outfit. Despite their success, they drew criticism for the poor working conditions of the Indian factories supplying them.

February, 2009

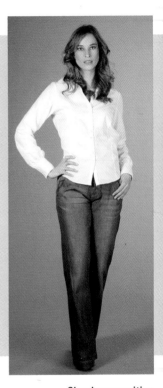

Simple proposition

All of Primark's merchandise is
made for the company and has its
own brand names. Competing with
other big names, it has a simple
appeal: stylish clothes low cost.

February, 2009